Strangers & Sisters

Selma James was born in Brooklyn, New York, in 1930. She has worked in factories and offices and as a full-time housewife and mother. In 1953 her first pamphlet, *A Woman's Place*, was published. In 1955 she came to England to marry a man who had been deported from the United States during the McCarthy period.

From 1958 to 1962 she lived in Trinidad, where she was active in the movement for West Indian independence and federation (and to expel the American military base at Chaguaramas), organising with women as much as possible. Returning to England after independence, she became the first organising secretary of the Campaign Against Racial Discrimination in 1965, and a founder member of the Black Regional Action Movement and editor of its journal in 1969.

In 1972 Selma James founded the International Wages for Housework Campaign. She has lectured widely in North America and Europe. Her publications include *The Power of Women and the Subversion of the Community* (with Mariarosa Dalla Costa), 1972; *Women, the Unions and Work*, 1972; *Sex, Race and Class*, 1974; *The Rapist Who Pays the Rent* (with Ruth Hall and Judit Kertész), 1981; *The Ladies and the Mammies: Jane Austen & Jean Rhys*, 1983. *The Global Kitchen: The Case for Counting Women's Work*, will be published in 1986.

Selma James is active as an organiser, public speaker and writer, and is based at the King's Cross Women's Centre in London.

to Eleanor

Power to the
sisters!

[signature]

17 Oct 2023

Strangers & Sisters

Women, Race & Immigration

Voices from the conference
'Black and Immigrant Women Speak Out
and Claim Our Rights'
London, England, 13 November 1982

Edited with an Introduction by
Selma James

FALLING WALL PRESS

Published by Falling Wall Press

First edition October 1985

'Introduction', 'Making trouble, making history', 'Postscript' and all other
editorial contributions © 1985 Selma James; conference transcript, conference
documents and cover photographs © 1985 Housewives in Dialogue

Cover design by Mark Ranshaw
Typeset by Folio Photosetting, Bristol
Printed and bound in Great Britain by Billing and Sons Ltd., Worcester
Cover printed by Doveton Press Ltd., Bristol

British Library Cataloguing in Publication Data
Black and Immigrant Women Speak Out and Claim Our Rights *(Conference:*
 1982: London)
 Strangers & Sisters: women, race & immigration: voices from the conference
 Black and Immigrant Women Speak Out and Claim Our Rights, London,
 England, 13 November 1982.
 I. Title II. James, Selma
 305.4'2 HQ1206

 ISBN 0–905046–29–3

Falling Wall Press Ltd.
75 West Street, Old Market, Bristol BS2 0BX, England

CONTENTS

PART ONE
Origins, aims and achievements

Introduction 9
A word on the script 51
Conference agenda 52
Thanks . . . 53

PART TWO
Conference proceedings

The welcoming 57
Session 1. Organising to come here — why and
 how we did it 63
Session 2. Building a life in Britain 99
Session 3. Claiming our rights 139

PART THREE
Completing the picture — the method

Evaluation. Making trouble, making history 183
Documents. For the record and the future — the
 grant application and other useful tools 193
Postscript 225

PART ONE
Origins, aims
and achievements

INTRODUCTION

On Saturday, 13 November, 1982, about 350 women, in the majority Black, attended a conference in London on race and immigration, and created a most memorable event. It was the first conference initiated by Housewives in Dialogue, a women's charity. The event represented two years of discussion and organising for all of us at the King's Cross Women's Centre, which is not many yards down the road from the conference hall. Our work brought together women whose origins were at least 38 different countries. Strangers in the morning, by the end of the day we had connected with each other to form a temporary sisterhood and perhaps even to lay the basis of a more lasting network. Such unity is unprecedented for almost any gathering, let alone one of Black and white, immigrant and non-immigrant, focusing on race and immigration from the point of view of women.

The conference was unprecedented in almost everything. In part because of our concern to spell out the new intention, the event had what is probably the longest title of any conference in history:

> Bringing it all back home: Black and immigrant women speak out and claim our rights.

It took the first part of its name from and was conceived to be an extension of the pathbreaking book, *Black Women: Bringing It All Back Home*, published for Housewives in Dialogue in 1980,[1] which for the first time began to spell out the work that

immigration means for women. Issues labelled 'Black' and 'immigrant' and those labelled 'feminist' were seen to be inseparable; and the meanings of the situations and relationships conveyed by all three when they are in isolation — in ghettoes — were transformed.

The conference, over two years after the book, was convened in order that Black and/or immigrant women could for the first time in some massive way articulate and share experiences and perceptions among themselves and with other women: to continue the exploration of race, immigration and feminism through such a gathering of experts, that is to say, through women with first-hand information on their own lives speaking out about them.

It is no accident that such an event with the focus of women's work originated at the King's Cross Women's Centre. The first women's centre in the London borough of Camden, it was started by the Wages for Housework Campaign in 1975. In its first statements two years earlier, the Campaign had spelled out the connection between the unwaged and invisible work of women everywhere, and the work, waged and unwaged, of all immigrants, women and men.

We also insisted that those of us who are immigrants, wherever we come from and wherever we go, attack the racism and provincialism carefully nurtured among every working class, by bringing another world — usually the Third World — with us into metropolitan centres. One side of immigration, we said, is that it is an element of State planning — using immigrants to undercut the wages, working conditions and living standards which have been won by the native working class, and to disorganise resistance. The other side is how immigrants — as much those from Malaga in southern Spain as those from Port of Spain in Trinidad — use immigration as a method of reappropriating their own wealth, stolen from them at home and accumulated in the metropolis. Immigrants are in Britain, we knew, not for the weather but for the wealth which — because much of it has been produced

by their own and their ancestors' labour — is as much theirs by right as those whose history of exploitation has never left Britain.

The work of women, basic first to organising for themselves and others to become immigrants, and then to transforming their communities from victims of the State game into a network of reappropriators, that work of women is hidden, as most of women's unwaged work always, everywhere, is hidden. By 1977, when in a speech at our Centre, Margaret Prescod began to describe that work in detail to an enthusiastic and deeply moved audience of about 50 women, we determined that her speech must somehow be published, and in the spring of 1980 it was.

Also in 1980, a few months later, some of us attended, along with 8,000 other women, the World Conference of the United Nations Decade for Women in Copenhagen, where we heard the first quantification of women's contribution to the economy of every country. The UN, that conservative, male-dominated collective of governments, had calculated that women do two-thirds of the world's work, get 10% of the income and own 1% of the assets. These figures are probably as conservative as the UN itself, especially when applied to the Third World women whose working day generally begins before dawn and never seems to end. The International Labour Organisation has already adjusted down the figure for income to 5%.[2]

Here was official confirmation of a case the Wages for Housework Campaign had been making since 1972: the enormous but invisible quantity of work done by women in every country for next to nothing. The two-thirds figure acknowledging women's work — Black women's work, immigrant women's work, *all* women's work, waged and unwaged — was basic information, the raw material from which was constructed the social weakness of women. For us this was the first quantification of sexism, a tangible measure of just how ripped off women are internationally.[3]

The great debate which has raged in the women's

movement about why we are together as women (or at least why we could be together despite a thousand divisions) is ended (or at least can be ended) by the UN figures: the work and the poverty of women and our struggle against it — these constitute the material basis of the women's movement, what one conference participant called 'the common roots of oppression' and what we had always claimed was the basis of women's relation to capital: women's exploitation.[4]

Such a quantification was a weapon against the work. One way to refuse to let the work go on is by refusing to let it go on unnoticed. We began to publicise the UN figures.

From the perspective of women's work, all issues are transformed. Take for example immigration.

How much work do women do to make immigration possible, to make possible the rebuilding of the community in a new town, city, country; among other races; speaking other languages; with different food, dress, customs, education, religions, hierarchies? What is the hidden cost — hidden because women pay it and are not paid for doing it — when the family and community have to confront and survive the economic and social consequences of racism, while the woman on whom such survival depends may be under attack as a woman even from within her own community?

Such questions begin to drag out of the shadows the mountain of work which has defined women's condition, as well as the mountain of work which is assigned to immigrants, particularly if we are Black, always if we are women.

For though as women we share overwork and poverty, yet race, immigration and other divides determine what kind of work we do, how much we do, under what circumstances and for what returns. While the UN figures quantify the sexual division of labour, there is also a racial division of labour, an immigrant/native division of labour, and so on, which have never been quantified.

In fact, every division among us expresses the division of labour: the quantity of work and the wages or lack of wages mapped out for each particular sector. Depending on who we

are — what combination of sex, race, age, nation, physical dis/
ability, and so on — we are pushed into one or other of these
niches which seems our natural destiny rather than our job.[5]
To allow anyone to deny in any way even one of these aspects
of our identity is to allow them to falsify and hide our social
position, to falsify and hide our workload, which they do most
often to falsify and hide the power relation between us and
them.

Generally in the self-proclaimed women's movement, our
waged work is only one of many unconnected issues. Our
unwaged work on the land and in the kitchen is hardly a
concern at all of many feminists. The same is true of political
men of every hue and complexion. For neither of these is this
torturous two-thirds of the world's work ever included in
definitions of either sexual or racial violence, though it is both.
Work is not just another issue, one of many ingredients of
oppression, one item on a list of grievances which add up to
women's inferior position. Work is not one branch of a
blighted tree, each branch having equal claim to treatment in
the cause of women's — or anyone else's — liberation. Work
is the tree, which must be destroyed root and branch because
it saps our time and energy, which happen to be our life. Work
— the activity women and men are forced to perform to
survive under capitalism — confines us, defines us and
shapes our relationships. But for women, to the degree that
the work we do is to care for, nurture, train and nourish
others, physically and socially, work *is* our relationships.
Because work is how we spend our lives and how we relate,
work shapes our consciousness of ourselves and each other.
Women are seen as naturally low waged or unwaged servants,
by men, by each other, in fact by the entire society, starting
with our own children. In fact and in consciousness, the work
we do, women and men, is the essence of our slavery.

Therefore, neglecting to confront work has devastating
implications for every movement. To the degree that any part
of the work we do, and the division of that work among us, is
hidden, to that degree the people who do this work and the

divisions — the power relations — among us are also hidden, including within the movement. And to that degree our struggle against this work and these power relations is undermined. Neglecting women's work — the two-thirds — hides the division between women and men; neglecting all the other divisions of labour hides other divisions among us, *including the divisions among women*.

Neglecting women's work has wide implications for every other aspect of struggle. For example, without a quantification of women's work, the case against imperialism, the multi-nationals, the military–industrial complex, obviously has a basic weakness, a tragic flaw. Why they conquer, what they steal, and how much they are exploiting whom, in factory, farm and family, are calculated on an incomplete reckoning at best. At worst, such a false reckoning conceals the most bitter truths about one of the two sexes, about the relations between men and women, and about every aspect of politics and economics.

The neglect of all immigrants' work, but women's work in particular, is a basic weakness of every anti-deportation campaign. The movement has often made the case that because most immigrants are of working age, we contribute more to the economy per capita than natives, who tend to be older; and that in any case we are doing jobs the natives have refused to do. This is true but it still postdates our contribution.

In 1978 three immigrant women's organisations together led a campaign to try to prevent the loss of child benefit to immigrant parents whose children were not in Britain. This £70m. a year was to be denied to parents who had already been denied their children by immigration procedures, rules and racism. The basic premise of the Child Benefit For All Campaign was that immigrants have always been working for Britain, first in the colonies and ex-colonies, and then in Britain itself. This work roots the claim for the basic right to stay and for rights to the Welfare State not in abstract justice only but in very concrete debts outstanding. 'Once this work

and pain is highlighted, we also see that we are owed far more than we owe."[6]

Women's unwaged work all over the world has produced this army of immigrants, women and men. While housework everywhere is consuming and endless, in the Third World it is generally accomplished without running water at home or at all, without State health care, education, welfare. Immigrant women came to metropolitan countries precisely to refuse this housework.

Many generations of Third World women have paid heavily so that Britain and other metropolitan countries could have a reserve labour force ready and waiting in the wings, so to speak, for when it was needed. That poorer nations subsidise richer ones by exporting immigrant labour power has been noted before. That it is women's unwaged work in Third World conditions of economic and technological poverty which has produced this labour power, and that this is a subsidy extracted specifically from women by international capital, is rarely if ever noted.

That women like Halimat Babamba (see p. 151) and many others should be seen as appendages of men in immigration legislation and be threatened with deportation, is directly attributable to the invisibility of that work. The State never mentions it. And neither does the movement.

It is vital for us as women that the economic and social foundations of society laid by our unwaged housework, field work, community work, office work and much more, in every society, finally be acknowledged.

The only politician ever even to begin to acknowledge the unwaged work of women is President Nyerere of Tanzania.

Nyerere has made the case that in Tanzania the city is financially dependent on the countryside, and that the countryside is almost entirely dependent on women's work. Both these claims appear in the famous Arusha Declaration, the fundamental document of the ruling TANU Party.[7] Putting the two together on the same page, we can draw the conclusion that the entire society survives and develops

largely on the backs of women. Since this may be a startling conclusion, and since economists and other authorities have not even hinted at it, we put the two quotations together below.

On the financial dependence of the town on the village:

> Our emphasis on money and industries has made us concentrate on urban development. We recognise that we do not have enough money to bring the kind of development to each village which would benefit everybody. We also know that we cannot establish an industry in each village and through this means effect a rise in the real incomes of the people. For these reasons we spend most of our money in the urban areas and our industries are established in the towns.
>
> Yet the greater part of this money that we spend in the towns comes from loans . . .
>
> . . . the foreign currency we shall use to pay back the loans used in the development of the urban areas will not come from the towns or the industries. Where, then, shall we get it from? We shall get it from the villages and from agriculture. What does this mean? It means that the people who benefit directly from development which is brought about by borrowed money are not the ones who will repay the loans. The largest proportion of the loans will be spent in, or for, the urban areas, but the largest proportion of the repayment will be made through the efforts of the farmers. [p. 242]

On how much women in the villages work as compared to men in the villages and waged workers in the city:

> In towns, for example, wage-earners normally work for seven and a half or eight hours a day, and for six or six and a half days a week. This is about 45 hours a week for the whole year, except for two or three weeks' leave. In other words, a wage-earner works for 45 hours a week for 48 or 50 weeks of the year . . .
>
> It would be appropriate to ask our farmers, especially the

men, how many hours a week and how many weeks a year they work. Many do not even work for half as many hours as the wage-earner does. The truth is that in the villages the women work very hard. At times they work for 12 or 14 hours a day. They even work on Sundays and public holidays. Women who live in the villages work harder than anybody else in Tanzania. But the men who live in villages (and some of the women in towns) are on leave for half of their life. [pp. 244–5]

In order that the reader will not underestimate the importance of these quotations, we add that a few months later, on 5 August, 1967 (and in statements up to this very day), President Nyerere reiterated that in the absence of foreign aid (because they were going their own independent way, trying as best they could to avoid domination and exploitation) and with the fall in the prices of agricultural crops (which lowered the value of their agricultural production in the world market — and this of course continues), a country like Tanzania was almost entirely dependent on 'hard work' and especially hard work in the countryside. 'Our future lies in the development of our agriculture and in the development of our rural areas.'[8] Which is overwhelmingly the work of women. So that the question of women's work on the land is not peripheral, secondary, marginal, but central to Tanzania, in fact its foundation.

Women's work is also the foundation of Tanzania's policy for striving to achieve independence from the superpowers.

The concentration of 'the development of our agriculture and . . . the development of our rural areas' has always been the distinguishing feature of President Nyerere's leadership. The international military-industrial complex continues to suck the Third World into its economic plans, turning whole national economies into outposts and subsidiaries of its multinationals, through aid, loans, investments, destabilisation and, if necessary, invasion (for example in Central America). When the Third World is referred to by development agencies and Western governments as the 'developing

world', it is to hide their intention that the Third World continue *not* to develop and certainly not in any way which would give it independent power from them.

Third World governments often bow to the domestic political power of the cities and to the threats and bribes of the superpowers. In contrast, President Nyerere has been attempting, despite opposition even from within his own government, to steer a uniquely independent course for Tanzania, based on developing the twin resources it already has — the people and the land — and on hard work. Now that we know who of 'the people' 'work harder than anybody else in Tanzania', we can more fully appreciate the centrality of women not only to Tanzania's present economy but to its hopes for an independent future.

We can also appreciate that, as long as Tanzanians continue to suffer the technological deprivation which keeps Tanzania so dependent on overwork in order to survive — where even tractors are a luxury in the age of the computer — an independent future is dependent on men sharing the workload which women and children in the villages now carry almost alone.

In the same way, the development of agriculture (the major 'industry') and the villages (with the majority of the population), as the priority and point of reference for the society and the economy, is also dependent on a more just distribution of work. Yet we rarely if ever hear about this, or about the social changes which would strengthen women's refusal of overwork and help them to shift some of the burden they and their children shoulder alone, to men. Rather, we hear about bringing women into 'development', a phrase so vague that we are not sure if it means more work for women or less.

While Tanzania's policies are unique, the women's work those policies rest on is not.

It is widely accepted that the society President Nyerere is describing, and the quantity of work which women do for it, is a picture not of Tanzania only but of most of Africa, and

probably much of the Third World. Nevertheless, nobody so far as I know has bothered to put together and explore what President Nyerere said in order to prove or disprove it. Many people admire President Nyerere's political leadership and, as we can see from his honesty and clarity above, justifiably. But unlike him, they do not admire or at least do not acknowledge what he said about Tanzanian women and the work they do. Women in Tanzania are not well served by those who praise their president.

Women's unwaged work appears nowhere in any country's gross national product (in Britain referred to as the gross domestic product), which is supposed to quantify the total amount of a country's goods and services. Those who claim to lead us in the struggle against exploitation, including of course trade unions, seem just as reticent to mention the two-thirds we do, the 5% we are given for it, and the mere 1% of assets we own. Women's unwaged work? Hard. Maybe even tragic. But marginal. Unproductive. They should get a job.

And so, with the gross omission of most of the world's poverty and of most of the world's work, women (and children), who bear the burden of this work and poverty, are omitted from every consideration of entitlement. Dismissed.

Dismissed as much by militant anti-sexists as by militant anti-capitalists and anti-racists, and even by those who pride themselves that they are all three. In dismissing or ignoring the UN figures which, we repeat, are probably conservative, two-thirds of the case against capitalism, racism, imperialism and sexism — against the racist, imperialist patriarchy — and two-thirds of the proof that there is a material basis for sisterhood, that we have a basis for common struggle as women and as workers internationally, is also dismissed.

In particular, the struggle of Black women day to day, where possible to refuse this work in poverty, and where it is unavoidable, to perform it and still survive, remains largely invisible and unrecognised. For example, while it is public knowledge that Black people, and particularly young Black men, are regularly harassed, falsely arrested and beaten by the

police,[9] there is rarely a mention of the women — mothers and sisters, wives and lovers — who go back and forth to courts and prisons, who organise defence committees and attend their meetings sometimes on winter nights after long days cleaning hospitals; or who deliver to prison cells, along with home cooking and cigarettes (and at times unwelcome words of advice), the laundered shirts, so that the accused — son, brother, husband or lover — can appear before his persecutors dressed in the community's care and support.

It was such women who picketed the Old Bailey, London's Central Criminal Court, a few years ago during the trial of the Islington 18, Black youths unjustly accused of a variety of petty crimes. Families, mainly mothers and sisters, of these youths, organised a Defence Committee and did everything humanly possibly to force the defence lawyers to take instructions, to do what the defendants wanted and needed done. In order to call public attention to the laziness and arrogance of the lawyers towards their clients, and to their cowardice in standing up for their clients to the court, the mothers' placards demanded that the legal aid fees that lawyers were collecting for their sloth be paid instead to those who had done most of the defending — the families. It is rare for the work of Black women to surface in this way.

Neither feminist separatism nor nationalism, by country or by race, has noticed the women who have provided the backbone of every struggle. Thus sustained, Asian communities, women and men, have defended themselves from attack not only on the streets but in the waged workplace, beginning as far back as 1965 with the Courtaulds' strike in Preston, Lancashire, against two men having to tend three machines instead of one each, thus resisting Courtaulds' new plan for all its factories which it was trying on with immigrants.

Women's cooking, caring, supporting — their organisation — made it possible for the women and the men at Imperial Typewriters in Leicester to take on the National Front physically and drive them away; and for Jayaben Desai and the sisters and brothers she led at Grunwick to wage their

more famous but no more dramatic struggle.

Such caring and supporting behind the scenes, since it is just women doing just physical and emotional housework, remains largely uncounted, unhonoured and unsung by every movement. Suffering such invisibility, especially if you lack the language, you are assumed to be passive, helpless, unaware and incapable — the stereotypic victim, rather than the survivor and protagonist, the identity that your actions and accomplishments could earn you if you were white and a man.

Few among us appreciate how weak we — any of us — would be without this work and how much it protects us from. In passing laws and inventing rules and procedures aimed at keeping families divided, the British State are showing more recognition for the work of women than many of those on our side. They who preach the holiness of the family know exactly when it is in their interests to split it up: they know that the presence and support of the kinship network, which women's work builds, nourishes and sustains, greatly strengthens any struggle against them.[10]

Elsewhere we have spelled out how the survival of the family is dependent on the woman's slavery.[11] On the other hand, women know very well when the family is our protection, when the breakup of the family by the State is an attack on us. It is therefore *always* in our interest to have in our power the decision to preserve or to destroy the family, which, after all, rests on our labour. Central to women's case against the immigration laws is our demand to wrest all decisions on what is to happen to the family from the hands of the State.

Nor is it only what women do in defence of others which vanishes by silence. Women arrested on anti-racist demonstrations as far back as the sixties have sometimes been strip-searched, even (some whispered then, when there was no women's movement) in the presence of male police. Esmé Baker, who spoke on the second conference panel (see p. 111), was the first woman we know to speak out publicly against

sexual attack by police on Black women in Britain. It was the support of other women which made her triumph in court possible. Her solicitor told Women Against Rape that their picket outside the court and filling the gallery inside had won the case. The exhilaration and relief that such a personally shaming experience was finally confronted and overcome by collective power moved the audience to give Esmé a standing ovation.

Excluding or treating as marginal the mountain of work, the two-thirds, serves to reinforce the racism of white feminist politics and the sexism of male politics. When the workload we as women share is invisible, it is not hard to believe what all kinds of people impress on us in all kinds of ways, that Black and white women have 'different' problems and therefore want different things. It is not a long racist jump from there to the claim that, while Black women want money, white women want 'higher things'; or that while Black women want to be housewives, whom some feminists despise, white women want jobs outside the home, a more respected ambition in their hierarchy of desires.

The truth of course is that Black and white women both want choices, to be able to have, given their particular circumstances, whatever will mean less work and more money, less than two-thirds, more than 5%; and that every woman is in the best — the only — position to evaluate just what her own needs and circumstances are.[12]

On the whole, working class women tend to make similar choices whatever their race; and so do the minority of women of whatever race with just a bit more power, who often demand what they want for themselves in the name of all women. When they demand equality in our name they may end up with careers. For the rest of us, 'equality' may mean — and has often meant — just another lousy job on top of the housework. A bit more power makes some people think they are more than a bit more 'advanced'. If poorer women don't want what the minority demand, then this minority — which has the power to define us — claims we have a low

consciousness.

Feminism without the work we have in common on the one hand and the different workloads that divide us on the other; without the poverty we share on the one hand and the hierarchy of wages on the other; such a feminism tends to be so vacant and so narrow that race and immigration are treated as complications which get in the way of 'the struggle against the patriarchy' — which is how feminism is generally defined. We had a classic example of that in fighting Esmé Baker's case.

For Women Against Violence Against Women, rape and other sexual violence are unconnected with economics and with the State power which reinforces the prevailing economic power. Nevertheless, a local WAVAW group, to its credit, did come out to support the Black woman insulted and sexually assaulted by the police, claiming this was yet another case of male violence — which it certainly was.

But it was not *only* that. WAVAW's picket chanted alongside Women Against Rape's in front of the magistrates court in Walthamstow, London. But they would have no part in any chant supporting Esmé's 16-year-old son who was appearing in the dock with her; her defence of him was what had laid her open to police attack in the first place. Narrowly defining the enemy as patriarchy — the hierarchy between men and women — without relation to the multitude of other hierarchies, impels many feminists into the same narrow, sectarian and racist corners that WAVAW found itself in at Esmé Baker's trial. It is an arrogant and one-dimensional view of humanity and the crisis of survival we share.[13]

The theory of the patriarchy, in targeting men as the enemy without attacking work or profit-making, leaves the military–industrial complex,[14] which thrives on everyone's work, all three thirds, free to do as it likes with all of us. Such kindness to the powers that be is worth money. There are careers, grants, invitations to international conferences and access to the best academic circles to be found in such separatism. The theory of the patriarchy cut off from and prioritised over the class, race

and other hierarchies, is a scabs' charter.

It is also a formula for defeat. The idea that by cutting ourselves off from those who share one or another aspect of our exploitation, other women, other men, our struggle against exploitation will be strengthened, is as absurd as it sounds. It is also dangerous. We need the support and protection of other sectors. Whoever suggests that we reject that support intends us, women or men, for whatever reason, to be isolated, the victims of divide and rule again, this time in the name of our own movements.

The conference succeeded in bringing together those who are potential allies, other women who share with us the burden of two-thirds of the world's work and the struggle against it, and we came together on that basis rather than on an abstract sisterhood. We did not sidestep the power relations among us or we could not have stayed together even for that day. Since the starting point was Black and immigrant women, all of us were able to tackle some of the basic issues which have plagued both the women's movement and the Black movement and falsely divided them. Black and immigrant women, the hidden source of power to each and the silent majority in both internationally, where the struggles against racism and sexism are inseparable, were the key to uncovering the bond we shared.

While this is what we aimed to make happen, and what did in fact happen, it didn't 'just happen'. For months we tackled the questions: How to avoid bogging down in theoretical/ ideological debates which generate hostility while clarifying nothing? How to communicate so that each individual's truth and each sector of women's uniqueness emerges — without mincing words, without liberal evasions — while at the same time bringing into life the sisterhood of those whose lives are consumed in the performance of two-thirds of the world's work? And last but not least, could Black and white women achieve this together; or would the presence of white women, immigrant or not, prevent clarity and inhibit truth? Would it all go up in smoke, in an outpouring of racial antagonism and

bitterness? Were the separatists right: were we so estranged
by racism that no sisterhood was possible?

* * *

Immigrants — women or men — are seen as strangers. In
Europe, so are Black people, immigrant or not. Yet the
conference themes, race and immigration, have been major
issues in the making of British capital at home and abroad, as
well as the making of the working class at home and abroad.
That is to say, while race and racism had always been a vital
component of British imperial rule abroad, we are led to
believe that Black people and the racial clash within Britain
are new arrivals.

In the same way, while we know that deportation from one
colony of the Empire to another was a commonplace — for
example, West Indian 'outside agitators' deported from one
island back to the island where they 'belonged' — it is
generally assumed that deportation as a basic and widespread
tool of State discipline within Britain is as recent as the 1962
Immigration Act and the increasingly repressive Acts which
followed, culminating in the Nationality Act of 1981;[15] that
deportation is basically about race.

It is beginning to be known that one of the byproducts of
the British trade in slaves and New World slavery was a Black
population in Britain beginning as far back as the 1570s. By
1772 it was estimated that of a population of nine million in
England and Wales, about 14–15,000 were Black.[16] Few of
those people ever left these shores and so, aside from old
Black communities in places like Liverpool and Cardiff, those
thousands must have become the ancestors of many British
people today, some of whom, because they have white skins,
seem not to be aware of (or at least don't acknowledge) their
African roots. (Some would have Asian roots, the descendants
of later arrivals.) Hints of this ancestry can appear anywhere,
and I will not forget being taken aback by a face of obvious
African derivation on the television spewing out racism in a

plummy accent on behalf of the Monday Club. Upper class hooligans on the extreme right of the Conservative Party may also have Black roots.

Deportation or threats of it also have a long history in Britain. Queen Elizabeth I deported Black subjects on the pretext that they were taking food from white ones. Two centuries later, the word 'transportation' was a euphemism for dealing with troublemakers by the deportation to the colonies of working class people convicted of crimes, most of them, obviously, crimes of poverty. In the process, the racial balance in the colonies of Virginia, Australia, etc., was changed, which the colonialists considered an additional bonus.

'Transportation' was also the method of subverting more acceptable forms of working class resistance to poverty. The Tolpuddle Martyrs — farm labourers, to this day Britain's wretched of the earth — were convicted of swearing an oath not to scab on each other, and to constitute themselves a trade union. For this they were 'transported' to Australia; 1984 is the 150th anniversary of their historic deportation. It is not irrelevant to us today that they were allowed to return after two years of their seven-year sentence, so strong was the anti-deportation campaign waged on their behalf in England. But it is not called that.

Immigrants today facing deportation, or the threat of it, which turns any claim for common rights into an act of bravery, have never been seen as the political descendants of those earlier working class heroes. The deported Tolpuddle men began to organise in Australia almost immediately they arrived. Thus Margaret Prescod's statement on the first panel, that 'immigration is the network along which the international travels' (see p. 85), is confirmed in this earlier chapter of our international history.

An example in our own time is how organising sanctuary for immigrants and refugees is helping to build a network of support within the United States for the people of Central America against intervention and destabilisation.

For years undocumented workers from Mexico — called

'wetbacks' because they were alleged to have swum across the Rio Grande, which is the border with Mexico, rather than face immigration controls — were the backbone of the agricultural labour force in the southwest. Their illegality was the weapon in employers' hands for imposing starvation wages, and when the illegals organised, they were murdered by vigilantes or deported.

Now the shoe is on the other foot. Today, organising against Reagan's policies in Central America is grounded in smuggling into the US those who are threatened with 'disappearance' — torture and then death — at the hands of the US-financed contras in El Salvador, and protecting them from the State Department, the US equivalent of the Home Office.

So that the issues the conference set out to address were neither peripheral nor marginal nor foreign nor strange. They were issues basic to Third World and metropolis, with a long history inside Britain, the country we were investing our lives and labour in, whether or not we were born here. And it was women from a variety of backgrounds, rarely if ever brought together, who were addressing these issues.

* * *

The King's Cross Women's Centre contributed to the conference not only its international focus of women's work but its organising experience gained over years.

The Centre houses a number of groups whose campaigning is based on bringing women together, often women who have not been involved in the visible women's movement before. In other ways too the groups can be trusted to attempt and achieve the imaginative and the unexpected.

Our first site in 1975 was a squat on Drummond Street, London, N.W.1. When we, along with a whole street of community organisations, lost our premises to redevelop-

ment by Camden Council, we occupied the Council with the
support of local squatters and, in the tradition of the
suffragettes, chained a woman to the railing of its upstairs
balcony (from which she gave radio interviews on why she
was there and how it felt to be chained) until we got the
promise of another site by the end of the day.

Housewives in Dialogue, a registered educational charity,
focusing on race and community relations from women's
point of view,[17] now runs the Centre, as a place where Black
and immigrant women can make their experience known.

Using the Centre are individual women and women's
groups, some of whom donate time to staff the Centre rota,
and provide the support and information which women ask
for. The support and information are of the highest calibre
because they are provided by skilled campaigners who know
their way through the State bureaucracy, local and national,
and who are prepared to protest, by writing, phoning,
lobbying in person, picketing — in fact by any means
appropriate and necessary — to get women their entitlement.

This combination of support backed up by campaigning is,
as far as we know, a new concept in women's centres and has
produced a centre which is always breaking new ground and
irritating those who think revolutionary feminism is nicer
with footnotes than with footwork. It also drives racists wild.
To their satisfaction, our campaigning has never been
funded.

Wages for Housework, which started the Centre, has within
it a number of autonomous groups. Black Women for Wages
for Housework has provided the leadership on race and
immigration which has distinguished the King's Cross
Women's Centre. In 1978 they were involved in trying to save
child benefits for immigrant parents (mentioned earlier;
Margaret Prescod also mentions this on p. 102). The Child
Benefit For All Campaign didn't win, but the collective work
with the Bangladesh Women's Association and the Union of
Turkish Women showed how immigrant women could
organise across racial and national lines in a way that mixed

organisations are only now attempting.* The whole Centre mobilised in support, and it was an occasion for our ongoing training as Black and white women within the Centre to co-ordinate our activities and confront racism among us. From the formation of Black Women for Wages for Housework in 1975, we had been working out collectively how Black and white women are to work together in a mutually rewarding way, and I will deal with this in a moment.

Wages Due Lesbians, the first organisation to be autonomous within the Wages for Housework Campaign, has fought cases where mothers, lesbian and non-lesbian, have lost custody of their children to the State or to individual men, and initiated action where lesbian women are under threat. For instance, they led to victory the fight against Maureen Colquhoun MP being unseated by her constituency during the last Labour government. The pretext was that she was a 'self-confessed' (i.e. public) lesbian, but the real reason was that she accused the Labour Party of giving lip service to anti-racism while in practice refusing money to the inner city, thus increasing racial antagonism. Wages Due also attempted an initiative in the gay community in support of the Bradford 12 (see p. 212).

The English Collective of Prostitutes (for which I have been a spokeswoman since it was formed in 1975), also part of Wages for Housework, has campaigned against the prostitution laws which criminalise women who demand payment for sexual services which women are expected to provide for free, and has found itself up against 'police illegality and racism' in King's Cross. Legal Action for Women, the comprehensive legal service for all women which the ECP

* I refer here to the newly formed network across Europe of migrants, immigrants and refugees. Working to cross racial and national boundaries on the one hand, and the legal historical boundaries which determine immigration status — ex-colonial, Common Market, refugee, and other categories which segregate us — on the other, this is one of the most dynamic and important organisational initiatives in recent years. See note 15 on p. 48 for further information.

started and runs, deals with an increasing number of deportation cases. (As we shall see, for the ECP the conference was a curtain-raiser for a historic confrontation.)

Women Against Rape is also based at the Centre and draws heavily on its organising resources.[18] As with every other Centre group, WAR always pursues how 'their' issue, in this case sexual violence, relates to all women, beginning with the most vulnerable, Black and immigrant women. For example, a woman from WAR was arrested on a demonstration against immigration laws to which they had brought a leaflet entitled, 'Immigration Controls — Passport to Rape'. This perspective is, unfortunately, rare in the metropolitan anti-rape movement whose racist tradition seems hardly to concern the loudest and most frequent voices, particularly in Europe.[19]

The leadership of Black Women for Wages for Housework has been decisive in the campaigning and functioning of every Centre group. This process, of Black and white women finding ways to work together, has been one with sorting out how lesbian and non-lesbian women and prostitute and non-prostitute women are to work collectively. The King's Cross Women's Centre, in fact, has spent a lot of time confronting the power relations among women as they surface in the course of our campaigning; spelling out the varied, pernicious and subtle forms they take; and working out ways based on that information to organise against them, among ourselves and with others.

This process is never completed, of course; the way any of us relates to anyone else is hardly a question of intention only but of the very structure of society, the very structure of our lives: the division of work and wealth which pits us against each other for basic needs. Given this rivalry, attacking and demeaning or at best ignoring the needs and claims and pain and struggle of others — beginning with children — appears to all of us again and again as a necessity for survival.

While we will not end racism — which says that any other

human being wants less, needs less, deserves less than we do, on whatever pretext — until the society which breeds such competition of needs is completely transformed, we *can* work together against this competition in a productive and satisfying way. But it is *work*. It is *hard* work. Which, if we are serious about uniting, we have to be prepared to do, not apart from but in the course of and central to organising. In this way, confronting our own and each other's racism is the same process as finding ways to direct our anger against the State which divides us, rather than against each other. We at the King's Cross Women's Centre consider ourselves experts at this.

So that the conception behind the conference, to begin with Black and immigrant women, and to cut across divisions and bring together those who are ordinarily divided, was no accident or one-off. It came from the daily practice of the Centre, which determined the way the event was constructed. This is important for the reader to bear in mind so she may judge for herself how the conference committee's planning and organising related to the spontaneous activity of the participants, each of whom came to the event with her own unique experience, preoccupations and expectations.

* * *

We knew that the conference could encourage women to share their experience and preoccupations only if it kept political rivalry and one-upmanship to a minimum. It is not easy to do this. Many a gathering organised with the best of intentions has foundered when participants, men or women or both, offered each other not much more than rival theories, often accompanied by moralistic and meaningless calls for unity.

The other danger was that the conference would be subjected to a catalogue of injustices, which would again succeed in demoralising everyone. At the same time, every

woman had to be free to speak bitterness as much as she liked. We consulted widely about this apparently irreconcilable contradiction.

The method we finally used was an invention of the women's movement's small consciousness-raising group: women relating their personal stories. We adopted this method for our purposes. Every speaker related her personal story — not the grassroots providing 'raw material' and others theorising and saying what to do. We invited women from a mix of countries and circumstances onto one of three panels, so that each panel would be a panorama of experience. One panel opened each session. The topics of sessions roughly corresponded to the stages every immigrant woman goes through:

1. *Organising to come here — why and how we did it;*
2. *Building a life in Britain;* and
3. *Claiming our rights.*

Within this framework, beginning from experience had many advantages. Women found their own language to relate their own history, which many had obviously reconsidered in working out what to say. No one was alienated by theoretical clichés which, if they ever had life, are now ritualised, impersonal and boring.

Secondly, in the framework of speakers beginning with themselves, women felt more confident, more at home. Everyone has vital social information gleaned from her own life; none of us need have read or studied or got degrees in anything to have reflected deeply on that. Most of us are justifiably suspicious of starting with abstractions which we fear will never get down to what to do. That the day was built on the specific and the particular was fundamental to the magic.

Wilmette Brown, conference co-ordinator, who gathered and chaired the conference committee for HinD, set the tone for the day in her opening remarks, giving as much information as was possible in a brief time about our

intentions, the structure, and the choices open to participants. She is a straight and powerful talker, and people were put at their ease. There was excitement and anticipation in the applause which followed her welcoming remarks.

Clotil Walcott, Trinidad housewife and factory worker, and brilliant and bold organiser, whom we had got to London for the occasion, opened the first panel and helped set the example for the speakers who followed. She described what immigrants from her country were leaving behind with none of the usual nostalgia and gilding about 'home' which people often resort to in self-defence on the one hand and out of loyalty to the land of their birth on the other.

Each panelist added her own piece of reality. The effect on the floor was decisive and explosive. Even women who in other contexts might have lectured to us to raise our consciousness to the level of their own, spoke from the gut, adding their experience to the dimensions of the day. In that process, who are 'grassroots' women, 'working class' women, along with much else, came in for reconsideration.

In my view, this was one of the most important conquests of the day. Such labels lend themselves to being turned into tools of political manipulation. It was, for example, in the name of the 'justified fears' of the 'real working class' that the Labour Party vied with the Tories to pass ever more racist immigration laws. It is in the name of tenants' associations — sexist, racist, heterosexist, sometimes National Front supporting, but 'working class' — that local councillors who pride themselves that they are 'progressive', that they are 'for' women, 'for' immigrants, 'for' Black people, vote for the police. Such left politicians and working class spokesmen and spokeswomen need each other, create each other and jointly protect and reinforce each other's positions, together frustrating and demoralising the most principled of politicians and constituents.

'Grassroots' doesn't mean holy. It means overworked and ripped off. What individuals do about that varies greatly. Some sell out; for a price, they use their working class accent

as a shield for an attack on their own people.

Wilmette Brown makes the point, in her classic work on sex, race, class and peace, *Black Women and the Peace Movement*, that dangerous nonsense is not less dangerous out of the mouths of Black and/or working class people, and that therefore

> Black women, as well as white women and Black and white men must be answerable for the points of reference we choose: answerable for whether or not and how they reflect Black women's struggle at the bottom.[20]

In other words, we cannot allow Black and/or working class tokens to be used as a cover for attacks on the movement. We must recognise that scabs, not only in the coalfields (I write during the strike of the mining communities) but wherever people are trying to organise, share the accent and the roots of those — or most of those — they scab against. Therefore the choice is not only about accents, colour, sex, etc., but about what people stand for and which side they are on.

The grassroots at this conference wielded power in a way that enhanced all women's power. In the framework of beginning with women's interests 'from the bottom up', as Wilmette says, the grassroots, the working class, who may be seen but whose autonomous voice is rarely given a hearing, drew an echo of the same interests from other women who would not ordinarily be identified as of the same class. The generosity, the desire to include and incorporate others, to assume their support and understanding, gave real pleasure and made clear that the power and the leadership of this conference came from the bottom up. That was the source of the sisterhood, the power of women, which the strangers had built.

The conference showed interest and empathy for speakers on the panels and from the floor, with applause for just about every one. Each personal story contributed to a broadening picture of who we were, what we had undergone, resisted, survived. Theories almost always leave out how widespread

and persistent is our refusal of the condition and conditioning of women. Locked in the ghettoes of our own sectors, none of us could have appreciated the depth and extent of this resistance. It came as a glorious and dignifying revelation.

As this realisation grew, of widespread resistance in a seemingly endless variety of forms, occasions and circumstances, it seemed to increase everyone's capacity to respect other women on their own terms. This quality is one of the most vital to movement building; a movement suffers if it is lacking. No one should have to qualify as a 'real' feminist by how she dresses, whom she sleeps with, whom and what she loves and hates; or as 'real' Black people, 'real' workers, 'real' lesbians . . . By the end of the day, there was no competition for reality. We were all real — real women with real tragedies, which we were confronting the best we knew how with real struggle. We were overjoyed. Many faces smiled, many hands were squeezed and many eyes were wet.

The conference met others' standards of success too. Women from the media ceased to be merely observers and were right there with the rest of us. Their reports were remarkably accurate — they took trouble with them — and they were glowing. The *New African Woman* described it as a 'unique conference' which 'dealt with issues that are normally pushed under the carpet and gave women's groups an opportunity to express their concern', and then added

> Tolerance of differences made the conference a joyful and optimistic event. [January 1983]

The *Caribbean Times* commented that it 'succeeded in bringing immigrant and black women together for the first time' and that

> Although the conference highlighted the distressing condition of women here and abroad, it gave optimism and strength to the women present, and most important generated a 'togetherness' which I'm sure has never been attained before. [19 November 1982]

The Leveller report said that

> The whole event was remarkable for its tolerance of differences, lack of bitterness and sheer optimism. Despite harrowing stories of racial and sexual humiliation, it was a joyful and strengthening day. What emerged from the testimony of the many speakers was that the current definition of 'immigrant' is wholly inadequate, and that, by rejecting labels like 'foreigner' and 'political refugee', new connections can be made between groups which have seen themselves as separate. [December 1982]

And *The Voice*, another West Indian weekly, described it as

> an overwhelming outpouring of information and viewpoints which left many participants drained by the day's end.
>
> Yet, despite the long hours and overlapping aspects, one enthusiastic woman from the attentive and responsive audience seemingly voiced the feelings of most as she stated: 'It (the conference) has managed to expose the common roots of female oppression'. [27 November, 1982]

What the organisers offered to women made success possible, but the conference succeeded because women took us up on the offer. When given the choice of unity from the bottom up, women responded eagerly, Black women, white women; immigrant women, British women; old women, young women; lesbian women, straight women, and more. So much for separatism.

* * *

Wilmette Brown had claimed in her opening remarks that

> . . . in saying that we are coming together to talk about immigration from women's point of view, and to make a

number of points about who is an immigrant — that
European women are also immigrants; that Black women
are also non-immigrants and so on — in making those
points and in putting those issues together: in taking the
so-called feminist issues out of the pigeon-holes where
they have been placed and speaking about them from the
point of view of Black and immigrant women; we are really
making history. (p. 61)

The conference did make history, on this and other counts.
One woman, to the approving nods of others, called it 'a
turning point in the history of Black women in Britain'. In our
usual meeting to evaluate the day (which I describe at greater
length in Part 3 — 'Evaluation: Making trouble making
history'), Wilmette connected this conference with the first
five Pan-African Congresses which, largely male, had paved
the way for national independence in Africa. It is not
far-fetched. Some may wish to keep those earlier conferences
in the safe and distant pigeon-hole labelled 'historical events'
which, like miracles, don't happen any more. In fact, historical
events are often unrecognised when they occur and social
transformation on whatever scale is the greatest miracle of
all.

I am not naively claiming that, like Superman or Wonder
Woman, we changed the course of the world with a
momentary effort. Conferences don't do that. But it did what it
set out to do, what a women's conference on race and
immigration should have done: it connected people and
struggles on the basis not of abstract theory but of common
need. It presented new ideas, or at least ideas newly
articulated in public, as it uncovered new passions and new
forces. Once they were out in the open, they had new
meaning, new power. Like the work of immigration which
was hidden until then, the women who did that work came
out and asserted their power, and thus claimed their
possibilities.

It was possible for Black and white women to talk to each
other, to understand and identify with each other, to rejoice

together at shared victories; and for neither to be threatened with domination by the other in the process.

It was possible for immigrants to inform the natives critically about the country which had birthed them, and for the natives to welcome the information and be strengthened by it.

It was possible for women to tell in public some of the truth about their life, and to have that truth respected and accepted by other women whose history, age, sexual orientation, financial standing, race, native tongue and more, were different from their own.

It was possible for any of us to describe the defeats of racism, deportation, sexual violence and the violence of poverty, without being reduced from survivor and protagonist to mere victim.

These were some of the possibilities we won. There were other victories.

Andaiye (p. 164) spoke plainly to women who might, for whatever reason, romanticise the idea of returning to their Third World country of origin. Her speech, coming as it did from the heart of the Guyanese reality, was a high point of the conference, one of a number of times during the day when a fundamental problem of Black immigrant women was addressed by an expert.

One of the panelists, Winifred Blackman, was the first Black nurse in Britain (see p. 141). We could profitably have given the entire day to her reminiscences, her piece of the history of the English working class making itself, which racism and sexism and ageism — among other scourges — have hidden up to now.

In fact, the entire conference was part of the making of that class, the part that does two-thirds of the world's work, revealing to the rest who we are and what we do; profoundly conscious of burdens and defeats, but also increasingly conscious of what we have achieved and what we have to offer; building our unity and our autonomy, our capacity to act for ourselves with each other. And because it is the

eighties, when our movements have established their auto-
nomy, the process of the working class in Britain making
ourselves is one with the process of the making of the
women's movement, the Black movement and — especially
because of immigrants — the making of the international.

* * *

I was in the chair at the end of the last session. Everyone
was very tired. It was already 6 p.m., well past when we were
to have finished. When I thanked everyone for having come
and closed the conference, there was a burst of applause and
then for about half a minute neither the platform nor the
audience moved. Neither wanted to break the spell by
motion, neither wanted to part from the others. As I finally
rose, the conference at last began to dissolve.

A few of us decided then and there, exhausted but elated as
we were, to begin to plan for the next conference, which
people had asked to become a yearly event.

Nineteen months was the best we could do. As I write, we
are on the eve of that second event. This one has a shorter
title:

Black and immigrant women claim our rights II: 'Women
Count — Count Women's Work'

but not much shorter! We were again in trouble to indicate the
originality of our intention by the usual three or four words.
That intention was once more to start from the bottom up, to
start with Black and immigrant women but to include all
women; to start from the basic facts about us, the two-thirds of
the world's work that takes most of our time, which happens
to be most of our life. We want to know exactly what we do,
and how much of it. Clearly we intend to make history
again.

We want again a multi-racial, multi-cultural group of men,
gay and not gay, to run the creche with the same care, concern
and real joy, so that the children, whoever they are, can see

themselves reflected in their older male companions and protectors.

We want again Black women of Asian and African descent as well as immigrant women of whatever race to comprise the panels. Unfortunately we can't expect the same participation of Irish women, since they are holding their own immigrant women's conference the same weekend, the first ever for Irish women. Hopefully we made some contribution towards this by the success of Irish participation at Conference I (see p. 71). We are looking forward to having more Chinese and Cypriot input, representing our international neighbours in Camden who make it such a culturally and politically rich borough. And since we are in the throes of a miners' strike, a woman representing the mining community will also be a speaker. The prominent — and probably decisive — part women are playing in this strike must be counted as work — finally.

Some things will be very different. The conference this time will be a two-day event focusing on all women's work, in the Third World and in the metropolis — any work women wish to put on record. And it will have before it a proposal for an ongoing project. A petition the Wages for Housework Campaign intend to bring to the final UN Decade for Women conference in Nairobi in 1985 will be presented for the first time at our conference. This petition reads as follows.

A PETITION FOR ALL WOMEN TO ALL GOVERNMENTS

WOMEN COUNT – COUNT WOMEN'S WORK

WHEREAS women do 2/3 of the world's work, receive only 5% of the income and own less than 1% of the assets;

WHEREAS women are the poorer sex, Black and Third World women are the poorest of all, and the poorer we are the more work we are forced to do;

WHEREAS women produce all the workers of the world, yet this is not considered work and we are not considered workers;

WHEREAS women, with the help of children, grow at least

half the world's food, yet we are denied the technology of our choice;

WHEREAS though women do the work of caring for children, yet we are often threatened with the loss of child custody;

WHEREAS most of the work women do is invisible and unpaid, and any welfare, pensions, benefits or services we receive are considered not a right, not a wage but a charity;

WHEREAS despite our enormous contribution and despite lip service to women's equality, women everywhere are denied equal pay, occupational safety, health, housing, food, education, information, childcare, birthing conditions and birth control of our choice, in other words, our basic human rights;

WHEREAS there is no peace as long as people anywhere, beginning with women and children, are struggling to survive the holocaust of overwork, ecological devastation and famine;

WHEREAS according to governments, raising a child is not counted as 'work', but being in the military and killing one is;

WHEREAS because of women's pressure internationally, the United Nations has called on all governments to count 'the contribution of the unpaid work that women do in the farms, at home and in other fields' (UN Decade for Women Draft Program of Action, 1980);

THEREFORE we petition every government to count the contribution to the economy of all women's work, so that it is recognised and reflected in every Gross National Product.

(The Gross National Product – GNP – is supposed to be the total value of goods and services produced, but up to now it has only included goods and services exchanged for money. Women's unwaged work, which is estimated in some countries to produce as much as 50% of the GNP, has been left out.)[21]

* * *

We were satisfied, judging from other conferences, with an attendance of 350 women. But for Conference II we are aiming for 500 women. And since it will be a two-day affair, we have decided we can invite men the second day, and are making the necessary creche arrangements so that the men who work with our children will have this choice to participate with us politically. But they are to play the role neither of leaders nor of stooges, neither of shadowy voyeurs nor of observers. Payday, the men's network 'in support of the Wages for Housework Campaign and against all unpaid work', will run the men's workshop. We hope the men will discuss their own hidden work —travelling to and from work, for example, is work for work, so to speak: unwaged work to make waged work possible — like housework. The men will report back to the conference in full session, as will the other women-only workshops. We must learn to cross the divides, to uncover our connections with others from the bottom up, whether they work more or less than we do; protected by the autonomy of the less powerful; so that together we may end all our work.

Therefore we are also hoping that at this record event, we will develop the connections between those whom Nina Lopez-Jones from Argentina spoke about: immigrants, migrants and refugees (see p. 119). 'We are all economic refugees,' she said. From all over the world, divided by race and language, and by what, if any, rights we inherit from the history of our relationship to the British Empire, we belong together, first of all as women.

We have a lot of cheek attempting to cross these divides, to make all these connections at once. But in a way, Conference I gave us our mandate. Nina, speaking for the English Collective of Prostitutes, drew a parallel between the vulnerability of immigrant women and the vulnerability of prostitute women and was warmly applauded. It was one of many signs — and not only at this conference — of the connections people are ready, willing, even thirsting to make. We can't excuse our own inactivity on the grounds that 'the

people' aren't ready. There is no time for such lethargy. To use Aimé Cezaire's phrase, we have to start 'taking the chances of the world' in order to save it.

* * *

A day less than a month later, on 12 December, over 30,000 women accepted an invitation to visit Greenham Common Women's Peace Camp (where the US was later to site cruise missiles) and 'embrace the base'. We met many women from the conference there, and it felt like a continuation of that earlier event. But something else had happened in between.

At the end of the last conference session, a follow-up meeting of Black women at the Women's Centre was announced. It took place a week later as planned, but it was held instead in a church.

The English Collective of Prostitutes, under severe pressure from the police for our successful organising and legal defence of prostitute women, Black and white, decided to take sanctuary in the local Holy Cross Church. So on 17 November, four days after the conference, and just as we were about to take a few days to recover, a 12-day Occupation began. Women who had attended the conference showed support in various ways. A few brought their bedrolls. Three Greenham women also came with their bedrolls to embrace *our* base. All that is another story which we have begun to tell elsewhere.[22]

What is relevant here is that the Occupation was in part a product of the conference, of the mutual support we had come to expect, and must be registered as one of its achievements. Other long-term achievements are harder to quantify, but the conference, we believe, has at least one ongoing use.

In the Britain of Margaret Thatcher, with about five million unemployed, the working class movement is under enormous pressure, not only from the State without but from those who

do the job of the State within — from scabs. One form this scabbing takes is careerism. With the growth of the power of women, the 1981–82 Black rebellions and other struggles, the State looks increasingly for those with feminist or Black Power credentials to counter the movement. Those who are prepared to make any alliance for a job or a grant, sell any new theory to blame and divide us, orbit round any shred of State power, seem — especially with the economic crisis — to be increasing in numbers.

This is not to say, however, that everyone who has a career can be used by the State. Quite the contrary. Ruth Bundey, who spoke in the last panel, is neither Black nor immigrant. She is an Englishwoman and a solicitor. Her involvement with the case of the Bradford 12 (see p. 155), her dedication to the movement and her demystification of the role of the lawyer in political cases, all of which emerged in her speech, makes it obvious that professional skills can be invaluable to us. The careerist uses them against us.

This State use of careerism is not uniquely British, of course. As the movement is international, so is the face of the State. The funding of Black careerists is reminiscent of the period after the Black rebellions in the US in the late sixties. (After the '81–'82 riots, there was a rush of Black American advisers who came to tell the British State that they should follow this US example.) State feminists came later, in the seventies, because the visible women's movement came later.

But as indicated earlier, to qualify for the job of State feminist, or the equivalent in other movements, you must be a separatist, in practice if not in theory. Separatism is a self-fulfilling prophesy: it pits individuals and groups against each other and then complains that they cannot unite. Based as it is on the inevitability of divisions, it is the strategy of defeat, the strategy of the State which, while defending its military-industrial complex from us, claims to be defending us against ourselves. That is the basic argument of the police: they aren't enforcing social, economic and military policies against us;

they aren't policing the crisis; they are protecting us from crimes we commit against each other — from mugging![23]

These conference proceedings, we believe, are one contribution to the defeat of separatism, whether it comes from the State — their police, their bureaucrats, their academics, their media, their leaders — or from the movement. For this reason we have worked to get them published.

Nothing succeeds like success, my mother says. On the basis of spelling out (some of) our divisions (there are many), a few hundred of us were able to get it together, some small indication that it can be done on a larger and more permanent scale, and that many are ready to do it. Other grassroots people all over the place are doing similar things. Since this is the least known work of the movement, and since the success you don't know about cannot succeed as much as it deserves to, we're telling the world.

We hope this book of the actual process of getting it together will be a small weapon in the struggle of the working class — beginning with Black and immigrant women — to speak out, to claim our rights, and ultimately to bring all the power back home.

Power to the sisters and therefore to the class.

Selma James
King's Cross Women's Centre
1 June 1984

Notes

1. *Black Women: Bringing it all Back Home* by Margaret Prescod (formerly Margaret Prescod-Roberts) and Norma Steele, Falling Wall Press, 1980.

2. *Women at Work*, International Labour Office Newsbulletin, Geneva, No.1/1980, p.v. In fact, the ⅔ figure originated in this journal.

3. In my view capitalist society turns everything, including human skills and abilities, into commodities whose exchange value

is *quantified* on the price tag or in the wage packet. The amount we are exploited is meticulously planned for and constantly *measured* and evaluated in stock exchanges, banks, board rooms, Cabinet meetings, at fox hunts and over dinner. Even, for all we know, in bed.

In general men do not work as hard as women; the differences in amount of work and income and in degree of exploitation are *quantifiable*.

To the degree that we quantify our exploitation, to that degree we can measure not only how much we lose but what we win, and frame our demands accordingly.

As a strategy, quantification began with Marx, whose early work was a description of the effects of exploitation and whose later work quantified this exploitation, showing how it resulted in the alienation he had previously named and described. (See S. James, 'Marx and Feminism' in Kenneth Leech, ed., *After Marx*, Jubilee Group, London 1984.)

4. The case was first made in M. Dalla Costa and S. James, *The Power of Women and the Subversion of the Community*, Falling Wall Press, 2nd edn. 1975. Restated and updated in 'Marx and Feminism' cited above.

5. See S. James, *Sex, Race and Class*, Falling Wall Press, 1975.

6. Solveig Francis, 'Until women have spoken . . .'. Introduction to *Black Women: Bringing it all back home* cited above, p.7.

7. Issued by the Tanganyika African National Union, 25 January, 1967. Reprinted in Julius K. Nyerere, *Uhuru na Ujamaa/Freedom and Socialism*, OUP, Dar es Salaam 1968.

8. 'The Purpose Is Man' in *Freedom and Socialism* cited above, p.320. President Nyerere's precision is an expression of his honesty. He avoids the vague apparently humanitarian generalisations which make up politicians' talk and which paper over the truth about our lives – like how much we work and how little we get back for it. His Arusha Declaration is a classic example of the importance of quantifying our work. Our forthcoming book, *The Global Kitchen*, will go into detail about the wide implications for women that our work is rarely counted or recognised in any way. It is *visible*; Pres. Nyerere shows that. But it is not *acknowledged* and we must change that. Pres. Nyerere also said, 'Let us go to the villages and talk to our people and see whether or not it is possible for them to work harder.' (p.244) He obviously meant to go to the men. At least I hope he did.

9. Even the police admit this. In the report of the Policy Studies Institute, *Police and People in London*, published in four volumes in 1984, the Metropolitan Police are accused of racism, sexism, framing suspects, drunkenness, etc. Since the study was commissioned and paid for by the Metropolitan Police, they did not deny its findings.

After the first headlines, the media dropped the subject and never returned to it.

10. The laws which prevent women from bringing husbands and intended husbands into Britain are not more sexist, not more of an attack on women than the procedures which keep wives and children in Pakistan or Bangladesh waiting for years, or forever, when they do not pass the British Consul's trial-by-fire interviews. Both are aimed at preventing a unified family.

11. 'The working class family is the more difficult point to break because it is the support of the worker, but as worker, and for that reason the support of capital. On this family depends the support of the class, the survival of the class – but *at the woman's expense against the class itself*. The woman is the slave of a wage slave, and her slavery ensures the slavery of her man. Like the trade union, the family protects the worker, but also ensures that he *and she* will never be anything but workers. And that is why the struggle of the woman of the working class against the family is crucial.' *Power of Women* cited above, p.41.

12. The entire debate in the women's movement about wages for housework is centred here. Feminists who oppose it almost always detach work from class and economics when it is unwaged and when it is done by women. We are told that a wage would not free us but would institutionalise us in the home doing this trivial, uneconomic, unsocial, unproductive non-activity. Rather, they say, housewives should get a job. An extremely impractical suggestion in a period of the highest unemployment in history, and a very metropolitan one – what would they tell Tanzanian women?

13. 'The identification of an anonymous, ovewhelming militaristic threat can and and does divert our attention from the all too familiar threats of male violence and dominance in our homes, at work, in the street, schools, etc. The lives of one woman, ten women or all women are not changed by 30,000 women surrounding a military base. We see the threat of nuclear technology as only one symptom and symbol of a male supremacist culture. Do some women prefer to put their energies into attacking the symptom they can see, rather than the fundamental cause, which is perhaps too dangerous to confront, i.e. the man next door.' ('Is Greenham Feminist?' by Linda Bellos, Carolle Berry, Joyce Cunningham, Margaret Jackson, Sheila Jeffreys, Carol Jones in *Breaching the Peace*, Onlywomen Press, London 1983, pp.20–21.) If Nato sat down to plan an attack on the women's peace movement, they could not have done better.

14. The 'military-industrial complex' was President Eisenhower's phrase used in his 1960 farewell speech to the nation, to describe the dangers facing Americans. It is a neglected phrase, and Wilmette

Brown in *Black Women and the Peace Movement* (Falling Wall Press, 1984) shows how useful it is as a description of our reality: 'The military monopoly of world resources: the arms trade to prop up dictatorships; the pillage of raw materials from the Third World; the concentration of industrial and technological development on the war machine, means that in Bangla Desh women spend several hours a day just fetching water; while in Harlem or the East End of London, older women annually die of cold or starve to death with Reagan and Thatcher cuts. Between North and South, and in the South which is within the North, the military-industrial complex daily turns Third World countries and inner city ghettoes into ecological disaster areas . . .' (p.20). Compare this with the quote in note 13 above.

15. While there are many books and pamphlets on immigration, I find the best place to get basic facts quickly is the Runnymede Trust, 37a Grays Inn Rd., London WC1X 8PP (01–404–5266). Many of us depend for current information and trends on the leaflets and pamphlets which come out of the anti-deportation movement, produced by grassroots groups and campaigns. *Compulsory Deportations: The Case of Cypriot Refugees Living in the UK* is one example. Written by D. Wiltcher for the Cypriot Community Workers Action Group and published by them, it is financed by refugees and represents the determination of Greek and Turkish Cypriots in Britain to fight for themselves by fighting for each other. (Based at Theatro Technis, 26 Crowndale Road, London NW1.)

A new and important manifesto, called 'Europe means also 15 million migrants, immigrants and refugees. For equal rights' is now available from the European Immigrant Lobby Steering Committee, c/o Migrants Action Group, 68 Chalton St., London NW1 (01-387-2214).

The soundest and most comprehensive book I can find on immigration law is Ian A. Macdonald's *Immigration Law and Practice*, (Butterworths, London 1983).

16. Peter Fryer, *Staying Power*, Pluto, London 1984, p.68. Other estimates went as low as 10,000 and as high as 20,000 in London alone.

17. For more information, see p. 201, 'What is Housewives in Dialogue?'

18. In *Ask Any Woman* (Falling Wall Press 1985), the results of the first comprehensive survey on rape in Britain, Ruth Hall of Women Against Rape had this to say:

> It was because of the years we had spent organising together with other women [at the Women's Centre] that we were able to ensure that our questions spoke directly to the many different

situations in which women find ourselves . . .

The questions on racist assault, for instance, grew out of many years of working together with and taking advice from Black Women for Wages for Housework . . . Discussions with women from the English Collective of Prostitutes and Wages Due Lesbians raised other questions about vulnerability to sexual assaults and about women's status in the eyes of the law . . .'(p.19).

WAR is now a member organisation of the Wages for Housework Campaign.

19. Some of the racism derives from ignorance. For example, Susan Brownmiller's *Against Our Will* is a racist tract. While many white women in the US know that, the book is treated like holy writ in Europe.

This ignorance is at least in part self-inflicted, itself a product of racism: white women time and again seem not to think it necessary to consult Black women, or when they do, choose the Black women who will tell them what confirms their own (usually separatist) politics. *Well-Founded Fear* (Hutchinson, London 1984), Leeds mini-survey on rape by Jalna Hanmer and Sheila Saunders, says they chose streets to survey which 'had a mixed population of white single and married people . . . We felt it was important to focus on the problem of the dominant cultural group in order to avoid our results being used in a racist way.' (pp.14–15) The reason such a conscious bypass of Black women's experience appeared in print at all is, firstly, because not only the authors but their friends found nothing jarring or worth remarking in this. Secondly, they are not used to consulting widely and routinely with Black women. Thirdly, Hutchinson probably has few if any Black women readers let alone editors, to catch and censor out such racism.

WAR's *The Rapist Who Pays the Rent* (R. Hall, S. James and J. Kertesz, Falling Wall, 2nd edn. 1984) has a Foreword by Wilmette Brown on 'Rape and Race: From Private Pain to Public Protest' which is an orientation. For example, ' . . . neither the Black nor the anti-rape movement can succeed without taking into account Black women's rape at home, at work and on the streets, and our sexual degradation by the police, the law and the courts. Quiet as it's kept, Black women's fight against rape is central to the agenda of both the Black movement and the anti-rape movement: to defining women's experience of rape, placing the blame for rape where it belongs, and ending police harassment and brutality against the Black community.'

20. Cited above in note 14.

21. Copies of the petition are available from the King's Cross Women's Centre, 71 Tonbridge St., London WC1 (01–837–7509). Information about the campaign in other countries can also be found

at this address.

22. The first issue of *Network*, the ECP's international bulletin (Spring 1983), carried an account of the Occupation. See also S. James, 'Hookers in the House of the Lord' in Joy Holland ed., *Feminist Action*, Battle Axe Books, London 1984.

23. See *Policing the Crisis: Mugging, the State and Law and Order* by Stuart Hall and others, Macmillan 1978. It makes the convincing case that police treatment of mugging owes much to the State's imagination and is the cornerstone of police mythology.

If *Policing the Crisis* were as balanced on women as it is on young Black men, it would be an even better book. I was particularly amused that the ideas in my *Sex, Race and Class* are attributed to a man who does not even agree with them. I suppose I should take it as a compliment.

A word on the script

There were two overlapping recordings made of the conference so that no words were lost when tapes were changed. Pat Woollard of Payday (England) did this work in the recording room above the conference hall. The tapes were transcribed by Jane Scobling and then replayed and corrected by Suzie Fleming, to ensure that the transcript was as accurate as possible.

With the permission of the conference committee, I edited out many of the organisational details, leaving in only enough to give the reader a sense of the interaction between organisers and other participants.

In my experience, punctuation is especially critical for meaning with the spoken word, and I spent a lot of time on this aspect of preparing the transcripts. I have a particular experience in punctuating speech. I did audio-typing for many years, mainly transcribing interviews for film editors and producers who needed to know when the voice rose and fell. Second, I spent about two years working as assistant to the editor on a bi-weekly nationalist newspaper in Trinidad during the independence struggle. Among many other jobs, I used to prepare the letters page. Most correspondents from the countryside did not write easily and I often spent hours on each letter to understand its meaning and to edit for that meaning to emerge without destroying the language of the correspondent. Both were good training in learning to hear: to respect and comprehend other people's ideas and the unique way each individual creates to convey them. I feel this helped with the editing of the transcripts.

Pecularities, mainly of word order, arise generally in speech, particularly in the speech of people whose first language is not English as spoken in England. My editing aimed to respect both the speaker's right to her own words and the reader's right to know. I edited out most repetitions.

Aside from this, every word remains.

S.J.

Conference agenda

BRINGING IT ALL BACK HOME: Black and Immigrant Women Speak Out and Claim Our Rights

One-day Conference ● November 13 ● Open to All Women
Camden Town Hall ● Euston Road ● Kings Cross ●
London England

The conference was inspired by the book, *Black Women: Bringing It All Back Home*, which exposed for the first time the price women pay to move country, and put together 'Black' and 'immigrant' with the issues labelled 'feminist'.

Race and immigration — from women's point of view: leaving parents and children behind; the work of settling a family in a new country; rape and violence in the home and on the street; claiming welfare rights and social services; abortion and sterilisation; choosing to be lesbian; facing police and courts; work permits and the threat of deportation; low-paid jobs and unpaid housework . . . and any other issues women want to raise.

10–10.30 a.m.	Registration
10.30–12 noon	1. ORGANISING TO COME HERE — WHY AND HOW WE DID IT
12–1.30 p.m.	**Lunch**
	Film — 'Salt of the Earth', a classic about how Latin American immigrant wives won a U.S. mining strike.
	Space will be available during lunch for women to meet independently in English or in other languages.
1.30–3 p.m.	2. BUILDING A LIFE IN BRITAIN
3–3.30 P.M.	**Tea**
3.30–5.30 p.m.	3. CLAIMING OUR RIGHTS

Statements We will reproduce up to 4 pages. Submit by Nov. 1.

Food (including vegetarian) will be available at reasonable prices.

Help Your help with the conference — circulating posters and flyers or sending them out in your organisation's mailing, or in any other way — is needed and welcome.

Housewives in Dialogue, Women's Centre, 71 Tonbridge Street, London W.C.1. Telephone (01) 837–7509.

Thanks . . .

Many people, both women and men, have contributed their time and skills in the course of organising this conference. We want to give our special thanks to the following individuals and organisations:-

Sisters Against Disablement and the Liberation Network of People with Disabilities, who patiently advised us on the arrangements for women with physical disabilities.

Joan Turner, social worker with deaf people, London borough of Camden, sign language interpreter.

Ziggi Alexander who arranged for us to have the *Roots in Britain* Exhibition.

The Brent Library Service for Black Women Writers Exhibition.

Elizabeth Varley of the British Council of Churches and Revd. Kenneth Leech of the Church of England, who believed in us.

Gina Lane, librarian at Swiss Cottage Library, and Francesca Klug, Information Officer at Runnymede Trust, who helped with sources for the Fact Sheet.

Sue Marshall, Women's Section, Compendium Bookshop.

Jo Pacino, Georgie Vargas and Susan Young, photographers to the conference.

The video team: Andrea, Annie, Hattie, Doreen.

The creche organisers — London Gay Workshop, the Gay Black Group and Creches Against Sexism.

The men from Payday — handimen who always help.

The Wages for Housework Campaign which has more ideas for organising and more energy to carry them out than any women's organisation is supposed to have.

The women on the rota of our King's Cross Women's Centre who made not only the conference possible but our work every day of the year.

And finally the conference committee; Sara Callaway, Graziella Doardo, Solveig Francis, Selma James, Daniella Mazzoni, Gisella Norman and Jo Pacino, who together made it all happen.

We are grateful for funding to the Community and Race Relations Unit of the British Council of Churches, the Calouste Gulbenkian Foundation (special thanks to Richard Mills) and the Commission for Racial Equality (special thanks to Clifton Robinson, his secretary Joyce Hobson, and Pam Bhalla).

<div align="right">Wilmette Brown
Conference Co-ordinator</div>

12 November 1982

PART TWO
Conference proceedings

THE WELCOMING

My name is Wilmette Brown, I'm co-ordinator of the conference, and I'd like to welcome you all.

First I have to say a few things about what we are trying to do with this conference, to talk a bit about how the day is going to be organised, and then we'll get right on into the first session.

Our conference originated from the book *Black Women: Bringing It All Back Home*, which put down, I think for the first time, how much invisible work women do in immigrating and the contribution to society that women make by immigrating. It began to look at immigration from women's point of view. This conference is to continue that process of looking at immigration from women's point of view.

In the course of organising the conference, the conference committee has been involved in understanding on deeper levels what it means for immigrant women to come together, to speak out and claim our rights. Many of the women on the conference committee were themselves immigrant women from a number of different situations. And as we worked together to prepare for the conference, we found ourselves having to grapple with all the issues that emerge when immigrant women try to do anything collectively. Getting together the practical details, trying to use our skills together as women and discussing how the conference should be set up, how the day should be structured, has been the same process that we are trying to promote at the conference itself,

> **Black and immigrant women have something to say about all the issues that affect all women and all immigrants and all Black people.**

namely, that immigrant women, on the basis of work that we have done, on the basis of contributions that all of us have made, can pool our resources and together build something which contributes to the struggle that all of us are trying to make and which means a greater level of power for all of us. This has also been the experience of the King's Cross Women's Centre, which has been operating in Camden since 1975. There too we have been working together as immigrant women. Also, a lot of women have come to the Centre over the years from both immigrant and non-immigrant backgrounds and we've all had an experience of pooling resources. And I think that you'll see many of those experiences reflected in the framework of this conference.

What we are trying to do at this conference is to break down the pigeon-holes which say that somehow Black issues are in one pigeon-hole, immigrant issues are in another, women's issues are in yet a third, and political issues are in still another pigeon-hole. What we are doing in focusing our conference on Black and immigrant women speaking out and claiming our rights is to say that, first of all, all Black women are not immigrants, and all immigrant women are not Black; that not all women are non-immigrants, and that Black and immigrant women have something to say about all of the issues that affect all women and that affect all immigrants, and that affect all Black people.

We are also saying that in a very fundamental sense all women are treated as immigrants; that even in the countries where we supposedly belong, we are all in some way dispossessed. So that, as women, in defining what the experience of immigration is about and what it means from women's point of view and where we can go with it, we have something to come together about.

The conference is set up as a forum, as an open space where women coming together from our different situations can pool our resources and talk about the issues of concern to us. And so we have tried to build into the physical structure of the conference the space and the facilities to do that. We want this to be a forum in which we have the space as women, immigrant and non-immigrant, Black and white, to define the issues that affect us, and to define and discuss our own points of view; to make connections among the issues that affect all of us; to make contact with each other and to become known to each other; for the work that we are doing to become known to each other; and for women who are involved in all kinds of campaigns to get support for their campaigns and to publicise their campaigns.

> **All women are treated as immigrants, all women are in some way dispossessed.**

Now a bit about the structure of the day and of the facilities. There is space for workshops during the lunch-break for any woman who wants to set up a workshop or a discussion group, to discuss any issue which arises — or any issue you like. There is space available in this hall, and also there are a number of rooms reserved in Camden Town Hall. If anyone would like to set up a workshop or discussion group on whatever topic, would you please let someone know at Registration.

Framing that workshop process, the day will be divided into three sessions. For each session, there will be a panel of speakers who will each speak a maximum of ten minutes. After that, there will be about forty-five minutes of discussion where the audience will have a chance also to speak. In setting up a dialogue in the sessions, we assume that all of us are experts, all of us women are experts in all kinds of things. So we've asked a few women to speak on the panel who can focus in on a particular experience, and then we've tried to find a

way to give as many people as possible a chance to speak. So what we're asking is that you hold questions and comments until after each of the panel members has spoken. Then the floor will be open for discussion. There are four microphones throughout the hall so that no one is far from a microphone. And we ask each person speaking from the floor to limit herself to five minutes, so that as many people can contribute as possible and no one monopolises the discussion.

You've seen by now that there is a literature area where we have a variety of books on sale, books on Black and immigrant women, books on women generally, books on the immigrant movement generally. In addition to that, there is a table of informational materials so that people who are looking for basic kinds of survival information, again with a focus on immigration, can find that material there. In addition to information tables and free literature and so on to do with immigration, and to do with women's survival issues, there are two women who have volunteered to be resource people for the conference, for anyone with questions about immigration. Both of these women can be contacted by asking a steward with a pink armband. In fact, if you need to know anything about what's happening or have any other particular need, you can find it through the stewards. In addition, there is a list of helpful phone numbers and addresses at the information stall.

A couple of other words about the set-up of the day.

You'll have noticed that there were women working on setting up video equipment who are not doing that any longer. What we were fussing about at the beginning was that the lighting for the video was so powerful that those of us who were up on the platform couldn't see anybody in the audience, and that certainly does not help what we came here to do. We came here to have a dialogue with each other, and the primary aim is not to get a picture of it but to actually be in it and for us to be able to talk with each other. We've made the decision that we can't allow those lights to come between us, so we will only be able to video in a very limited way.

We feel that the conference in saying that we are coming together to talk about immigration from women's point of view and to make a number of points about who is an immigrant — that European women are also immigrants, that Black women are also non-immigrants, and so on — that in making those points and in putting those issues together; in taking the so-called feminist issues out of the pigeon-holes that they have been placed in and speaking about them from the point of view of Black and immigrant women; that we are really making history. And one of the things women have been fighting for is to make ourselves visible and to make our history known. So that was the purpose of having the video. We wanted it, for example, for courses on race relations where it's necessary to get across women's point of view.

Since the cameras are here and women have volunteered their time and skills as a way of participating in the conference, the cameras are available in the basement all day for women who want to put their views on video tape.

The same is true of the photographers, who are taking photographs under the auspices of Housewives in Dialogue. This is the way these women are contributing to the conference. If you don't want your picture taken for any reason, your right to refuse will be respected absolutely.

A final word, about the speakers for the conference. You will have noticed on the leaflet that Buchi Emecheta was supposed to have been a speaker. We are very sorry to say that there was some misunderstanding about the terms on which she was to speak. She was requesting payment to speak, which we were not able to provide. We understand and are not at all critical of any woman's request for payment to speak, but it is something that we simply could not provide. We certainly could not pay one speaker without being able to pay all speakers. We couldn't do that. And we certainly couldn't afford to pay all speakers, so that everyone who is participating today from the platform is doing so on a voluntary basis. [Applause]

SESSION 1
Organising to come here — why and how we did it

WILMETTE BROWN | I'd like to open the first session with just a few facts. In speaking about immigration from women's point of view, one of the most salient facts, one of the most important facts, is the United Nations estimate that women do two-thirds of the world's work, get one-tenth of world income and own one percent of world assets. So that all women are dispossessed, and even in our own countries we are immigrants to the extent that that place is not seen as belonging to us. That is a backdrop for all of our discussion today.

We know too that the history of Britain has been such that immigrant women from the Third World have been working for Britain even before they ever came to Britain, and that is another fact which has to inform all of our discussion of 'Organising to Come Here – why and how we did it'. We know too that European women are immigrants as well and that the division between European immigrants and immigrants of colour has been a weakness for all of us in being able to speak out and claim our rights. What we continue to find is how hidden immigration is: how many of us in Britain are actually immigrants.*

* According to the 1981 census, 3.4 million (or 6.2%) were immigrants, that is, were born outside of the UK, of which 1.5 million were born in the New Commonwealth. ('New', as opposed to 'Old Commonwealth', is a euphemism for a predominantly Black country. 'New' includes all Commonwealth countries except Australia, Canada and New Zealand. Pakistan, which

I think another thing that will certainly emerge in the first session is that, while none of us are in a position to say that the countries that we come from are paradise, we know also that none of the places that we have come from are a write-off or a waste. And one of the things we are trying to discuss and get to the heart of is some kind of balance between our experience of having to leave one place, go to another, having still to fight in the places that we go to; and where within that do we make our place as women.

> **Immigrant women have been working for Britain even before we came to Britain.**

Sharing the chair with me in this session will be Suzie Fleming from Bristol. She is the publisher of *Black Women: Bringing It All Back Home*. She is herself born of immigrant parents, who fled the Nazi occupation of Czechoslovakia. She was an organiser of the 1973 Family Allowance Campaign and has continued the work of defending family allowance. She's writing an introduction to the book called *The Disinherited Family* by Eleanor Rathbone, the English woman who fought in the 1920s and 1930s for mothers to have family allowance in the first place. Eleanor Rathbone, in addition to that, was active in opposing the closing of Britain's borders to Jews in World War II. Suzie Fleming will be introducing our speakers for this session.

SUZIE FLEMING I'd like first to introduce Clotil Walcott. I would like to welcome Clotil to Britain. She has come specially from Trinidad for this conference. In Trinidad, she

left the Commonwealth in 1973, is nevertheless included.) The estimate of 2.1 million Black people in Britain (about 4%), immigrant and born here, is considered low by those who believe there is an undercount of Black people. The Black and immigrant population is highest in major cities, and it is generally accepted that one in every eight Londoners was born in another country.

works on an assembly line in a poultry factory and also as a mother and grandmother. Clotil has five children and seven grandchildren, so she has her time pretty full with that. She is the chairperson for the National Union of Domestic Employees, NUDE, a spokeswoman for the Wages for Housework Campaign in Trinidad & Tobago and has been campaigning for women's rights for the last twenty-five years. [Applause]

CLOTIL WALCOTT Thank you, chairwoman. Greetings, sisters. I am very grateful for the opportunity extended to me by Housewives in Dialogue to share my thoughts and reflections on *Black and immigrant women speak out and claim our rights*. I would like to be brief in making my contribution on the hardships and difficulties facing the women in Trinidad & Tobago.

When you are past 35, they do not employ you.

One: the unemployment situation in our country is not in keeping with woman's human dignity. There is a government project where the women have to sell their bodies to gain employment. They give you a ten days' work, sometimes you get only ten days, which is one fortnight, for the year. If you are an older woman who is suffering from unemployment and if you want a job, you have to get someone to pull a string for you, because they hardly employ old or middle-aged people. It also relates to people working in industry in Trinidad. When you are past thirty-five years of age, they do not employ you. I view this as a discrimination in age and I feel that this conference should do something to assist us in Trinidad.

And another thing again is that when these women cannot get employed they have to leave and emigrate to places like America, Canada and Britain. Right now in Canada if you want to be employed there, you have to have a certificate to cook, wash and iron and do all the household duties. Which

means that people from Trinidad who are suffering from unemployment, they have no certificate and they cannot get to Canada again.

Another problem is that a father is not a father when having sex with his own daughter. Rape does not occur only in the street, it occurs in the home also. And when girls are ten and twelve years old, they are young and innocent and they are afraid to speak out. Just last year a child ten years old was raped by her father.

Another problem again existing in the whole country is fathers who have deserted their children and their mothers have to seek employment. The eldest child is taken out from school to see about the other young ones.

Another problem is when the fathers do not maintain their children. The mother takes them to court; the father puts the money in court and when the mother goes to receive that money, she does not get it. There is a system in Trinidad & Tobago that the government has put a voucher for an amount of money, for when you go there to claim that money. But if you reach too late you do not get any money. They tell you to come back. What is the position with this woman with five and six children to maintain?

Another problem is the legal status of a child born out of wedlock. The law does not apply the same rights to the father's property: they don't get anything.

> **Women have been emigrating, even committing suicide, because of the violence of husbands and boyfriends.**

Another right women are denied in their place of employment is equal pay for equal work. You don't get promotion, and there is favouritism. And when you refuse to work overtime you are fired. Just recently where I work a girl got fired. She had children to see about and when she told the boss that she was not able to work overtime because she has to go and see about her children, she was fired. And the trade

union, who is the recognised trade union, does not take up any matter like that. It is nine months now since this woman got fired and up till this present time the union hasn't taken up any matter.

Another problem is that women have been committing suicide because of the sex and violence with husbands and boyfriends. And this is one of the many reasons too that they emigrate to other countries. Just recently a nurse committed suicide through sexual violence, and the National Commission on the Status of Women does not assist anybody in our country, it is not seeking the interests and welfare of women in the country.

> **In our country domestic servants are recorded as non-workers.**

In our country the government does not recognise domestic servants. They are recorded as non-workers and they cannot even be represented in the Ministry of Labour nor the Industrial Court. I have been having discussion with the Status of Women Commission almost five years and up to this present day they haven't been seeking our interests to assist us. The head is also a Senator in Parliament and she would not speak anything against that. She, the Commissioner, even refused to recognise the United Nations Status of the World's Women Report. The Concerned Women for Progress and the Revolutionary Brigade of Women and my organisation, NUDE, have called on the Commission to recognise domestic servants and they have remained silent on the matter.

These are some of the problems that we have been facing in the country of Trinidad & Tobago and I would like if this conference could assist us, especially to get the domestic servants recognised so that they can be represented by a trade union. If we have to achieve our rights, we as the leaders should be able to stand up and support one another in the

different countries. Thank you. [Prolonged applause]

SUZIE FLEMING Our next speaker is Anowara Jahan, Secretary of the Bangladesh Women's Association. Anowara is the mother of three children. She was one of the key people in the Child Benefit for All Campaign in 1977, which many people will have heard of and there is a lot of information about it on the tables. She was also one of the Commissioners for the Commission for Racial Equality but was asked to leave because she was too outspoken on women's behalf and on behalf of the immigrant community generally. Anowara.

ANOWARA JAHAN Madam chairman, my sisters. It's good to be here and on the panel to speak to you. I don't know whether I'll speak up to your expectations, but at least I'll be able to get some of the steam out of my system! That's why we're here perhaps, because never, ever our voice is heard by people in powerful positions. However, still we talk.

In this panel some of us may be experts but I am not one. Perhaps I can speak better on behalf of myself than anyone else; maybe in my own matter I am an expert, and that is the platform I am taking.

> **Someone got up early in the morning and saw that her daughter's home is in India and her home is in Pakistan. And she can't go to see her daughter without a visa.**

The topic is 'Organising to Come Here'; that means how and why we came here. Now why we have come here is common to all of us and I've seen in a book, it's a comic book perhaps, saying why were we here, and the answer was: because they were there. That's why we are here. And without going into that, the nitty gritty of the political issues, I think it's still the reason why we are here, because we were suffering from the aftermath or hangover of colonialism, the 250 years India was ruled by the British government. Except a few

networks of railways, there was no real effort ever made to improve the lot of the people. Women's position became worse even than it was before. Their position was to toil in the kitchen for 250 years.

After political independence, even that political independence didn't take into consideration the people who are made independent. As you know, India was divided on an artificial basis, on the basis of religion; the country was divided on the basis of Muslim and non-Muslim. If you imagine this hall is the country, just by sheer luck part of it went to India and part in Pakistan, and by that many people suffered. Like the part of the country I come from. Someone got up early in the morning and saw that her daughter's home is in India and her home is in Pakistan. And she can't go to see her daughter unless she has a visa. So this is the political effect of partition. The independence of India was agonising.

And coming to the economic issue, it was more so — we paid for that artificial division.

These are the issues of colonialism; after all these years we couldn't get over the hangover of that colonialism. And the reason I say that it is still there — how we came, at least in my situation how I came: in my particular case the work wasn't the attraction, but somehow my husband thought that he will have the benefit of British education, as if the education he had wasn't enough. And that's the reason he came here. And to give my children a proper home, a family environment, and not have a so-called single-parent family, I followed my husband. And that's how I am here.

So that's why I say that the effect of colonialism didn't finish, it's still there, people have still the feeling that if they come to Britain, they will have a better life; and if they go back from here, that they will have a much better life. So this is the reason we have come here. But this comes from the head of the family, that is, men, and we are the tails of the family and never counted. That's why I feel that it's great to be able to say how the tails feel when they had to carry the burden of the head.

In my case I am here, and I brought my children with me, but there are many more families whose heads are here and tails are still there; part of the body is here and part of the body is there, if you take the family as a whole. In our case, in the case of the Bangladeshis, the incidence of split families is so great that if you go to the East End of London, you'll see that almost two in three families have part of their members here and some of their members there. It's not that they opted for it, it's that they were put into that situation because of the immigration procedures: these people are not articulate enough to satisfy the interrogation of the immigration entry officers. It's a long, long history.

Attacks on the street can be verbal, they can be physical. We have to cope with it.

Now those of us who were fortunate enough to be able to come here, they have to make huge adjustments physically, financially and culturally. When we come here, part of the family still there, we are severed from that part, and in our system family is not your children and husband alone, but the father's mother and in-laws and what not. So women severed themselves from that warmth of the family, and when they come here what do they gain? Very little. They are cooped up in one room. Sometimes they are not sure about themselves and what's more they're in the headlines of newspapers for the wrong reasons, not for the right reasons. And they also attract the attention of racists on the streets. These attacks can be verbal, these attacks can be physical. We have to cope with it. When the husbands are either unemployed or partly employed or underemployed, we have to cope with that situation. Asian women, especially dressed like me — long hair and it's assumed you can't speak English. If you go for a job, even if you are highly qualified, you are asked: will you be able to do this, do you understand that? 'Yes I do.' 'Oh, you

have learnt quite good English. Where did you learn it from?' And you have to say, 'Well part from here and part from there.' It's not realised that we are educated in English, in a bilingual system. This we cope with.

I've been asked to give part of my own experience, but I think we come from the system where telling your own story is not taken very well. You know, always we have learnt that we have to keep ourselves to ourselves. So that's why perhaps I was stopping myself from giving my own experience. But one thing that I can tell you: the discrimination we face in employment is enormous. The discrimination our children face in education is enormous and it's hidden because we are not a very vocal community. I hear that my time is up and I'm glad for that because I don't know what I'll be talking next! Thank you. [Applause]

SUZIE FLEMING Our next speaker is Mary Lennon, who is from Ireland and the Irish Women's Group in London. Irish people, because they are white, are very often not even seen as immigrants, and the issues they confront are seen as very separate, so we are very glad indeed to have you speak.

MARY LENNON: Thank you. Hello. The first thing that I just want to say is the similarity in my experience with some of the

> **Arbitrary partitioning of the country was as true of Ireland as of India.**

things that other speakers have said. In particular some of the things just mentioned by the woman from Bangladesh, who has talked about the experience of colonialism and the effect that that has had on a country in terms of the job opportunities, the access to our rights, the access to land, property, any of those things that women have been denied through colonialism. And also the experience of partition: an

arbitrary partitioning of my country as was true of India; and an overnight situation which develops with two parts of the same country becoming something different.

I came to live in England in 1973, and I came then mainly because the work opportunities were better here than they were in Ireland. At the time I had about four aunts on both sides of my family who had emigrated. Along our road every family had aunts and uncles who had emigrated. Because emigration was a way of life and had been for a century and a half, it was just something we took for granted. But I gradually realised through living here that there was nothing about immigration that should be taken for granted. That basically it wasn't a fact of life that Irish women had to emigrate in the numbers that they did. That the reason why they did was because Ireland had always been treated as an appendage of Britain. It was treated as an appendage in the sense that our land was taken from us; that our industries were prevented from developing if they should compete with British industry; that it was a predominantly rural country because it was

> **Emigration was the Irish way of life. There was nothing accidental about it, nothing natural about it.**

important that Britain had a country nearby that could supply it with food when it started to industrialise. There was nothing accidental about it. There was nothing natural about it. It was a systematically developed policy whereby Ireland's fate and rights were always subordinated to the fate of Britain.

And when I arrived here I found it very strange that English people I met thought it was a fact of life that I was here. Well, I sat in on discussions about immigration and Irish women were never mentioned — we weren't immigrants. And gradually I began to realise that what was happening was that we had been made invisible. We were here because we were supposed to be; we were part of the furniture. We were in the absolutely typical women's role: we were to do the invisible

work, which was the domestic work, like nursing, looking after children; we also did the factory work and agricultural work, but we weren't immigrants. And I began to realise that this just wasn't on, that this denial of our identity as immigrants was no longer acceptable to us. And I think that there are many sides to this.

If Irish people keep our heads down and our mouths shut, we'll get by, invisible in a way Black people are not.

One aspect of the issue of invisibility for Irish people in this country is that if we keep our heads down and our mouths shut we'll get by. And that's an option that Black people don't have in this country. But it's a very high price, too high a price, to ask us to pay, and a lot of Irish people have that experience, of saying, 'They thought I was OK until I opened my mouth and then they realised that I had an Irish accent and that *wasn't* OK.' And so we experience invisibility in a way Black people don't.

On the other hand, the invisibility is something that can work against us, in the sense that it's also denied. Because another way that Irish people are treated is as stupid fools. It's very common to have anti-Irish jokes and that's supposed to be acceptable. Those jokes exist in such a way that's totally offensive, and the response to us when we complain about them is, 'Have you no sense of humour?' And the jokes exist, I believe, as a way of trying to avoid some of the political issues that Ireland raises in Britain, like the fact that there is a war in the north of Ireland that continues, and by trying to make people out to be stupid you can deny the basis of the war.

And when we're not stupid we're pathological criminals. Like, for example, in the recent elections in the north of Ireland where five Sinn Fein MPs were elected: the response to that on the part of the press is not only to say that the candidates are pathological criminals but that the people who vote for them must be. So our invisibility is also a selective

one: they don't always let us remain invisible, even if we wanted to be.

And I think another aspect of that which has affected me and friends of mine and other women, is the Prevention of Terrorism Act, which basically was introduced to deal with Irish people, and which has been used on thousands and thousands of Irish people since 1974. Ninety-nine percent of Irish people who've been picked up under that Act have never been charged with anything. And what it is really is just an attempt to deny Irish women, Irish people, the right to be political in this country.

And so the experience of invisibility for me has been a double edged one. It's offered to me if I keep my mouth shut and try and present myself as an acceptable Irish woman, which I'm not prepared to do. Or else if I assert myself, assert my Irishness, assert the right to support Irish struggles, Irish political issues, then I can be harassed under the Prevention of Terrorism Act.

So I think that in lots of ways there are similarities in my experience with those of other women here today. I think there are also differences to do with our origins and to do with our history.

The final thing I would like to say is that Irish women have come here for the last century and a half, primarily as workers, and there's very little about Irish immigration that's been recorded or documented. And I think within that, the experience of Irish women in particular has been invisible because any history that is written is written by men. And the amount of work, invisible work, that Irish women, like other immigrant women, are involved in is phenomenal, and it's in particular types of work areas. I think nursing is a really good example, where in Britain today 35% of all nurses are immigrant women and 12% of those are Irish women.

I don't know if it's the same for women coming from other countries but in Ireland, growing up, I knew that if you wanted to become a nurse you had to have enough money to pay a hospital to train you; you had to pay for your uniforms,

you had to pay for all the clothing, all of the extras. To become a nurse in Ireland was a high status profession that you basically needed to be well off to do. When women came here to Britain they could actually train for free. And so because of the historical underdevelopment, women got access to jobs in Britain that they couldn't have got in Ireland. But what a lot of Irish women and I'm sure other immigrant women didn't know before they came to hospitals here is that the status of nursing in Britain is very different because you don't have to pay for it, because you don't have to be well off to do it; and in that way women actually gain access to jobs in areas of work in Britain that they couldn't get in their own country.

Since 1970, emigration from Ireland to Britain has declined. The number of people going back is greater than the number of people who actually leave. But the racism continues and in fact is always more vociferous depending on what's happening in Ireland. And I think it's really important for us to support each other against the racism in this country. [Applause]

SUZIE FLEMING The next speaker is Graziella Doardo who came to England from Italy three years ago. Graziella was involved in the women's movement in Italy as a student and has been active since she's been in London in Women Against Rape.

GRAZIELLA DOARDO Hello, everybody. I want to start by speaking about somebody who is not here, and that is my mother. I came here in 1979 and I was able to do it only because of my mother. And it all started back in the sixties, when my mother, with five children, had the guts to leave my father; the youngest me, five years old, and the oldest my sister, fifteen years old at the time. And to leave him, running away from him with five of us, and she did it all on her own with the support of her family. She ran away from a situation of total economic dependence on my father's family, and faced hard work and humiliation and really very little money for us. She was in a situation in which, for buying the

shopping she had to go and ask my grandfather for the money for it. And she got fed up and after fifteen years of that life she just packed her bags and our bags and she left.

And she went to this other village far away, in the north of Italy, and it's thanks really to her and to all the fighting that she's been doing for me that I'm here today. She always fought for me, and all of us, and she taught us all to go and get the things that we don't have because nobody is going to give them to us. After a few years my father joined the family again and my mother had to accept him for the simple reason that she needed money. In Italy there is not, even now, any sort of social security or assistance, and basically if my father wanted he could have taken us away from her any time because she had left his house and because she was guilty of trying to get a better life for us.

> **Every family in Italy has somebody who emigrated, every family. I can go anywhere in the world and I will have somebody there.**

Now some things have changed in Italy since then, and there is much more money and much more freedom and innovation of that kind. And a lot of that is really due to all the people who left Italy and went abroad. I mean every family in Italy has got somebody who emigrated, every family. And especially my family. I can go anywhere in the world and I will have somebody there! Somebody that is related somehow to some of my family. And all the innovation and all the things that have changed, changed in part because of the money that these people sent back to us and because of all the new ideas that they were also bringing into our family, into our villages. And thanks to them, thanks to my grandfather who emigrated to South America, thanks to my uncle who emigrated to Switzerland and then came back, thanks to my other uncle who is still in the States (but you know, I can go and see him maybe) — thanks to all this, I'm able to be here today.

> **In Italy the way of life is ruled by three things: the family, the Church and the Party.**

Now why am I here? In a way I could have a sort of decent life in Italy because it's not as hard as it used to be any more. But in Italy the way of life is ruled by three things: the family, the Church and the Party. I don't know exactly in what order, but they all have the same sort of power over you. And it is exactly like that. I mean, if you want to get a job, you've got to be sure that you know somebody, or that somebody knows your family, or that you are inside some political party or that you know the priest and you go to church every Sunday. And if you want to get out of your family there is no support that comes from the State but you have got to rely only on yourself. And that means you have got to have a job. And if you don't have a job you have got to have a man who will provide the food and the money. And if you don't have a man, you just don't go out, you stay at home; you stay with your family for the rest of your life.

And I decided that I really didn't want to cope with that, and I made my fight and I went to the university. I studied and I decided that I wanted to get away from it all. And I decided that the place where I wanted to go was the place that I heard so much about when I was a little girl, and that was England, that was especially London. I have always been fascinated by this, you know, big town. And I decided to come here for the language, for learning a language that gave me the possibility of speaking to everybody, and literally for running away from all those restrictions.

Now when I came here I did also realise how much hard life it is to be an immigrant and I've been asking myself many times if it was really worth it, but every day I tell myself I'm more conscious that it was worth it. And I feel that I'm here with a lot of other people and organising and continuing the fight that my family and my mother started in the sixties, and that is the fight to get more money, to get more freedom, to get

a better life and a decent life.

Now one of the things that also is very important, that was very important for me, one of the reasons for leaving Italy, was the violence. In Italy, obviously if you have to be totally dependent on a man, on a husband, you are also more likely to be in a violent situation. And violence stays very much within the walls of the families, and when it goes out from the families the general attitude is very much that somehow you're provoking rape or you want it or you were looking for it. Not only that, but it also depends on who the rapist is. I remember four years ago a girl was raped by this guy who was an activist of the Left, and there was a big strike of the Left in support of the guy, because he was a 'good guy' and he couldn't be a rapist because he was of the Left. That means that if you are a rapist and you're one of the Left, then fine: it's not that you are a rapist but that you are fascist or communist or socialist or a priest or whatever.

And you know, when I came here I had to face a lot of violence: violence at work in the way of being insulted or being called spaghetti brain when I do something wrong. And violence in your house and in the street where you live, because obviously being an immigrant woman and being on my own, I really had to cope with this whole new life and find the cheapest place possible, living in a squat, living in difficult areas. And that's why I did join Women Against Rape, that's where really I felt that I could fight to protect myself and to protect all immigrant women and to give us a chance of having a better life.

I want to finish by saying that I came here from another country of Europe, I am white, I have got a decent job right now, but I am still an immigrant and I will always be an immigrant and I'm proud of being an immigrant. Because I come to get my things and that's it! [Applause]

SUZIE FLEMING Our last speaker before we open for discussion is Margaret Prescod, who is the author of the book, *Black Women: Bringing It All Back Home*, which was the inspiration for

this conference. Margaret emigrated from Barbados to the United States in 1961 and is now living in Los Angeles. She is at the moment a full-time housewife with a two-month-old daughter. But before that her job was teaching immigrant students basic English language skills. She has been involved in a lot of organising. I won't mention even a quarter of it, with immigrant students in New York, with immigrant nurses in California — which she will say something about later — and also in giving advice to her husband who is president of Local 132 of the Utility Workers Union of America, about the union's responsibility to women employees, to the wives of the men who work there and to women in the community generally. Let me introduce Margaret then. [Applause]

MARGARET PRESCOD I'm going to try and say a lot in ten minutes and those of you who are familiar with the Bajan accent, the Barbadian accent, know that that's a little difficult, but the Afro-American side of my accent should get me along with it! And since Barbados is the only place in the world that

> **When you have family away, your life in the village is immediately affected.**

was ruled by Britain for three hundred years, I called my talk 'Three Hundred Years of Hard Labour'.

I'm always very happy to get the opportunity to speak in Britain because I feel a lot of anger towards the British State, I feel a lot of frustration. As we established in *Bringing It All Back Home*, centuries of fortunes were made off our backs, I think off the backs of most of those who are sitting here. We have come here to reclaim what's ours. When we say we are here to reclaim what's ours, that's a big job and we cannot do it without each other, which is one reason that Housewives in Dialogue has organised this conference.

I wanted to say a little about being an immigrant in your own village. I'll explain what I mean. For myself I was a second

generation of being an immigrant in my own village. That means that my mother's mother, my grandmother, left for the United States in 1920, when my mother was three. She grew up without any of her immediate relatives around her. Her father, who was separated from my grandmother, also went to the States. My grandmother was her sole support. And as my mother put it, she basically was sent from pillar to post, in the village and in parts of the island, you know, to different people who helped to care for her and to raise her. And as her children — and there are three of us — we were born into that situation of having somebody who was away. At this point, as with many of us that are here, I could go to many different parts of the Caribbean and many other parts of the world and find relatives.

Now when you have family away, your life in the village is immediately affected by that. There are some things that are immediately different about you. Although you haven't been anyplace yet, you're still home, but maybe your mother's in America, maybe your mother's in England. What that means

> **The letter says, 'So-and-so bought a TV yesterday.' 'A TV?' And you explain what that is . . .**

is, one, you're getting news from abroad. That's very important, you know, when you live in a village, when you live in a small place. Getting news from the rest of the world, what's going on in the metropolitan areas, is very important, and usually in my village practically everybody knew when we got a letter from America, right? You know, the postman come up, and the neighbour: 'Eh, you got a letter from America today. What's the news?' And you sit down and say, 'Well yes, you know, So-and-so, she bought a TV yesterday.' 'A TV?' And you explain what that is, right, and is it in colour or is it black and white? You have a whole discussion about these things that you can get in this other place. So immediately not only do you want that TV or whatever that

the other people have, but so does everybody else in the village. So the fact that you have family away means that your expectations in your own family are immediately raised. But also the expectations of everybody else in the village, because you know everybody else is going to know the news, and whatever it is they got in New York we want it here too. So everybody's expectations go up.

> **Men who were away would decide they need to set up shop where they are, if you know what I mean.**

Also, very important, news about political organising goes back and forth. I'll give one quick example. My grandmother's husband in New York was a Garveyite — I don't know if people here know about Marcus Garvey of Jamaica* who did a lot of organising in the 1920s, there's no need to go into that here — and he would send news back about what was going on in the Black movement and what they were doing, etc. So that meant that the man who lived next door to us, who we knew as my grandfather — he wasn't really a grandfather, he was some kind of cousin, but we called him grandfather — he was then recruited into the movement and he also became a Garveyite. So there was this little bunch of Garveyites then living in Lodge Road. So there's that kind of news about

* Marcus Garvey (1887–1940) led the 'Back to Africa' Movement of millions of Black people. His base was Harlem in New York, 'capital of the black world', whose population 'was composed in the vast majority of southern and West Indian-born immigrants' like himself. (*Race First*, Tony Martin, Greenwood Press, Connecticut 1976). Exercising Black power on an unprecedented scale, his organisation, the Universal Negro Improvement Association, established Black political centres called Liberty Halls in a number of countries. In the US these became bases for those migrants who formed a massive Black movement to the North – on the basis of a massive rejection of the segregated South – during and after World War I. (See Emmett J. Scott, *Negro Migration During the War*, Arno Press and the New York Times, N.Y. 1969. Emmett Scott, a Black scholar, wrote this study in 1920. It has much to teach.)

political organising that also goes back and forth.

You can already see what I mean about being different because people come to you for the news. 'Hey, Mrs. Prescod, I hear you get a letter from your mother this morning, so what's the news?' So people are coming to you for that international news. They are already using you in that way.

The other way in which you are different is that you are getting some money, especially if your relative who's gone abroad is a woman. It's much less likely if it's a man. If your man, who maybe you were married to or maybe you weren't — and in the Caribbean there is a very, very high percentage of children born out of wedlock, it's something like seven out of ten children — if you were unfortunate enough that your man left to go to London or left to go to America, you kept your fingers crossed that you were ever going to hear from him again. Quite often the men would decide, well, they need to set up shop where they are, if you know what I mean. So they get another wife and maybe a few other children. And the women and children back home they just forget about. So you don't look for those letters from London or those letters from America with the 5, 10, 20 dollars or whatever, if your man is away. But if it's a woman it's a whole other story. So you find then that you are getting

Every August my mother begins getting things together for the box to send back home for Christmas.

some money in, and again that's a difference. Another thing that a lot of women do, and my mother still does from New York to this day: every year, beginning in August, she begins getting things together for the box to send back home for Christmas. So you get the clothes: you buy the material, you sew something, some you just send the material; you buy some canned foodstuff, whatever it is, and you send that box back home. So we were also getting that box. And there's

some good things and there's some bad things about that.

There was going to church, the Church of England was a very big thing there, and the clothes we wore to church always seemed to be those that my grandmother sent from New York, which never fit quite right. The shoes, I remember they were always a nightmare, because the styles maybe would be an American style that hadn't quite reached Barbados yet, so everybody thought they were a little strange. Not only were they a little strange but you had to stuff paper in them sometimes to keep them on your feet. So there was always this embarrassment about going to church in this dress and these flip-flop shoes, you know, things like that. So it had its bad side too, getting these things from abroad.

But the point really is that a woman immigrant in another country is supporting a whole network of people. She's not just supporting herself and those members of her family who are with her in London or New York or wherever. She's also supporting not only immediate relatives she left back home, children or whatever, but neighbours, cousins, I mean the extended family could go on and on. So there's a whole network of people whom she is supporting and she assumes responsibility for.

Another way in which you are different in the village if you have family away, I'll give an example of the relationship between my mother and my father. Now I'm sure they were deeply in love, etc.; they courted for seven years before they married. But the whole question of violence in the family — and violence in the family has already been mentioned by two people this morning — that really is a very big thing and something I'm glad is coming out a lot more, because sometimes we don't like to talk about it because we don't want to paint our men in a bad light, but the fact of the matter is that these things are going on and they can no longer be hidden. So in my village, as in every neighbourhood in the world, somebody getting beat up was, you know, quite normal.

But I must say in the relationship with my mother and my father, my father never hit my mother. Now I think a lot of that

had to do with the fact that my mother, she had a little power: she had a mother in America. The way our family was surviving — both my parents had a waged job but they were making barely enough to support themselves and the three of us. And my father knew very well that we were dependent on that money and those clothes and everything else coming in from America. So because my mother had that something to fall back on, and that kind of economic strength in that relationship, it really made a difference to whether she was going to get beat or she wasn't going to get beat, and whether she was going to be participating in making decisions for the family or not. So she was at least in part protected from that violence because she had people away who were able to help provide for her.

Immigration is the network along which the International travels.

And this business about sending things back, immigrants are subsidising a whole lot of people. We subsidise whole families. We also subsidise the economies of our country: in a lot of ways immigrants provide the welfare that the Caribbean governments or maybe other governments don't pay. We really do, because if you live in a Third World country (what they call 'developing countries', which I don't like), often you don't have social security, welfare, pensions, anything to fall back on, and the way that a lot of people are making it is through the family that they have abroad.

We're also contributing to the chosen country, we're making them money — one statistic I ran across is that the majority of West Indians in Britain are aged between 26 and 54, meaning that they are the waged work force; that 50% of West Indian women who are unemployed don't draw unemployment; that close to 23% of nurses in Britain are from some part of the Third World. And we don't have the statistic for the transport workers but we are sure that there are a lot.

So we are putting a lot into the host country, a lot more than we are taking out. And obviously by sending money back to our home countries, we are also providing a lot. There was a statistic that in 1976, a third of the money in the Turkish economy was what immigrants were sending home.

I understand that my time is up. I think that the challenge that we face, that we have to discuss today, really deals with ending our invisibility, with breaking down our isolation, and with reclaiming what's ours. And when we say reclaiming what's ours we should be very clear about what we as immigrants have to offer to those people who were born in the country. And one thing we offer is that we transport struggles from one part of the world to another. Immigration is the network along which the international travels. [Applause] Thank you. [Applause]

WILMETTE BROWN Our discussion is now open. We've already had one request to speak and so many issues have been raised, I know many people will want to speak out.

NEW SPEAKER I'm an Iranian woman and I would like to talk about the woman's situation in Iran because at the moment under the Islamic Republic in Iran, repression is a part of everyday life.

> **In Iran they rape nine-year-old women in prison because it is against God if they execute a virgin.**

Wedding day, well, is compulsory. Political women are tortured and raped before execution. Especially young women. They rape nine-year-old women in the prison because it is against the God if they execute a virgin woman. Women are attacked in various horrific ways, such as acid being thrown in their faces, their hair being burnt if it is not covered. It means that just to be a woman in Iran is a political crime.

In Khomeini's regime fear goes further than the Iranian border. Iranian women abroad are forced to wear the veil in their passport photographs; otherwise they will be denied their passport. Those Iranian people who are active abroad against the regime are punished by Khomeini's government. The Iranian Embassy refuses to stamp their passport. The Iranian government also employ some Phalangists from Iran with the name of diplomat who disrupt political meetings and violently attack people.

> **Iranians live in fear that the British government will deport them.**

Iranian people don't only suffer from their own government's repression. They also live in fear that the British government will have them deported. The International Solidarity Front for the Defence of Democratic Rights in Iran believes that the people in this country should be informed about the situation in Iran. ISF should start to help those Iranians in Britain who are threatened with deportation, which for many could mean imprisonment or death.

Sisters, our struggle is your struggle. We need your support, by buying our news bulletin and asking us to send speakers and more information about the woman's situation and the Iranian people's situation in Iran, because we are fighting for very, very basic things. We are fighting for democracy, we don't have the right as a woman to walk the street because of the situation in Iran. That's all. [Applause]

NEW SPEAKER Following up what the speaker from Barbados finished up with. If I understood you rightly, to say that you felt that immigration was the beginning of a move towards international understanding, if we treat it right. I may have misinterpreted that. I'm sorry, I didn't come in at the beginning of the discussion, I don't know whether anybody has spoken about what we probably feel to be discriminatory

mechanisms within our own country as well, and seeing where that relates to the discrimination that is felt against people from other countries.

> **I belong to a group which is looked upon as a less valid group – people with disabilities.**

But I belong to a group which is looked upon as a less valid group, which is people with disabilities. There are two sides to this coin. One is discriminated against in one sense, and put into a position of unwanted power in another sense.

There is great feeling in our country of discrimination against certain sectors of the community which started off with the peasant revolt and industrial revolution. I feel that it's a dynamic that we all share. And what I felt the speaker from Barbados meant was that by trying to understand our particular sense of oppression and where it comes from, perhaps we can break the smaller oppressive hierarchies within our own immediate relationships and within our own countries and open a greater understanding. Thank you. [Applause]

MARGARET PRESCOD I think you summed it up quite well. I wouldn't go so far as to say that immigration was the start of international understanding, because there were many of us who were taken from parts of the world, like from Africa, and brought to various parts of the West Indies, America, etc., that was just forced. I mean slavery. And obviously bringing with us a lot of experiences and obviously influencing Western society in a way that is still being felt today. But I think the fact that there are so many of us — the massive numbers of immigrants who are in Western Europe and also who are in the United States — clearly there is a huge movement of people going on, even more so than the movement that went on earlier into the United States. The movement is even more massive now than it was back then and people taking with

them all kinds of experiences, struggles, etc. I think that the challenge that we're facing is exactly that which you posed, and the second and third sessions will go into the specifics of the issue you raised.

WILMETTE BROWN I think too, one of the things that has come across from this panel has been the way that one group of people organising around their particular discrimination gives power to everybody else who is discriminated against to come out about being discriminated against. And I think that's been very true in the movement of women and people with disabilities generally. I know in the US as well as here, the

> **One group of people organising around their particular discrimination gives power to everybody else.**

movement of people with disabilities has grown massively and really come out over the past fifteen years in a way that wasn't the case before. And I think that had a lot to do with the way in which first the Black movement and then the women's movement and the gay movement came out. So that when one set of people who is discriminated against comes out, it makes it that much easier for everybody else to come out. And what we're about is pooling the power of all those struggles. [Applause]

NEW SPEAKER The sister from Trinidad raised some very crucial issues. I just want to say one thing, that I welcome this conference very much and I would hope that it is held annually or some form of frequency be established. [Applause] Because if we are to help people like the sister from Trinidad and to help causes like those, we need an ongoing forum to generate this energy. And I hope that the people in the conference will decide today how we are going to proceed on the basis of this conference. Thank you.

WILMETTE BROWN Well, it took us two years to organise this one. It was a lot of work! Hopefully it won't be so much work to do it again. But I certainly think that we should consider how to sustain the momentum of this conference, keeping that very much in our minds as the discussion goes on today.

> **I come from France. I used to call myself a foreigner and now I call myself an immigrant.**

NEW SPEAKER I'd like to say that I used to call myself a foreigner and now I call myself an immigrant. I come from France and I wasn't pushed out of the country because of poverty; I followed my husband who was going to go into further education here. And I was very, very thrilled to go to another country and to go to Britain. And at the beginning I was very happy. I was a foreigner, I could speak out. I could say whatever I liked to say. Everybody said, 'Oh, it's all right, she's a foreigner. She can always say it.' And now I'm known as a troublemaker in my job because I've said so much that now I'm a victim of what I've said, and a victim of being a foreigner. Because I've said it so loudly that I don't get any of the rights that I should be entitled to really. This is the other side of the coin.

> **It is emotionally and psychologically difficult to bring up children who are from a different culture.**

Also I would like to say how difficult it is emotionally and psychologically to be an immigrant and to bring up children who are from a different culture. My two children were born in this country and they come back from school with different stories, different fairy tales, different songs from the ones I have known. And this is something that we really don't share at all and it's very, very draining. But anyway — I'm extremely

proud to be here. [Applause]

NEW SPEAKER I come from Bangladesh and I have a few words on behalf of the women of Bangladesh as a continuation of my sister, Anowara Jahan. As I was thinking of coming and speaking here I remembered a little story. It's about Napoleon. When he was losing in a battle, he asked his chief military adviser, 'What's wrong? Why are we losing?' He said, 'There are 17 reasons for us to lose.' Napoleon said, 'Let's hear quickly the first one.' And he answered, 'The first one is we don't have the gunpowder.' And then Napoleon said, 'That's enough, I don't want to hear the other sixteen!' So the trouble with us women, the Bengali women, is not that we lack gunpowder. We have guns, we have gunpowder, but what we have is a lot of tears and we waste our gunpowder. And I have come here to get some keys to know, to really gather some courage, to make some effort, to dry the gunpowder. Not because we don't have all those things, but because we don't have courage to do so, or effort really. And the beginning is we must know how to speak. I always think that because we cannot speak in good English, we cannot communicate with other women. But today I feel that even if I can't communicate with my language I will be able to communicate with my feelings. [Applause]

If I am taking a bit longer, I apologise, but I have another point to raise. One little girl said, 'I do understand everything about sex, I know where the baby comes from, I know the where, but it's how which bothers me.' So I know what we should do, and what are the rights that we should claim, but it's how that bothers me. So it's how that we should learn very much. I'm proud to see Margaret Prescod. I saw her and I thought she's one of us, but when she spoke I realised that I would like my daughter to be like her. [Applause] That's what I am really trying to say, that made me speak, made me speak out. We can let our people know what we are feeling. And like Tagore said — you must have heard of the Bengali poet Tagore — Tagore said of one of his heroines: as far as affection

is concerned we want her to be like a mother, but as far as power is concerned she should be a king. And I think that we should all try to do that, otherwise we shall always be ruled by the men.

Best wishes to all the mothers, sisters and daughters. Thank you.

> **Waiting for relatives at the airport, we do not know what is taking place in Immigration.**

NEW SPEAKER I came here with the expectation to hear about how we organised to come to Britain, and also how and why we did it. I thought the most important part was organising to come here. Because a lot of us who are here have families back home who'd like to come here for a holiday or possibly would like to come here to stay. But they do not know how to go about it. We go through all the struggles back home, to get the visa or to get the permit to come here. And when we finally reach at Heathrow Airport, there's another problem before you get past the immigration officer. And we do not know, we who are here and are waiting for the relatives, do not know what is taking place inside the airport. And I was hoping that my luck would hold out, like we would have somebody from the immigration, maybe a past immigration worker, who would be here to give us advice on how we go about organising our efforts to help those who are home to be able to get here and what we are doing wrong. Because a lot of us who perhaps have dependants back home do not know what we can do from this side. And I think that that's the main reason that I'm here really, and I'm very disappointed in not hearing any mention about that. According to this title, I thought that this was one of the reasons why we were having the conference.

WILMETTE BROWN I think that there are many levels to the issue of 'Organising to Come Here: Why and How We Did It'. And

the sisters on the platform have been addressing that issue from a particular angle. In reference to your point about practical information on how to deal with immigration, there are two women at the conference who have volunteered to be resource persons to give that kind of practical information.* So if you speak to one of the women wearing a pink armband, she can point you to those resource women. In addition, there is an information table with a number of free leaflets and so on, giving survival information about immigration, but not only about immigration, about all the other kinds of practical needs that women generally have to deal with.

> **We are widening the discussion on immigration to consider and define the issues from women's point of view.**

In addition to that, this afternoon we are dealing with the question of 'Claiming Our Rights'. There will be speakers from a number of different immigration campaigns, as well as people from other campaigns which connect with immigration. So that we're trying to approach the kinds of practical question you raised from many different levels.

But in addition to those practical dimensions of immigration, we are also widening the discussion, so that we have space and time as women to consider and define the issues involved in immigration from women's point of view. That's what we have least time to do. One of the effects of the immigration legislation is to keep us running so much keeping up with deportation orders and a whole series of things, that we never even have the time as women to sit down and figure out what we're doing and to share that information and that perspective with other women. That's what

* They were: Caroline Maldonado, who has been organising against deportation and for migrants' rights for some years; and Sally Hautot, who was at that time working at the Paddington Migrants Unit (London).

we are fundamentally trying to do at this conference.

There have been a number of other immigration conferences that have focused more on the kinds of issues that you raise, but this conference is different in making a space where women can have another kind of discussion and get another kind of perspective.

NEW SPEAKER On behalf of South African women and their struggles against imperialism and against the oppression of men within the family, we should all the time as sisters realise that when the status quo changes, we seem to suffer most from our men. I don't know why, and I have to apologise because I am one of those who came in late, so I only got the last sister's speech.

This thing of men going abroad from the West Indies in reply to imperialism, and starting other families in New York. They did the same thing when they moved from the Cape in South Africa. They went to Johannesburg to mine, and when they got there they started other families and we as women, as Black women of South Africa, have always had to be very, very monogamous. If you are not, your man has the right to beat you. It has never been challenged that a man can come back to the Cape and find you with a baby that is not his or find that you are going off with somebody else whilst he's been in Johannesburg for 10 years and has not been writing and has done nothing. He still has the right to come back and beat you, and if he killed you within that beating, it was all silent because you were a bad woman.

> **We must not accept this violence in the family.**

Now whilst every woman is aware of the fact that we have been moved about like this as immigrants in reply to imperialism, this violence in the family is something that all of us here as women must not accept, certainly not willy-nilly. Right now in this country, in Kentish Town some weeks ago, a

woman was burnt almost to death. One child of hers and a
grandchild died in that fire. She is still in Whittington
Hospital. The reasons are very unclear, but what comes out
very, very clearly is that the man was jealous of the
grandchild, believe it or not. That woman has lost her child
and grandchild and she is still in hospital today. I have gone
about speaking to male audiences and women audiences. Our
men would have jumped on that bandwagon to attack a white
man if he had started that fire; but because it was a Black man
who started that fire within the family, there is total
ambivalence. I have never seen such embarrassment. Our
Black men, even the fighting ones, the ones who are saying
that imperialism must be attacked physically, we should all go
to war and attack imperialism, this oppression in the family
they don't want to talk about. [Applause]

> **What is this manliness that men can't look after their own
> children which they want us to have?**

I must say that I am sorry I came in late, so I don't know
what the other sisters had to say. But my request to this house
is that, sisters, while we all recognise that we are victims of
imperialism, we should also be very worried at individual
oppression from men in general. So that while a man is free to
come to you and talk to you about his wife and his girlfriend
who don't understand him, your question inside your heart,
whether you are about to flirt with that man or whether you
are just listening to him as a fellow oppressed person, you
should ask yourself what it is the other woman who went out
with him in the first place does not understand. [Applause]

What I am trying to get at is that we should try and be very
much united within our hearts. If a marriage is breaking or a
marriage is broken, there is very little you can do inside that
situation. But don't beg another sister to go back into
another violent family because the man has come to convince
you to do that for him. [Applause] All that you can do and say as

a woman is that when another sister is being called difficult, is being called all sorts of names — the South African ones are great at that, I mean they just call one sister a bitch and that's it, finished, she can't ever surface. I mean she has been blackmailed emotionally and otherwise. So whilst accepting that a man is angry and he's got the power to beat the other woman when the other woman is being called a bitch, for God's sake don't jump on that bandwagon. The best that you can do, perhaps if you are scared for her life, is to keep quiet. But you must know that you are going to give that sister emotional support, whether the case against her is that she is careless, she doesn't look after the kids, she doesn't cook, she doesn't wash, she doesn't iron. We are accepting two jobs — housewifery and earning a living — which is what Black women have been doing ever since we were disturbed in Africa by imperialism. What is this manliness about our men that they can't look after their own children, which they want us to have? [Applause] When a brother is saying that a woman does not understand him, what he is actually saying is that he is not being looked after, his washing is not being done, his cooking is not being done. Thank you very much. [Applause]

WILMETTE BROWN Now I'd like to ask Fran Willard, who was involved in making *Salt of the Earth* in the fifties, to come up and talk a little bit about the film, which will be shown during lunch.

> **For the first time in seven years in London, I really feel at home with my sisters.**

FRAN WILLARD First of all I just wanted to say I'm extremely honoured to be here. I am an immigrant also and for the first time since I've been in London (and I've been here seven years), I really feel at home with my sisters. I also wanted to say that in the broad sense I think that women all over the world are all immigrants, because we live under the definition of

someone else and we do not own ourselves yet!

On to *Salt of the Earth*. I don't know how many of you have seen the film or know anything about it. It's a film that was made in the early fifties and records the struggle of a group of miners in New Mexico, in the United States — lead miners who had been on strike for sixteen months. These people, like the sister who was an immigrant in her village, were also immigrants in the land of New Mexico though their people had lived there for five hundred years. When the whites came they took their land away from them, allowed them to live and become serfs, working for the new corporate landowner and individual landowners. These people's backgrounds are Mexican, Yaki Indian and Spanish. And their forefathers owned mines that they were eventually having to work themselves and became not slave labour, but wage labour. In any case the film was directed by a man known as Herbert Biberman, who was one of the Hollywood Ten, who had been in prison for contempt of Congress for refusing to squeal on Communists or deny his

> **The women who had been keeping the strike going behind the scenes suggested that they take over the picket line.**

background during the McCarthy period. He and a group of others made the film in an effort to demonstrate his feeling about his idea of democracy, and it took two years for him to find this story. At the time that they came across this strike the women had taken over the picket line. This came about because there had been injunctions against the strikers that had been defeated. But finally the owners of the mine got an injunction against picketing, which stuck. And the males, who were of course the miners, didn't know what to do because if they obeyed the injunction the strike was lost, and if they didn't, then they would all be in prison. The women, who had been active in terms of office work and feeding the strikers on the picket line and keeping the strike going behind the scenes, suggested that since the injunction was against the strikers, they should take

over the picket line; and the men — their macho instincts were insulted. They thought this was a terrible thing, and what would happen to the children and so on. And the women very aptly pointed out that the men could take care of the children and take care of all the tasks that women had been doing, while the women kept the picket line going. And this is what happened; they took over the picket line and you will see in the film the incident where the leaders were arrested and taken to jail. And the women insisted that their children come with them and they demanded all kinds of milk and baby food, and so on, and drove the Sheriff absolutely nuts! The strike was finally ended and most of the demands were met.

One of the things that I don't think came out in the film was in relation to the housing. The Mexican workers were housed in shacks which they built on land around the mine that was owned by someone else, and the company maintained houses for the whites — management workers — which had electricity, plumbing and so on and were well kept up. The Mexican houses had no plumbing and just the bare minimum of electricity. And one of the demands the women brought forth in the negotiations was for proper housing and inside plumbing. And the men laughed at that in the beginning and said, 'Oh well, no, this isn't an issue for the union to take up.' But when they had to do the washing and feed the family, they immediately made this one of their demands. And they won it.

OK, I hope you enjoy the film.*

[Lunch]

* The film made history on many counts, and on 2 May 1982, almost 30 years later, those participants who were still alive came together to commemorate the struggle against, among others, the immigratin authorities who tried to sabotage the production. The *New York Times* report of that reunion was a conference document. See p. 219.

SESSION 2
Building a life in Britain

WILMETTE BROWN I want to introduce the second session by giving you a little bit of information about ourselves, the women at this conference. There are a number of countries represented among us here today: Japan, Australia, Ireland, Italy, Cyprus, Jamaica, Hungary, Canada, St. Kitts, Malaysia, United States, Sierra Leone, Guyana, the Bahamas, Nigeria, Wales, Austria, South Africa, France, New Zealand, Spain, Barbados, Trinidad, Morocco, Dominica. [Applause] I'm sure we'll find there are still more. And don't forget the natives! So there are plenty of us from different parts of the world here.

We are also pleased that we have a number of cities represented. One thing that we worked very hard at in organising the conference, was to make sure that we got to women in other cities to participate so that it wasn't only a London thing. So we have Liverpool, Sheffield, Birmingham, Bury (Lancashire), Cambridge, Bristol, Stroud, Leeds and Reading, and perhaps other cities we don't yet know about.

We are trying all we can to make as open a forum as possible, but that depends a lot on you, so if there's something on your mind, please get up and say it. Nobody can do that for you. And we'll try to get that into the framework of the conference. There are also translators here. So if you need a resource of some kind, see a woman with a pink armband.

There were some issues that came up this morning such as the question of practical support for campaigns; that's an

issue that we don't want to get lost, and there will be opportunities to deal with that further. There's also the issue of what kind of continuity we want following this conference, and still another question of how we define issues and relate them to campaigns.

Also in reference to workshops, as it turned out no one set up a workshop, but that doesn't mean that the chance for discussion is over. If people by the end of the day want to have future meetings on some particular topic, please get up and announce that or see a steward about organising a time when that can be set up and announced by the chair.

Many countries are represented here today: Japan, Australia, Ireland, Italy, Cyprus, Jamaica, Hungary . . .

Now I want to introduce the women who will be chairing this session. First, there is Anne Neale who was an immigrant to Australia from England at the age of twelve and lived in Australia for eight years. While there she was active in organising the first strike in the Philosophy Department at the University of Sydney in 1973, a strike demanding a women's studies course. Anne was a founder member of Wages Due Lesbians in 1975. Since then, in addition to organising in a number of areas, Anne Neale has been involved in the campaign to keep Reggie Yates from being deported, which has won a big victory. She was also active in the campaign to free the Bradford 12. A lawyer from that campaign will be speaking later today.

Co-chairing this session will be Margaret Prescod who by this time should need no introduction. One thing about what Margaret has been doing most recently, she has come direct from a campaign in Los Angeles which she is organising with Black and immigrant nurses in the state of California who are being discriminated against in a variety of ways, in particular in the examination which they are forced to take to qualify as nurses, which has already been proved to be racist; and

which, in addition to being racist, is being used as a basis to deport Filipino nurses from the United States. Margaret has been co-ordinating the campaign and petition drive against that.

Even if you're born in Britain, if you're Black, you're treated as an immigrant anyway.

MARGARET PRESCOD In opening this session there are a couple of things I'd like to say. The first session began to deal with defining what is an immigrant. Wilmette said earlier that all women are immigrants because we're all dispossessed, and at the same time Black women often have to deal with both being an immigrant and also being Black. And even if you're born in Britain, if you're Black, you're treated as though you are an immigrant anyway.

In this session we'll explore what it means to be Black and/or immigrant in Britain, and the extent to which those Black people born here are regarded as immigrants and therefore assumed to have less rights than others. Being an immigrant makes all other aspects of one's life more difficult — as I'm sure we all know. Whether it's jobs, whether it's housing, whether it's the police, whether it's health care — and with the direct attack on the part of the government with the new rules on the National Health Service,* that's been very clear.

* In October 1982, regulations were introduced limiting treatment on the NHS to those ordinarily resident in the UK. This breaks with the founding principle of the NHS which has always catered without question for anyone who was ill in Britain – even tourists. According to doctors, the financial saving, which is the official rationale, is minute. But the attack on Black people, who are the ones most often asked to produce passports before getting free medical attention; the apartheid this injects into society; and the erosion of the principle that everyone has a right to health care, are obviously the aims. Like the government expenditure of £7bn. on the miners' strike, this medical policy – to use the government's own word about the strike – is an 'investment' in a more divided, more frightened, and thus more disciplined society.

Whether it's getting unemployment, supplementary benefits, sickness benefits; and whatever your situation, whether you're lesbian, whether you're working as a prostitute, or just a target of police racism, being an immigrant often means whole areas of your life may become illegal or semi-legal, especially with racist immigration laws and especially if you're an illegal immigrant.

> **Being an immigrant makes all other aspects of one's life more difficult.**

The first session also dealt somewhat with the hidden cost of being an immigrant: the wages that you get, wages that are lower than others'; the fact that you are supporting family back home and you really have to be able to support yourself and your family in two different countries. And I know here there was a Child Benefit For All Campaign that fought to keep child benefit for children who were abroad, and whose parents were in Britain.* In this session we will be dealing with building a life here, what we've been able to win in terms of money and also of independence.

ANNE NEALE The format of the second session will be the same as this morning. We've got several panelists who will speak for no more than ten minutes, and then the floor will be open for discussion.

The first speaker is a woman who is reading a speech written by another woman who preferred to remain anonymous. The woman reading the speech is Joan Grant, and she is from Edinburgh. It's a personal account of a Black woman who was born in this country of mixed parentage.

JOAN GRANT White mother of two daughters, Black father nowhere to be seen. These daughters, only one year and a bit apart, as babies were very different. One passed for white, the

* See Introduction, p. 14.

other the spitting image of him. This mother became a proud parent of one. But the other, a miniature resemblance of a bitter past, went into care at eighteen months old after a series of foster parents. These sisters were re-united when this mother finally put the little sister into care when she was three. Here in the Dr. Barnardo's Home the sisters followed the word of the elders, like most good children.

The social life of this mother could be described with colours. Her female friends were white, had dyed blonde hair, had Black boyfriends and coffee-coloured children. Having a Black man's children for this mother was a life sentence she did not appreciate, something as a child I, sister of the dark side of the coin, understood only when a story slipped through the hushed world of adult affairs. A disagreement between a friend of my mother's and her had caused the friend to call the respectable Post Office in which my mother worked and inform them of her two Black children, hidden secretly away in Dr. Barnardo's. My mother was probably sacked for ambiguous technicalities. Our Blackness was her alienation. The variety of relationships she desired was jeopardised by our very existence as Black children.

> **Her friends were white, had dyed blonde hair, had Black boyfriends and coffee-coloured children.**

Once in the Home, things were just as alienating in terms of our complete identity. First came the important truths which had to be learnt concerning the all-good white, married, nuclear family. My mother became the absent angel, soon to descend upon us and rescue us from the unnatural circumstances of the Home. This indeed she was forced to do when she married, at last, a white man, as only two weeks after her wedding we were packed off aged ten and eleven to our rightful place with our natural mother and our newly legal stepfather.

Second was the discovery that home and its Christian

ethics were completely wrong. This mother in fact rejected the idea of us being her 'sudden' family and eventually cut herself off with her husband and her new baby, her 'best' baby, as she used to say, into the upper half of the house, declaring herself a sympathiser with the National Front. This for me was most unfortunate. Not only am I Black but I still carry the painful resemblance of my father, from which she shuddered if ever she saw one of those inherited expressions on my face. I hadn't even met the man. In fact when any limit of my Blackness was emphasised, for example by the plaiting of my hair, or by having Black friends from school, her anger and disgust were clearly demonstrated. For this Blackness she was persecuted. This Blackness was for her the only evil.

I sympathised with the National Front myself, hoping to cleanse my soul.

To gain peace of mind, I sympathised with the National Front myself, hoping to cleanse my soul. To gain peace of mind I grew to hate the father I had never seen.

Meanwhile back at Dr. Barnardo's they were doing the best they could to reproduce the natural surroundings for any child. But we were told whenever questions of our nationality were asked, 'We are all God's children, God treats us all the same, nobody is different.' The matrons were Aunties, to set the family scene, and indeed some of the women were dedicated beyond any rules or favouritism. Some became mother figures for some children, helped along by the genuine affection and concern felt by them.

One such mother figure of mine, when I was big, too big to handle, would argue with me whenever any colour darkened the picture. She used to say things like, 'You used to be such a lovely girl, with a kind heart. What happened to you?' Or 'If you're Black, how is it that your headmistress said to you on your first day at school, "Oh, what a pretty little girl"?' The very physical racial differences were glossed over; they were

'superficial' differences. Kinky hair, for instance, was merely a curly hair style. This hair was not to get too long and become an Afro or some other monstrosity, so I was told, 'Your hair doesn't grow.'

'If you're Black, how is it your headmistress said you were a pretty girl?'

My recognising my Blackness threatened the mother figure fantasy held by my matron. It either meant that she couldn't pass as being my true mother if she admitted to herself and to me that I was Black, or that the association for an unmarried woman of Christian beliefs was too Black a cross to carry.

Later, having found my father by accident at fifteen, I sought permission to live with him. A social worker told me that it would be a highly suspect situation. Because of my age — now a young woman — my father might rape me, and permission was refused. My father had been described to me in so many words as 'the Black devil'. He was to go to Hell — the Bible said so. He had left my mother without marriage or money and was not to be sought after, a man of sin, a rapist, a runaway, a devil — a Black man. When I found my father, it was the beginning of finding myself. [Applause]

ANNE NEALE The next speaker, Mary Smith, came to this country from Antigua as a child and now is a social worker. She is going to talk about living in Britain as a Black lesbian woman.

MARY SMITH I came to England when I was five. I can't remember very much about Antigua, but I remember that when I started school in England that's when my problems started. I found it very difficult to settle down in England, because I was the only Black child at school. I had quite a lot of problems and my school decided to turf me off to see an educational psychologist. I feel that the reason for that was because they didn't really understand me. So I spent about

two terms at this educational psychologist. I also remember whilst I was at school that reading through the books, there were hardly any Black faces, or any stories about Black children.

I then went to a junior school and I remember particularly the problems I had there. I felt that I achieved very well and I was in the top class, but because I was seen as a tearaway, as the school would class it, I was placed two grades lower, because they felt that I didn't behave at school. So therefore if I was good, then they'd place me back into my original class.

I then had problems in my secondary school because once again I was the only Black girl there. So when I left school I decided that I would have to do something for myself to better my career prospects. I went to a College of Further Education and did Catering. My problems started once again when I left college and I was trying to find some kind of employment, for one being a woman and for another being Black. I went to many interviews and I was refused, for the simple reason that in catering it's very difficult for women to get senior positions. I then worked at a children's home in Enfield and then I took a keen interest in being a social worker. I applied to many boroughs and I was finally accepted by Hackney. I felt it was particularly interesting because in care there's quite a lot of Black kids and there's very few Black residential workers. So I felt that I'd be able to do an awful lot for those Black kids there.

> **I remember reading through the books and there were hardly any Black faces or stories about Black children.**

Once again I had problems there, I kept speaking out for these Black kids because there were various racist comments made by the staff whom I class as being very white middle class, and who didn't understand the particular problems of Black kids in care.

I was there for two years. The last year my superintendent decided to take disciplinary action against me, but fortunately I fought that case and I won that.

Then I decided to come out and to declare to the staff that I was a lesbian. I had particular problems there, because they decided to use that against me, and so I had to leave.

I was the only Black woman at the first lesbian club I went to.

When I went on the lesbian scene I found it particularly difficult. I was the only Black woman at the first club that I went to and I felt that in some ways there was some discrimination there. I'd attend the club and I'd be very isolated. I was left in a corner with practically no one talking to me. And as I progressed to visit further clubs and I got to know more Black women, I felt more at ease because I find that Black women, especially lesbian Black women, do stick together and there is quite a lot of sisterhood. [Applause]

ANNE NEALE The next speaker is Parminder Vir who was born in India and came to this country as a child. She works in the Greater London Council's Ethnic Minorities Unit, and she's a member of the Black Women's Working Group of the Women's Committee of the GLC.

PARMINDER VIR The GLC employs something like 23,000 people. I am the only Black woman at a senior level,* and still often thought of as a clerical officer because they are not used to seeing Black faces, particularly young Black women, at

* There are now more Black women at senior level. The question which now arises is: how accountable are they to the communities whose struggles got them the jobs? Recently a Black local government officer claimed that politicians should be held accountable but not employees. At the same time, politicians claim their policies are not racist because of Black civil servants, not sexist because of women civil servants, etc., etc. Heads they win, tails we lose.

decision-making level. And the whole emphasis of my contribution is actually the participation of Black people in decision-making, in decision-making on policy, on issues that directly concern us, and for Black people to begin to see that as a role that they have to begin to play if they are to control the directions in which their lives are to be taken.

> **I came here aged ten. I was told it would take five years to learn English. I mastered conversation in two months.**

Before talking about that I'd just like to take five minutes to tell the sisters here the attempts in my education or miseducation in this country, to actually redirect me away from the hopes and aspirations that I had as a Black woman.

I came here at the age of ten, directly from the Punjab, not being able to speak a word of English. I was told to remain in class to be taught English, which was going to take five years. I managed to master the language in two months, enough to be able to communicate with my friends. I went through the schooling here, which taught me that India was discovered by Clive, that India had not existed before, it had no history. I was told there were certain ways that Indian women and Indian girls were supposed to behave. When at the age of fourteen I decided I wanted to be a physical education teacher, that horrified everybody in school. They had never had an Indian woman who wanted to be a PE teacher. PE teachers always assumed that once Indian girls reached the age of puberty they were not going to participate in recreational activities, though they felt that West Indian girls were born to be sportswomen. I persevered and said, no, I want to be a PE teacher, because of my love for the games that I played in, and

> **PE teachers assume Indian girls will not do recreational activities but West Indian girls are born sportswomen.**

also just to prove that Indian girls did want to participate and were willing to participate if they're given the opportunities.

I went through teachers' training college and obtained a degree in movement studies. And then I wanted to go on and train to be a recreational manageress and that horrified people even more, because there are no women — I mean white women — who trained as recreational manageresses, let alone Black women. And again I was persuaded that that was not the path for me. But even before trying to train as a PE teacher I was told by my careers teacher that I should think about training as a secretary or maybe as a nurse, because that suited my temperament much more; but that I would never make it as a teacher.

> **Resources are now available to Black people as a result of my parents' generation and of the rebellions in 1981.**

That's to give you a background in the kind of obstacles and kind of struggles that I as an individual have faced in order, by the age of twenty-seven, to be working for an institution such as the GLC; and to be in a position actually to make decisions on resources that rightfully belong to the community and particularly to the Black community.

I was asked to speak about the GLC and what it is doing. That various resources are now being made available for Black people hasn't just happened because some people thought, 'Well, it's about time we gave Black people something.' It's as a result of the struggles of my parents' generation, the rebellions that we saw in 1981 and for years preceding that on the streets of this country. It's as a result of that, and of the compensatory measures that have been taken, that I am doing the job that I am doing.

Working at the GLC is no easy task, first to be the only Black woman, second to be the only woman often on committees which are run, and controlled, and have been run and controlled over years and years and years, by men who have

made decisions purely from a male point of view. And when they see a Black face, when they see a Black woman, often the racist language in which they have talked before, you hear it day in and day out.

The GLC has taken the initiative in actually allocating certain resources to the community. I'm particularly responsible for the arts and recreation, and have a budget of something like £300,000. My objective of being in the GLC is

> **At the moment resources are going to white middle class women's organisations who know how to relate to the system.**

not to sit for the next I don't know how many years before I retire and draw a fat salary, but to recognise that there are resources that have been sitting in that institution which are rightfully for the people who actually contribute in taxes. The objective is to get as many of those resources out, in the space of time this administration is in power, to the community and particularly to the Black community, because as far as we're concerned that is the group that is the most discriminated against and the most disadvantaged in this society. And Black women within that have a right and a claim on those resources, and there are a number of other committees, for instance the Women's Committee, which at the moment has £200,000–£300,000. I'd like to see many Black women actually benefiting from those resources.

At the moment both of those resources are going to white middle class women's organisations who know how to relate to the system and who know how to actually get that money or get those resources out. Our objective is to enable as many Black women's groups to get access to those resources and to use them.

Secondly, to actually change the structure of the GLC. The GLC, as I said, employs 23,000 people. If you look at the presence of Black people in that workforce, they are all at a

manual level, the lower ranks. All Black people seem to apply to work in the canteens of the GLC as they seem to want to apply to work in the canteens at the BBC and the IBA. We've discovered a tremendous amount of racism and discrimination within the GLC, and the kind of racism and discrimination faced by Black people who actually want to go through the hierarchy and apply for jobs within that hierarchy. The thing is to fight that racism and to open access to resources and opportunities to enable Black people to get into positions where they're actually in control, in a position to make decisions about allocation of resources, decisions about policy that are ultimately going to affect the lives of ordinary Black people living in London. I could go on to talk further but it would be much easier to respond to questions. Thank you. [Applause]

ANNE NEALE The next speaker is Esmé Baker. [Applause] I see she needs no introduction. But anyway, she has been in this country for eighteen years. She works in the service department of Thorn EMI, she's the mother of three boys and

> **I equate my experience to the past when Black women were put on blocks, stripped naked, assaulted and then sold.**

has recently won a very important victory in fighting her case against sexual harassment by the police, which she is going to tell you about. Women Against Rape organised a picket and organised to get some press coverage for the case, and the picket was attended by a number of women's organisations and local groups. It was a very good example of the kind of power that Black and white women can have when we organise something together.

ESME BAKER Yes. Well first let me say how delighted I am to be able to come here to speak, because what happened to me, I feel that every woman up and down the country should know

about, what is going on today in the country. As far as the
police are concerned, Black women in particular, they have no
regard for them as human beings let alone as women. The
events that took place in April this year have caused me to
reflect and think hard about the past, because it hasn't
changed one bit. When I say the past I refer to the times when
Black women were put on blocks, stripped naked, assaulted
and then sold. Because this is what I equate my experience to.
Similar things happened to me, some people might find it
hard to believe, and the police made it quite clear that their
vicious attack on me was in retaliation for my son being
cheeky to a white woman.

Now it was heartening to see the overwhelming support
that I got from this movement, and not only Black women but
white women as well were persistent in the support they gave
me. I'm sure not all of you are aware of the facts of what
happened that night. But it is true when I say that all I had to
do was to simply walk downstairs to my front door.

Now the SPG,* they came on the housing estate presumably
to evict the racist, fascist thugs who started to use the estate as
a meeting place and to harass Black people. Three times in six
weeks my oldest son was stopped, questioned and once
threatened with arrest, because they couldn't figure out why
his name was Foulkes and mine was Baker. I had to go down
to the station, where I was told that my son's name did not
correspond with mine. I said to him, 'Obviously that one
wasn't too hard to work out.' His reply to me was that my son
ran when he saw the police approaching. I said to one of them,
'Well, have you any charges against my son?' He replied, 'No,
but he ran.' So I said, 'Since you haven't any charge against my

* Special Patrol Group of the Metropolitan Police, specially trained for
riot control and 'fire brigade policing': 'Instead of being encouraged to defuse
difficult situations and calm people down, police [have been] given even
more powers to rush in in large numbers and to arrest people at random',
'summoning instant response (or district support) units in transit vans.'
Louise Christian, *Policing by Coercion*, GLC Police Committee Support Unit,
1983, p.65.

son, let him go.' He said, 'Well, he ran.' So I said, 'Well, officer, obviously you don't find anything on him. The fact that he ran is a clear indication that he's damned scared of the police.' One officer said, 'Yes, he should run. He should run from skinheads, he should run from the police and he should run from any white man because we intend to run you niggers into the ground.' I replied that not everyone in this country thinks and feels the same way as he does, and we would not just sit there and be trampled into the ground. I will cut that short by saying that I recognised four of these same policemen in the vicious attack on me.

> **I'm sure every woman here will feel pain when I say that this brute hit me twice in the stomach with his fist.**

Well, they took hold of my son and take him around the back of the flat where we live. I heard these terrible screams. I had no idea it was a son of mine. All I knew was they were human screams and this person was in pain, great pain. I went downstairs cautiously, I had no intention of confronting these burly trained riot-busting policemen. Immediately as I set foot outside my front door, I heard one say, 'There's the mother.' Three of them approached me and I was brutally clobbered on the head with a truncheon. One, knowing the damage that the truncheon would cause, said to his colleague, 'Don't use that.' So they took me underneath the block of flats where I'm sure every woman in this audience will feel some degree of pain when I say that this brute hit me twice in the stomach with his fist. When I said to the judge and their defence counsel that I couldn't cry out, he did not know what I meant. I just could not cry out, I wanted to lie down.

As if that wasn't enough, they actually took me close up to where they were torturing my son. And after that I'm sure every mother would become a bit agitated. I wanted to get away. There was nothing that I could do, I just wanted to get away, because these riot-busting police were really looking

for a riot. I wanted to get away, I want to run, but where? I couldn't. So in my weak attempt as a woman I managed to get one arm free. That was when one of the policemen grabbed me by the front of the dress and tore my clothes off me. I was dragged, half carried, to the van, nearly naked now and barefoot, where they decided now to have a bit of Friday night entertainment.

> **No woman, Black or white, should suffer at the hands of the police as I did.**

They arrested my fourteen-year-old son. My other seventeen-year-old son, they were still enjoying the torture they were inflicting on him round the back. They put my fourteen-year-old son to lie on the ground and they sent for another van for the older boy. In my naked state I could do nothing or say nothing because of the pressure this police was putting on me with his body, he was squeezing me up tight against the van. One would have thought then that he would have some decency to get a Woman PC, but as I said, I was a woman and I was Black, they did not see me that way. So they begin their entertainment by jabbing me on the breast with their truncheon and remarking in a tone full with surprise, 'Man, I didn't know that nigger women have breasts.' Yes, this is what went on in Britain in 1982, and they continued to torture me. One can understand my humiliation and helplessness, I could only retaliate by spitting in the face of the policeman closest to me.

Then they took me up to Chingford. When we walked into the station, one thing I'll always remember. Now I'm not prepared to make a blanket indictment of the white people in this country, because there was one man who gave me hope, reassurance. He didn't have to say a word, he just looked at us, embarrassed, shocked. The inspector who was in the van with me, unaware now that the scene has changed, remarked quickly, 'This one was cheeky to a white woman,' pointing to

my son.

Well, the support that I received from the women's movement — which I think is the best thing that could ever happen, and I think it should grow and be supported — was overwhelming. Albeit I am an alien resident in this country and I'm a Black woman, the support the white women gave me was overwhelming and it shows me one thing, that they mean by their support that regardless of what colour you are or what creed or where you're from, you're a woman. You're a woman, and we intend to put a stop to this brutality that they inflict on women both Black and white, albeit in different forms. I wish to say thank you for the victory that I — not I, *we* achieved, because many of you here helped me to achieve that victory. No way could that victory be denied. It should strengthen us to go on and on and this movement should be publicised and grow bigger so that no woman, Black or white, should suffer at the hands of the police who represent this Establishment in the way I did, ever again. Thank you all very much. It was a great victory for women. [Applause and standing ovation]

ANNE NEALE The next speaker is Nina Lopez-Jones who is from Argentina. She left Argentina eleven years ago and was first of all an immigrant to Italy, where she lived for several

As an Argentinian, I am now a 'national enemy'.

years, and has been living in England now for six years. She is a spokeswoman for the English Collective of Prostitutes which since 1975 has been campaigning for the abolition of all the laws against prostitutes. She is also the mother of a three-month-old son.

NINA LOPEZ-JONES As somebody who is now considered an enemy, a national enemy, I feel like I have to start by saying something about the Falklands War, the Malvinas War. And

the first thing to say about that is what the Falklands War has meant for Argentinian people who are living in this country, which nobody ever thinks about. You know, when you hear about the Falklands War, you don't actually think of the Argentinian people who are immigrants here, who are living here. There has been a terrible racism against Argentinians in this country — I mean we are now called 'Argies'; that's the new thing. And people who are living here are worried about their immigration status, they are worried about their right to be here, they are also worried about threats of violence or actual physical violence against them. I mean I am quite careful. This is a women's conference, but if it were a mixed conference, I don't know that I would say lightly that I am an Argentinian. I would probably say that I am a Latin American so you could be from anywhere around there, because you never know who you are speaking to.

I don't want to get into details about the Falklands War, but there is a letter written by another Argentinian woman called Anita Garcia* which is available at the table, and which really puts the women's point of view on the Falklands War. Very often people from Latin America do not refer to themselves as immigrants; they prefer to call themselves migrants or political refugees, according to where you belong, kind of thing, which box you are in. And what it means is that if you are a migrant you're a white worker, usually on a work permit, or that's how people see you, as a white worker on a permit. And if you're a 'political refugee' it means that you have come to Europe after one of the military coups, one of the several military coups, possibly with assistance from a government. My sister and her family are political refugees in France, and they had some kind of assistance from the French government. They found them housing and jobs and they take care of your kids and that kind of thing. You get a much better deal usually than if you are just an immigrant, in France, anyway.

*See p. 221.

And the reason for all these different categories, to be a migrant or an immigrant or a political refugee, is that when you are a migrant or a political refugee you see yourself as white, you see yourself as political, so therefore you are different from immigrants who are Black. And you think, well, I've got a little bit more power by sticking with my own people instead of mixing up with all of them out there. And really what it means is that you are so vulnerable as an immigrant that you don't want to associate yourself with a whole set of people who are also vulnerable, and you think you're going to be adding to your own vulnerability by associating with all these other people who are just as vulnerable as you are or sometimes more vulnerable.

> **Everything Esmé Baker said about Black women and police treatment, that's what prostitute women get and double if you're a Black prostitute woman.**

As a member of the English Collective of Prostitutes, I know very well what it means to be vulnerable and how women feel. Like when you're a prostitute, how you feel about being vulnerable, because everything that Esmé Baker just said about Black women and the kind of treatment that Black women get, that's what prostitute women get and even double if you're a Black prostitute woman. And this kind of vulnerability — I mean the police raids, the police abuse, police rape, police assault that you get as a prostitute woman — is just so horrendous that in fact a lot of immigrants don't want to associate with prostitutes. They think, well, if that's the treatment they get, I've got enough with my own treatment without associating with this other set of people and making it worse.

But this being in little boxes really hides the reality of our own situation, which is that, first of all, we are not just immigrants. I mean immigrants are a whole set of other things. First of all Latin America is not the white continent that

it often passes for being. People think, Oh, Latin Americans, yes, they're all white. I mean, that's a lie. Most countries in Latin America are at least 50% Black. At least. The Black people in Latin America are either of Amerindian origin or of African origin, and the rest are usually of European descent. So that to say that Latin America is all these whites really is such a lie. We are all hiding behind the migrant thing when in fact a whole bunch of us are Black.

The other thing that it hides is that, as I was saying, as immigrants we are also many other things. Some of us are illegal for all kinds of reasons. We may be illegal immigrants to start with. A lot of people are illegal immigrants. A lot of immigrants are also prostitutes or lesbians or shoplifters. You know, when you are an immigrant woman, when you come from the Third World, you often have a lot of responsibilities of looking after your family and the opportunities open to you are so few and such bad ones that often you have to resort to illegality in order to make a living and take care of your family, and that includes prostitution. There is a lot of prostitution in the Third World, and there's a lot of prostitution in England, and there's a lot of prostitute women in England who are Black and immigrant women, because those are the opportunities that are open to immigrant women. And those of us who are not prostitutes might be shoplifters because that may be the only way we can get some food for our kids. There is a whole list of illegalities that women get into which are small crimes. Prostitution is a small crime in the sense that it doesn't do any damage to anybody.

Those are the kinds of crimes that women are into because quite often we haven't any other choice. After all we don't sell other people's bodies, we sell our own body, and the reason these crimes are often regarded as big crimes is that the price we pay for it is very, very big. When you are a prostitute woman the price you pay for being a prostitute and selling your own body — I mean you can go to jail, you can be fined, but more than all of that, you are going to be a social outcast, which means that nobody is going to want to relate to you,

that the people who actually do relate to you can be in danger of going to jail themselves. And that is a very big price to pay for such a small crime.

Now all the immigrants who are here today, and all the other immigrants who are in Britain, have come here from all over the world and for different reasons. People have said some of the reasons they came here, but none of those reasons have anything to do with the weather. Margaret said that in her book, that we're not in Britain for the weather. All those reasons why we have come here have something to do with money, in one way or another. That's something that we all have in common. We are all immigrants, we are all the victims of poverty and whether we are immigrants in the sense that we just came here to get a job and to get a better life for our children or whether we are so-called political refugees, we were all fighting against the poverty in the Third World, we were all fighting against those governments that were institutionalising that poverty for women and for people in general in the Third World. And that includes the governments that we have to deal with and it also includes the British government and the US government which have had most to do with making the Third World poor.

> We're all refugees. We're *economic* refugees. And we have a
> right to be here.

In 1981 people from Haiti who had immigrated to the US were told by the US government that they couldn't stay there because they weren't refugees. And they said, 'Oh yes, we're all refugees, we're *economic* refugees.' And when they said that, they were speaking for all immigrant women and for all immigrant people, because that's what we all are, we are all economic refugees. [Applause] And we all have a right to be here. [Applause]

ANNE NEALE Before I open the floor to discussion, we've had a

couple of messages of support from people who unfortunately weren't able to come today. One was a letter from the Dublin Women's Centre saying how pleased they were to see the conference was taking place, that unfortunately they were involved in something else today and so weren't able to come but wish the conference every success. There was also a message which came on the phone from the Newcastle Community Relations Council who wish the conference well. And there was a message from the Lesbian Exchange newsletter, *Grapevine* which is put out in Manchester, who also said that they felt that what the conference was doing was really important and hoped that it was exciting and successful. And they hoped that some women from Manchester are here. The floor is now open.

NEW SPEAKER What I've got to say is not comments on the talks we just had. There are really three main points. First of all, the Liverpool 8 Black Women's Group decided to leave the conference this morning. I'm not a member of the group, although I am from Liverpool, and they left the conference because they felt that the conference wasn't likely to develop along lines that they had expected, i.e., issues which particularly affected Black women. Although they agree that those issues may affect all women, they in particular were thinking that they would like to discuss them in terms of how they affected Black women, whether it's violence in the home, whether it's education or older women in the community. My comment on that is that I think that they should have stayed and that they should have made this point. But I think that maybe they didn't stay because they are a new group.

Which leads onto my next point, that the title of the conference is Black and Immigrant Women's conference, which led me to believe, one of the main reasons I came along, is that I thought there would be opportunities in terms of workshops for greater dialogue between members in the group. I know that the organisers said that people can set up workshops if they want to, but given that there are many

women like myself, which is why I am stuttering and stammering, who are not used to being in situations where you go along and you organise things — I'm not saying Black

> **There's a whole history of Black women organising their resistance through slavery and colonialism.**

women or other women cannot organise things, because there is a whole history of organisations from all kinds of women, and in particular I'm thinking of Black women, and their resistance through slavery and colonialism. But I would have thought that the organisers may have helped this along somewhat by having particular headings for workshops and allocating rooms and perhaps, you know, ushering people to places.

What's happened is people have actually met in the cafeteria over lunch, and so therefore people have exchanged ideas. But I think that it may have been more constructive for dialogue across the group, rather than from the panel to the group and then the group back to the panel, for those workshops to have perhaps been slightly more organised, although there are lots of people who are against totally organised meetings.

And on that, one of the women from the Liverpool 8 group said that she had read the book by Margaret Prescod, and that she felt it was really sound and she would have liked to get to grips with some of those ideas in smaller groups, in smaller meetings. Anyway that's an organisational issue.

The point that I want to talk about is, I teach in a secondary school in south-east London, and I'm particularly concerned with things that are happening with Black girls in schools today, and I've started talking to a lot more teachers recently. It seems to me that there are lots of Black girls in school who, although perhaps they are not able to put it into words themselves, have sussed out the situation in terms of racism, in terms of sexism, in terms of how they are going to have to

live in Britain if it's Britain they're going to live in. And
because they've sussed it, although they're not always putting
it into words, they resist a lot of things in school organisation.
These are not girls who are truanting or being naughty
because they are 'thick', as some people call them. These are
intelligent girls who according to the system could get
examinations, their 'O' levels, and their CSEs, and could get
good jobs at the end of it. And they're resisting the situation as
they understand it. And unfortunately, I feel because their
energy isn't channelled perhaps into constructive areas where
they themselves think about the issues that are happening to
them, they end up very disruptive — smoking in the corridors,
hiding in the toilets, pushing people around in corridors, and
end up getting suspended and expelled from the school or
sent to various units, and ILEA* has got a whole range of
places that people can be sent to outside school.

I was hoping that people who actually work in any kind of
organisation, community work, women's groups or whatever,
that they are aware of this thing with young girls in schools.
And I would imagine, although I don't know, that this is
possibly happening to other identifiably immigrant groups. It
may be happening to people who are white immigrants, i.e.
Americans or whatever, but I think in terms of large numbers,
it might be happening to identifiably Black groups.

And finally on a more personal point, although it's not the
least important, there are lots of single parent families, and I
am one of them, and I have had to bring my son along to the
conference. He goes to nursery five days a week and doesn't
want to go to the crêche, because he just wants to be with me
today. I apologise if he's disturbed anybody, but I don't
apologise for the fact that I've brought him into the
conference.

MARGARET PRESCOD I would like to respond to a couple of the
issues that were raised by the sister. One, I think if some

* Inner London Education Authority

sisters from Liverpool left the conference this morning, it's unfortunate. I think they have missed a lot of very good stuff. I don't think it's every day in Britain that Black and immigrant women do get together in this kind of forum. [Applause] Also I came in from Los Angeles for the purpose of this conference and to do some organising work while I'm here with Black women as well as other women. And I know that we have not had an event of this kind in the US, and I hope that we do in the near future.

I also know that in organising a conference one cannot please everyone. We thought very, very carefully through the format and the structure of the conference in terms of having a number of workshops going on at the same time. In the past when that has been done people have said, 'I was at one workshop, but I really wanted to hear this other stuff', and people were concerned about missing information and going away and missing the opportunity for all of us to come together and share information. Also with the structure of the conference, we feel that the panelists have provided a lot of information and certainly a lot of inspiration to us and set the tone in a lot of ways for women to then speak out. And we have been very careful with the time; panelists have been limited to ten minutes.

You referred to my book. Well I could have talked for an hour or two hours this morning. I did not because I also wanted to hear what you had to say, because I need that information for any organising or anything else that I am going to do. So we worked very carefully for us to be able to share information with each other. Also, we left a lot of time at lunch and between sessions precisely for people to meet formally, and informally in the cafeteria. But you could also have gone to a room to meet, and you still can. People who felt that they missed the opportunity during lunch should let somebody with a pink armband know, and we would be very happy to assist in working out some space and subject with you. That's what I wanted to say about the structure.

NEW SPEAKER I don't speak as an immigrant woman. I speak as an English woman who has been married to an immigrant man from Latin America, and I also speak from my experience both of living in Latin America and of working within the Latin American community in this country. The first thing that I would like to say is really the same as the two sisters before me, but from a different point of view, which is what caught

> **What has excited me about this conference is that it has managed to show the common roots of oppression.**

my eye to start with about the poster: it is about Black and immigrant women. What has excited me about this conference, and particularly hearing different women's experiences, is that it has managed to show the common roots of oppression. And I think that the only way in which a struggle can be united is based on recognising those common roots of oppression. And that for me is the most important part of this conference. [Applause] I think, speaking from the Latin American community, this is particularly clear for us for the reasons that Nina Lopez-Jones said: that the Latin American continent is a very, very multi-racial continent because of its particular history of colonialism by different European countries.

What I did want to do was just to add to Nina's list of illegalities which immigrant women fall into in their efforts to survive in this country, and another way that women and immigrants are compartmentalised, and that is through the illegality of overstaying, of staying beyond their leave in immigration terms. This is something that becomes more and more common as immigration restrictions grow and immigrants need to survive and to remain in this country. They are forced into a situation of illegality.

Women have been seen particularly to be affected. There have been quite a few campaigns of women recently, of women because they had originally followed a man to this

country and the man has left the country, and the woman is left here, and for various reasons cannot go back to the country she originally came from, particularly if the man is there. She has got kids to look after and remains in this country, and by overstaying becomes a criminal. She is turned into a criminal by the State because it is the State that defines that particular crime, and in the eyes of the State she is a criminal. But not only in the eyes of the State, also in the eyes of other immigrants, also in the eyes of other Black women, also in the eyes of other white women. And I think it's important that this conference thinks about that, recognises that, and whenever there are campaigns that are attempting to regularise the status of women not only on an individual basis, not only to save the one woman from being deported, but any campaigns that many of our communities are trying to fight, against a lot of opposition, I do hope that they will be supported.

NEW SPEAKER I'm sorry, I pushed my way to the front because Esmé Baker has to leave and I particularly wanted to thank her publicly. I'm from Women Against Rape and we helped to organise the picket outside the court when she was being tried for resisting a violent assault on herself, and I think it's important for people here to recognise the job that she has done by coming forward to speak about that, not only here but in the court itself. It takes enormous courage to bring a case like that before the public. They're not uncommon, they are all *too* common, they happen all the time, but it's very rarely heard because for somebody to actually take on the fight of

> **One of the jobs immigrants and Black people have done in this country is to expose the violence of the State against all of us.**

going to court and accusing the police who are accusing you, is an enormous strain. It's been an enormous strain on Esmé Baker, I know it has, but it is doing a job. It's part of the

invisible work that immigrants have done in this country. It's one of the jobs that Black people have done, to expose the violence of the State that in fact takes place not only against Black people but against all of us. Now that's a big thing. What people in this country have been taking for a long time, Black women have actually led the way in opposing, have given the movement pointers — how to handle it, how to do something about it, how to not take it lying down. It is an enormous contribution. Those of us who like myself are in the movement against violence, we have to recognise that that's being done. I think that's very important.

There are other ways as well in which a lead has been given on violence at this conference and by this conference. People have pointed out violence in the family and the relationship of violence in the family to money. That emerged very strongly in the first session this morning. Now in Women Against Rape we've been accused of bringing in all sorts of things, you know, 'what's this got to do with rape, this is an irrelevant issue', 'what does immigration have to do with rape', 'what does money have to do with rape'. I think this conference has made these connections very clear, and the anti-rape movement now has no excuse not to take these things up. The movement, white and Black, has to recognise that one of the reasons people emigrate is to escape violence, but that one of the things that people face when they come here is violence. It's not only violence from the police. The police actually enforce violence committed by other members of our own communities and by members of other communities. Racist violence against us is actually enforced by the State. And the economic dependence of women — the low wages we get, the low level social security and so on — all that is also enforced by the State. That's the violence against women which the anti-rape movement has to deal with. These are issues that this conference has exposed, and I think that it is really vital for us to take them up, if we're serious about confronting the violence that is happening to all women.
[Applause]

NEW SPEAKER I'd like to speak very briefly on behalf of Malika Benkhelefa, a Moroccan woman who is currently under threat of deportation. She is a woman who followed her husband to this country, she didn't choose to come here. The relationship broke down, and because women aren't given any independent status of their own, she is now being threatened by the Home Office and the whole State machinery.

> **The immigration laws are framed so that women have to throw themselves on the mercy of the State, as if it had any.**

She's at the moment going through the legal process of an appeal to the Home Office, which is an appeal on exceptional compassionate grounds, because the laws are framed so that women don't have any right, so they have to throw themselves on the mercy of the State, as if it had any. They have to give every detail of their personal life and their personal circumstances, which they shouldn't have to do. And she's currently awaiting to hear the outcome of the appeal, which will be in about three weeks. If the appeal fails then we intend to apply to the Tribunal, which is the same business but you have three so-called independent adjudicators, and if that fails we intend to campaign on her behalf. So can you remember the name of Malika Benkhelefa. If you want any news about the campaign, she can be contacted through Camden Law Centre. That's where the petitions currently are. Hopefully, we won't have to campaign, hopefully she's going to win first. But it may be necessary to do that and I'd like you all to think of her.* Thank you. [Applause]

MARGARET PRESCOD If you're working with a particular campaign and you are interested in letting people know about

* In June 1983 she won the right to stay.

it, or in setting up a table, maybe putting up a sign where people can speak with you during the break, please go to the reception desk for help.

> **We need each other, to hold hands and to help and support each other in cases like Esmé's.**

NEW SPEAKER I've just got two things to say. The first is, I think this is a fantastic conference. I ran an all-day conference in my constituency in Walthamstow and one of the complaints was: while all these workshops are going on, we're missing the speakers! So it's a no-win situation to run a conference. I think that you've got to accept that.

And the second thing is that without all of your help, Esmé and myself — because I was supporting Esmé and people needed to support me, and we need each other, we need each other to hold hands and to help and support each other, especially over cases like this. I do thank you all. [Applause]

ANNE NEALE Yes. That was Madge Crute who is also involved in Walthamstow Labour Party.

NEW SPEAKER Wait a second . . . and who was determined to get the women's movement involved in Esmé Baker's case, who contacted Women Against Rape and the King's Cross Women's Centre, and who slogged her guts out for this victory to happen. [Applause]

NEW SPEAKER A lot has been mentioned about women immigrating to this country, but I think mention ought to be made of the fact that Black people who are born in this country are getting so pressurised that a lot of us find ourselves pushing ourselves through the education system. For instance I'm doing Maths and Computing and my whole aim is actually to emigrate out of it. [Applause] So that the pressures that

Black women or Black people find themselves under, we have to actually take that into consideration because this country is getting very heavy for Black people, [Applause] and I just thought that maybe a discussion ought to be opened on that.

NEW SPEAKER Hello, everybody. I'd just like to raise a point that Parminder raised, and that's organising on women's issues. I'm from Warwick University and quite recently we had someone from *Race Today* to talk about things, and she was arguing quite strongly that the money that the GLC has at the moment which it's virtually throwing at any minority that can make a good case to have money, rather than being a good thing, is in fact detrimental in the long run. It's causing a lot of what she called the project-hatching schemes. Instead of people really mobilising around issues, which really does get women politicised and does actually make women see that we can actually fight a campaign and in that campaign get politicisation, get awareness and get strength from fighting

> **The money that the GLC is throwing at every minority is detrimental in the long run.**

alongside each other; every, in inverted commas, 'bright, young Black' can get a grant to make a project and they're getting fat salaries off that. And so I want to ask you what you have to say about that, whether you agree with that. Because you were saying that what's important is for more Black women to have access to money. Whereas in fact that really isn't the case because Black women can be bought off, just like anyone else can be bought off. And once they get the £8,000 salary a year — however much goodwill they have at the beginning — give the £8,000 to the people that really need it, instead of fostering a mentality, well not a mentality but just a recipient, you know, people just getting these things, projects set up, and I think that is a point that should be made, that

women have to organise themselves rather than this whole —
well anyway . . .

PARMINDER VIR I think that there's a whole discussion about
taking State funding. I started off working advising artists,
particularly Black artists, as to how they could develop their
work, particularly in relation to State funding. There are two
things that I have to say. One, the money that the Arts
Council and the GLC re-distributes is your money, it's your
money through taxes. [Applause] It's *our* money, through
taxes. It's our money through rates, that we pay day in day out.

> **The money that the GLC redistributes is your money, it's
> our money.**

Up till now Black people have benefited the least from both of
those resources and for the first time in the GLC, in terms of
setting up this so-called Ethnic Minorities Unit, we've got
Black people actually making decisions and saying where the
money is most needed. In the GLC what we've done is to go
out into the community and ask the Irish community, the
Latin American community, we've asked women's groups,
we've asked the youth, Black youth, we've asked a whole
range of groups how they think the resources that we have,
which is just under £1 m., at the moment allocated particularly
for the Black community, how it should be spent.

 One of the things that I come across is, everybody thinks
that he or she is the closest to the community. I go to one
project and they say, 'I'm doing this for the people.' You go ten
yards down the road and you talk to another person. 'Oh, but
he doesn't know what is going on at grassroots level, I am the
person closest to the community.' I think in terms of issues
and campaigns and the type of schemes, etc., that need to be
supported — for me the most important thing is that money
has to be put into areas of unemployment and young Black
people, not giving it to some political activists who've been

around for years and years and years, and who have been saying the same old things over and over again. I agree with all the reservations about taking State money or funding. I think we have to know how we want to use it and where we want to use it and to be aware of all the contradictions in taking that money.

'Is we money, we should take it.'

MARGARET PRESCOD The issue of money — especially when it starts coming into the community — is always a big issue and I have had the experience in the States in the sixties, following all kinds of rebellions, where all kinds of money came into the community. Let me tell you, the movement was very glad to get our hands on it and I think, as we would say back in Barbados, 'Is we money, we should take it'. But if somebody is taking money and then they don't do anything with it, as far as I'm concerned they're pimping on the movement anyway.

But that's not really the issue. The issue is that this is *our* money, and it should come into our hands. [Applause] That's really what it's about.

NEW SPEAKER Hello, everybody. Well, I don't know how to start, it's a long time since I've spoken to a lot of people. I really don't know where to fit myself, because I am neither Black nor white, I'm somewhere in the middle. But well, I suppose I think I belong to the Third World where our feelings are sort of attached, I suppose. And as a Third World person, knowing the history, and I think history is very important, we know for how long we've all been oppressed by the white capitalism. Well, I won't try and make it too political, but something attracted me to Black people and the whole cause.

Some of the very horrifying stories that I've heard happened in this England, you know, the imperial England we think represents culture and education. Well, two of my friends, they were a couple, they were art students. He was a

Czechoslovakian Jew and she was from Trinidad, and they lived in Walthamstow a few years ago. She was pregnant, and they happened to live in a neighbourhood where there was a lot of bad feelings between themselves and their neighbours — well, racism, yes, plain racism. Well anyway, one day a fight

> **I thought, well, I don't have to be involved in anything, it doesn't concern me.**

broke out between the couple and their neighbour who was a big, fat, heavy guy. But he started a fight and during the fight the whole neighbourhood came to watch them fight, you know. But nobody lent a hand, nobody rang the police, they seemed as though they were enjoying a sort of sadistic scene. Well this woman was pregnant, and the man was told that she was pregnant, but he took her up by her long hair and swung her round and threw her down on the ground.

Well anyway, what happened was the whole thing went to court, but they lost the case. Could you imagine, they lost a case because, well, it was a complicated thing — it would take a long time to tell the whole story, and I'm getting nervous because I'm thinking of the time. But it just showed me, it was one of the first real life stories that I've ever heard. Before that I was not aware of racism, you know, it was a personal fight for me. I thought, well, I don't have to be involved in anything, it doesn't concern me, I know what it is, and I know where I am going to put my energy, and that was sort of enough for me. I don't know what brought me here, I think it's because I saw the poster. Perhaps I'll see you all again. Thank you.

NEW SPEAKER I think one thing that this conference has raised, among other issues, is how do Black/Brown women, or women from Third World countries, maintain their roots, sustain their nationalistic sentiments, even when in a foreign country. It is very easy for us when we come to a foreign country to get dazzled by all the wealth, all the goods, which

back home we have been flooded with information about by all the big foreign companies. And why is it necessary to maintain our nationalistic sentiments? Because the problems that we face here, the problems of migrant women here, are rooted also in the problems back home. And when I say that, I speak from my own experiences in my country.

> **How do Black/Brown/Third World women maintain their roots, sustain their nationalistic sentiments, even when in a foreign country?**

In the Philippines, we have been taught to be second class people to all the foreign colonisers who came to my country. Before the Spaniards came in 1521, the women occupied a very high position in the communities, in the tribes. They were the priestesses and their people followed them; they were the wise people of the communities. And when the Spaniards came in 1521, they found them as powers to struggle with, and so they said that these women are bad, these women are witches, these women are evil. And they taught the Filipino women to be submissive, to be timid, to be subordinate, to follow their husbands' wishes, and when this happened, it was to pacify the people, to make them accept the Spanish colonial rule.

But we were able to overthrow them, after which the Americans came. The Spaniards came for 300 years, and then the Americans came, bought the Philippines from the Spaniards for 250 million dollars or something, and then they taught us how to copy the American ways, to put on Max Factor or Revlon lipstick and to bleach ourselves, [Applause] to make us white, you know, because to be Black or to be Brown is not being beautiful. They taught us that to be beautiful is to copy the Americans. So that even the magazines, in the adverts, you see white women; even the films, you see white women, Mestizo-looking women, who look more like foreign actresses, like Sophia Loren or any of

those Godard actresses. So these are the things which prepare a woman, even for a life outside her own country, and this migration is only traceable to the same roots, this kind of colonial mentality which the foreign colonisers have instilled in the minds of our Filipino women.

But when the Filipino women come here to work — OK, so they earn a pittance, but still it is something grand to tell the relatives back home: 'Yes, I am here in London, I am here in Paris.' But they keep to themselves how humiliating, what kinds of conditions they suffer from here. They cannot even pay their bills, their electric bills. They suffer from deportation cases, they cannot bring their children over here, and they have all sorts of other problems. But still it's a whole kind of consciousness, starting from our roots, back to foreign countries, which these big multinational companies are trying to inculcate and to sustain in the minds of the Filipino women. [Applause]

> **We would like in the Philippines to be informed of what struggles other women are conducting.**

And I would like to say that this conference is one step forward for all women of the world to maintain contacts with each other, that we should not be afraid, that other women in other parts of the world are conducting their own struggles. And we would like for us in the Philippines that we should be made aware, we should be informed, of what struggles other women are conducting in their own countries; what we can do as women, what kinds of powers we have; and especially we should have information also about how the Cuban women, the Nicaraguan women, the Vietnamese women and all women all over [Applause] are doing to liberate their countries. That's all. Thank you.

NEW SPEAKER What I have to say is very short and very simple. I'm talking about professional sexual harassment. I am from

the Bahamas and I have been in this country two years previously, and this year I'm here only a month. I am a journalist, and I worked at the radio station in the Bahamas. I have come over here and am writing articles about the Bahamas from a cultural and historical point of view, telling people that the Bahamas is not just an island or a country of maids and bellboys. It is a country composed of people who are very culturally aware and would like to know more about what's happening with other people in other parts of the world.

> **Editors, journalists say, 'Yes, we'll publish your story.' And the next thing you know the damn man wants to bed you.**

Professional sexual harassment, that is something very hateful for me because I am young, I am qualified, I have the information and I meet various people, editors, journalists, whoever, who say, 'Yes, we can help you, yes, we'll publish your story.' And the next thing you know the damn man wants to bed you. I'm not into bedding. If I want to bed someone, I'll choose that person. [Applause] And I want to ask if anybody on the panel can answer me: is there some way that I can deal with this problem without harming my chances of getting a job? Thank you.

MARGARET PRESCOD There are some women here from Women Against Rape who I know have been dealing with these issues, and there may also be other women here from other groups who have been dealing with sexual harassment on the job. So if any of you do have information that would be useful, again you may be able to use the poster paper and put up something saying 'sexual harassment', where you will be able to get together after and organise something.

NEW SPEAKER Hello. I'd just like to say while you're fighting

colonialism in this country, both colonialism on the basis of colour and of sex, please don't forget those countries which are left trying to sort out the mess that British colonialism has made. In this case specifically Australia, where the Aboriginal people are fighting for their right of self-determination [Applause] and for their land, which is the basis of all their culture and their religion. And if anybody wants to know more about this, could they please get in contact with the Aboriginal Commission to Europe, 12 Barnfield, Upper Park Road, London NW3. Thank you.

I want to speak about what I gained in immigrating, about the way I viewed my body.

NEW SPEAKER I just wanted to speak about one of the things that I gained and no doubt other women gained in immigrating, in regard to the way that you view yourself. I'm talking about the way I viewed my body. I had always hated my body proportions, all my life, and I spent many, many hours, when I was a teenager, up to when I came here, which was when I was twenty, really wanting blue eyes and blonde hair. I mean I had an obsession about it. And that was because I come from Italy, and you know there's a lot of immigration going from the south of Europe to the north of Europe where the money is, and where most of the blonde people are also, and so I wanted the money really and not the blue eyes!

Italy is very mono. It was always mono-colour, you know, a white country. I had no idea that there were so many people who aren't white, which is most of the people in the world. And who are not blonde. So my view of my body proportions changed completely, and I could relax for the first time.

An immigrant told me that London is a window for the world, which it is in fact. But at the same time I had the shock of my life on the question of the language because, well, I couldn't speak the language and it took me a while to learn. Which means that you are invisible, you can't talk for a

number of years. You can't express humour, maybe you used to make big jokes, you can't express anything. Even the way you keep your face, a lot of people don't understand your facial expressions, and you get into trouble that way. So that you remain quite invisible.

But the fact that I couldn't use my mouth was really a big shock, because it was really the only instrument that most poor people have in our life. Not the only one, but one very big one. We might not have the money but we have the mouth to speak. And when I didn't have it, it was a shock.

The other thing that I wanted to say was that we are here today to get together because we have been divided across nationality and racism and many other lines, and we are trying to get together and organise. We are organising right here, but in fact I wanted to point out that even when we were in our own country, and even in situations of real isolation, we were really still in a way working together. For example, as a child, as a white child, we didn't get much news, but one day on TV I saw some riots, and that was the Black movement in the US, and that was an enormous power for me to see people smashing windows and setting the ghettoes on fire. [Applause] And I think it was an enormous inspiration for everybody in the world. And because as a child I always thought that I was a slave, but people weren't really saying it. So when I saw the Black movement I was very glad.

> **If you can't speak the language, you can't express humour, you can't express anything. You remain invisible.**

So what I am saying is that we manage to get information about what other people in the world are doing through other means also, like music. So we are getting together, and we have been getting together, although sometimes it does not appear that we are getting together. [Applause]

ANNE NEALE We announced earlier that there are some

resource people, who in fact have spoken during this session, and if anyone has particular questions that they'd like to ask them, they will be at the reception desk during the tea break.

MARGARET PRESCOD If during the tea break anybody would like to get together with other people to discuss sexual harassment or a particular campaign, maybe you could make an announcement now about it or please put a sign up.

[Tea]

SESSION 3
Claiming our rights

WILMETTE BROWN Let me introduce the women who will be chairing this session.

Solveig Francis is the co-ordinator of Housewives in Dialogue which put this conference together.* Solveig was born in Britain but grew up in Zambia. Unlike many southern Africans who, although they are born and brought up in Africa, continue to define themselves as Europeans, some white people in Africa not only consider themselves Africans but are also fighting against race being used to divide people, in Africa and throughout the world. And Solveig Francis is one of those Africans. She was the first co-ordinator of Housewives in Dialogue and a key person in creating and developing it.

Co-chairing the session with Solveig is Selma James. Selma is perhaps best known today as the founder of the Wages for Housework Campaign and as a spokeswoman for the English Collective of Prostitutes. But she has a long history in the women's movement. As far back as 1953 she was the author of a pamphlet called *A Woman's Place*, † which described the life of working class women like herself in Los Angeles, and that

* A month later, from December 1982, Wilmette Brown became, with Solveig Francis, joint co-ordinator of the King's Cross Women's Centre, which is run by Housewives in Dialogue.

† Republished in M. Dalla Costa and S. James, *The Power of Women and the Subversion of the Community*, Falling Wall Press, 2nd edn. 1975.

statement is still very relevant and very much alive today.

In addition to her history in the women's movement, Selma has a long history in the Black movement. She has lived in the West Indies, in Trinidad, and was active in the fight for West Indian federation and independence. In this country where she has lived for many years, she was the first organising secretary in 1965 of the Campaign Against Racial Discrimination and was a founder member of the Black Regional Action Movement in 1969 and editor of its journal, *The Black Ram*.

The conference so far has been a speakout about how we struggle and how we organise.

SOLVEIG FRANCIS We come to the final session of what I personally have found to be a very thrilling conference, I must say. And I think one thing that has come out in the first two sessions is that it has been a conference about women's struggle; about our struggle as Black women, English or immigrant, and as white women, English or immigrant. The first session concentrated on 'Back Home', and really that was about our struggle to come here, and how we did it. The second session was about our lives and struggle here. And the conference so far has been a speakout, and sometimes it wasn't a question of just story telling; it was actually speaking about how we struggle and how we organise. This third session is going to be about how the struggles are being waged now, how we are claiming our rights now.

SELMA JAMES There will be five speakers and I have promised to keep them to ten minutes. Our first speaker is Winifred Blackman. I have to say first of all that I am very glad that there is an older woman as well as myself on this platform. Older women don't get too much of a look-in and we are determined to change that.

Winifred Blackman began nursing in 1937 and was the

second Black nurse in Britain — I am corrected: she was the first; the other one was Haile Selassie's daughter, she says. But she's getting into her speech already! She's a mother and a grandmother, and a fighter, and a lesbian. Winifred Blackman. [Applause]

WINIFRED BLACKMAN Hello, gang. Excuse me if I'm a little tired, I've been in bed for three days and only got up yesterday, and I've got multiple sclerosis, so this is a very long day for me. I've come from Epping Forest and it's the first time I've been able to attend anything for seven years. But that's by the way.

I first came into any of the movements when I met Peter Blackman,* who some of you may have heard of. He was on *Everyman* [a television programme] some time ago. I divorced him, but that's neither here nor there. The point is, at first I didn't know any Coloured people. I was born in London, my mother was white, my father was killed in 1918, so therefore I did not know any Coloured people.

> **My mother was young, blonde, English, and it was 1919, and she was stoned because she had a Black baby.**

It would be stupid for me to say that I went through the traumas of being Coloured. Where I grew up they knew me from a baby and I was spoilt, not by my mother but by a great-aunt. My mother did not bring me up, I think she was horrified. When the First World War ended, she was walking along the street with me and she was forced against the wall. She was young, blonde, English, and it was 1919, and she was stoned because she had a Black baby. So she left me with my aunt, my great-aunt, who also had four Coloured children. She

* Born in Barbados, Peter Blackman was a prominent spokesman for and pioneer organiser with Black People in Britain in the 1930s. A leader of the Negro Welfare Association, he edited (1938–39) *The Keys*, newspaper of the League of Coloured Peoples (see footnote on p. 144).

was English and she had married my father's uncle. And my mother didn't want to know about having a Coloured child. She used to come and see me but she didn't live there. But this I don't blame her for because you must remember that it was in 1919, before you were even twinkles in your parents' eyes.

So the point is I understood that but I was surrounded by a lot of love until I was nine years old when my cousins were all grown up (they were a lot older than I). They had a very small flat and so my mother was asked if she would get a place for me to live, she didn't want to, and I was put in an orphanage. I was there until I was thirteen years and eleven months, when I was put into service.

Well, in the years that I was at the orphanage they had no teacher there, so we did not get any schooling. Any that I knew I'd forgotten. I was in service for quite a long while. I learned how the rich live, how to lay tables, how to behave when I entertained, which was just as well because when I was Peter Blackman's wife we entertained people like Stafford Cripps and Creech Jones, all the parliamentarian people. But this was going on a bit.

I was the first Coloured woman, London-born Negro girl, to be accepted into the nursing service of England.

Before that I went into nursing. I got in because I was a maid to Sir Reginald Kennedy Cox, who was then Chairman of the London County Council. He liked me, I told him what I wanted, he said if I'd like to go to night school and try and get a London Matric, he would try and get me into a hospital, which he did. And Matron Wilkinson at the Plumstead Hospital said she was willing to take me if I could make the grade, which I made it my business to do.

But what I want to point out is you say that this is fighting. They've got here 'Fighting as a Black woman'. Well I had to do *everything* — I was a vanguard, a leader, the first Coloured

person, they put it in all the papers, they made a great fuss about it. I was the first Coloured woman, London-born Negro girl, to be accepted into the nursing service of England. I was the first non-grammar school child to be accepted into the nursing profession of England. So you'll understand they wanted to make a lot of it. Even then, they were no different to the way they are now. They thought it was a huge thing to put around.

> **I'd never met a Coloured man, let alone gone along to meet them at a meeting.**

And incidentally, when my mother died I found all the cuttings among her papers. But my mother and my family all said, you've had no education, you're only a servant girl, you'll never make it. So I had to prove myself to my white relatives, which meant that when everybody else was in bed at nine o'clock at night — we used to have to be in bed by ten in the old days. The youngsters have no idea what nursing was before the Second World War. But the point is we had to be in bed, the Home Sister came down and searched the rooms to make sure that you were in them at ten o'clock at night, lights out. And when they were, I used to get under the bedclothes with a torch until three in the morning to make sure that way that I was better than anyone else, not because of brains but because I had to. I'm that kind of a person, I *had* to be better. I was able to pass through all my exams. Second, third on exams all the time.

I had met Peter Blackman when I was there. The war started while I was nursing, and they decided they needed more nurses and it was then that they decided that they would have a few nurses from the West Indies, Coloured girls. But they had to come from certain homes. Afterwards anybody could come, but in the beginning, they had to be people whose fathers were judges or lawyers, or whose brothers were at university, that type. Well, one of these ladies came over to

my hospital, we became very friendly, and she belonged to
the League of Coloured Peoples run by a certain Dr. Harold
Moody.* And one day she was told that she was on duty and
she had the minutes of the meeting, and she asked me if I
would take them to the meeting for her. Well, they were
mostly university students here at that time, and I went full of
trepidation. I'd never met a Coloured man, let alone gone
along to meet them at a meeting. I went there and when they
saw me walking in, they'd never seen me before, they didn't
know who I was, and there was a great deal of curiosity. And
Peter Blackman was the secretary so I gave him the papers,
and so he invited me to the cinema, and one thing led to
another and I was entering into a Black community.

I was unfortunate or fortunate, whichever way you like to
put it, because I met all students from the Student Movement
House, university people. They were the only [Black] people
except for people at the docks, the seamen, who we didn't
meet, not because we were snobs but because we just weren't
there, if you understand me. It wasn't where I lived. But
anyway one thing led to another and we did get married and I
had to wear my wedding ring round my neck because nurses
were not allowed to be married until six months after war was
declared. Then the matron called me to her office. She said,

* The Jamaican Harold Moody (1882–1947) qualified as a doctor in
London in 1910 and was swept into serving the survival needs of London's
Black population. He founded the League of Coloured Peoples in 1931 which
declared its aims to be primarily 'To promote and protect the Social,
Educational, Economic and Political interests of its members' and 'To interest
members in the Welfare of Coloured Peoples in all parts of the World'. The
League's newspaper, *The Keys*, was used by many strands of the anti-colonial
and anti-racist movements in Britain in the thirties: there were few other
outlets for Black voices. See Peter Fryer, *Staying Power – The History of Black
People in Britain* (Pluto, London, 1984), for a good summary of the presently
known Black men and their activities during that period. Win Blackman's
speech gives some indication of how much work women did and how
invisible their contribution still is. As women's unwaged work comes to be
recognised and counted, the quantity of many women's typing, cooking and
other apparently personal services will emerge like an iceberg in an ebbing
tide.

'Well, Mrs. Blackman, you can take your ring out now and put it on.' I didn't know anybody knew; apparently everybody in the whole hospital knew. I got married in five nights off and that was it. Walking round in the delightful feeling that matron didn't know, and they were very strict, the matrons then, but she was always very sweet to me.

Well, through Peter Blackman, who was greatly into politics, every kind of politics, I met lots of leading lights in the political field, Coloured political field. True, I was his hostess. But I could listen. I wasn't allowed to join in, I wasn't allowed to say anything, I was only a woman and they were worse than they are now, I mean I could have been in purdah. But I learned a lot and I met a lot of people. I'm not going to say that I actively took part in any of it. I used to go to meetings with him. I used to meet them at the house. One thing led to another, I brought my children up. I was too busy nursing to go into anything else. I met a friend: we had agreed to differ very early on in our marriage, but we stayed together because of our children. And it wasn't until my daughter got married, the last of my children, that we decided on an amicable divorce. But that's again by the way.

> I said, 'I don't like being pushed about, I don't like being pulled about and I don't like being raped.' She said, 'You're gay.'

What actually happened was, whilst I was nursing at the Royal Free, I met a youngster there and she said to me, 'You're gay.' I said, 'I beg your pardon?' She said, 'I can tell, you don't like men, you don't like your husband,' she said, 'and we get on well together.' I said, 'Well, what's that got to do with it?' She said, 'You get much better with women, don't you?' I said, 'Yes, I always have done.' She said, 'That's right. Didn't you say you had not slept with your husband since 1948?' I said, 'Yes. I don't like being pushed about, I don't like being pulled about and I don't like being raped.' She said, 'You're

gay.' [Laughter and applause] And I was forty-two years old.
And she was right.

She took me to a gay club, to the Gateways Club, I met a lot
of gay people there. I was the only Coloured one, I'll admit,
but I was very well treated, I made lots of friends, whom I still
have.

And now I'm going to put in a moan. I sent a letter to the
Black lesbian support group early this year. Now this is a
moan against Coloured people, my own kind. They came, I put
on a very good dinner because I was taught how. They were
full of enthusiasm, young people, went away, said, 'We'll send
you all the information, we'll do this, that and the other.' I
heard nothing. I phoned three times and got very off-putting
replies. I wrote two letters to their organisation which they
didn't answer. I can only assume that when they saw I was an
elderly woman in a wheelchair, they didn't want to know. So
how can we expect other people to mind what we do when
our own are not interested in their own elderly people who
were the fighters that made it possible for them to come out in
this country? Thank you. [Applause]

> **I believe you have to begin with women in order to build
> the International, the International we heard this
> morning.**

SELMA JAMES We have just heard a little bit of the continuity
that we need in order to know that it didn't all begin today. It
started a long time ago, and we are the inheritors of
everything that has gone before. Our mothers have done a
very good job. [Applause]

On the other hand, I was very moved this morning, because
my dream is always the International. But I believe you have
to begin with women in order to build the International, and it
was that International which we heard this morning. Our next
speaker is Angelika Birk from Germany, who is also making a
contribution to our building the International today. She is

from the Wages for Housework Campaign there, and now the
Green Party, which some of you may know about. She'll tell
you something about it herself.

ANGELIKA BIRK I have to give that thank you back to Selma
because it was also because of the English Wages for
Housework Campaign that I am in England. Selma visited us
two years ago in Hamburg where I am living. And there I
came into contact with the Campaign and I was impressed,
because it was a conference something like this, full of women
telling about their lives and telling their experiences in trying
to get their own rights, and therefore I joined the Campaign.

> **The government of Germany, one of the richest in the
> world, has no money to pay teachers to teach immigrant
> children.**

I am twenty-seven years old, I'm German, I belong to that
nation which has a very dangerous and dark history; you
know, all this nazism and international wars; and this is the
first time that I see you all here, women of all sorts of nations,
and it's an overwhelming moment for me.

I am an unemployed teacher. The funny thing is that the
government of Germany, one of the richest governments in
the world, has no money to pay teachers to teach children, and
to teach foreign and immigrant children; and therefore we
teachers are sent all over the world to teach there in a
colonialist way and that's a struggle we have as young
teachers not to do this, not to be sent all over the world to
teach to the old imperialist tune.

I want to tell you something about why I have come to
Wages for Housework and how the Green Party is dealing
with the problem of immigrants. First of all I have to say
something also about my mother, like Graziella. My mother
was always fighting to make me a good housewife and at the
same time to get rid of it, because she herself hates to be a

housewife, she hates to be considered as a very, very low person. And her whole life through it was a struggle to show me something of her own strength and to show me how to do the housework and to get rid of it at the same time.

At first I thought it was the problem of my father because he was doing nothing in the household. But I came to the conclusion it's not only the problem of somebody not doing it. It's the problem that this work is not recognised and is not paid, and you have the problem in all sorts of communities and in all sorts of liberal people's houses. Because also the Left people and the people who consider themselves as very wise and emancipated, they have also this housework problem unresolved. And therefore I joined the Campaign to do something against it. [Applause]

> **To make contact with Turkish women, we invited women to do the housework together, some cooking or some sewing.**

You know, we had a lot of immigrants in Germany, they came for work after World War II. They were coming in former times also. But I am talking about those who came during the last thirty years. They came from southern Europe and from Turkey. And first only the men came because there were only jobs for men. Then they were allowed to let their family come because the State thinks it would also be good to have women as low paid workers as well in our country. But now we have also a big crisis, and German workers and German politicians have become more racist than before, because a lot of people fear to lose their jobs. They think, all those foreign people, they take our jobs; and therefore we have a lot of problems with racism also against the women.

Our main problem, for instance, is that a lot of women, immigrant women, have no opportunity to be visible as you here are. That's a very big problem, also because for people like me who want to come into contact for instance with a

Turkish woman, there is no opportunity. Women hide in their houses because it is very dangerous for them to come out. And I want to tell you some opportunities we made to meet.

One opportunity is to invite other women to do the housework together, to do some cooking or to do some sewing together and to talk together by that occasion. It's a sort of trick to get rid of the husbands and to talk to one another! [Applause] And we started it in one part of Hamburg and we tried to build up a sort of information system in that way.

And we realised that a lot of problems that foreign women have in our country is the problem with the education of the children. Because the children are in German schools and there is a lot of racism, they cannot speak the language and so on. And so we have to fight the German school system and to do something so that all children can learn together. And one problem that we have is that the classes are so big, twenty or thirty children, so nobody can learn well. And one fight that we have together with immigrants and non-immigrants is to have smaller classes, so that there is more time for every pupil to learn and more time to chat together, and I think it's a good chance to do something against racism. The government wants to put children of the immigrants in separate schools, like disabled people, and we are also fighting against different schools and separate schools for disabled people. We think all people should learn together.

And it was a chance for the Greens to say that in Parliament also, and we got a new sort of section in Parliament — we have sections for traffic, for ecological problems and so on, in the Parliament of our city; that is to say, the problems will be treated there first and then they will be treated in public.* It's a sort of preparation for later legislation. And we have now five new

* A section is roughly the equivalent of a committee for the Greater London Council, though the Hamburg Parliament covers a larger area around Hamburg than the GLC does around inner London.

sections, and one is to treat problems from women's point of view. That is, a new section which has never been before, a section for women's rights, and every new law has to pass this section before being accepted. The second thing is we have a section for immigration laws and for immigrants' point of view. That is also very new, because it has never been before in a Parliament a section which says we have to make laws for equal rights for immigrants. We are now in Parliament only for some months and it's only a little bit that we have done, but I hope we can go forward in this way.

It begins with beating down the rights of immigrant women, and then of every woman in Germany.

I think I have to say one thing about the political refugee and the economic refugee. Our government has understood that to fight all sorts of refugees and immigrants they have to put the finger on the economic refugees. It is forbidden in our country to be an economic refugee. Imagine that they shut the borders for the immigrants and they say nobody who is an economic refugee has the right to come into Germany. And they do that to kick out all the women and all the children of male immigrants. They only want those who are healthy, who have jobs and so on, and they want no-one to come in, neither political nor economic refugees, and that's the big thing we have to fight against. Because if the government can beat us down in that way, it's the way back to the old nazi system that we had once before.

And it begins with the women, with the beating down of women's rights, the rights of the immigrant women, and then it gets worse and worse and it will also beat the rights down of every woman living in Germany. And therefore I think it's my task also as a Wages for Housework Campaign woman in this Green Party to put the finger on this thing and to fight for equal rights for immigrants in our country. [Applause]

SELMA JAMES I neglected to mention that Angelika is an elected member of the Hamburg Parliament, the Campaign's first elected member. A feminist representative who wants the money from the State for all women, not only for herself, is a very dangerous person!

Our next speaker is a woman who is threatened with deportation, but is fighting it. She lives in a Leeds Women's Aid refuge and has honoured us by coming here today to tell her story and to tell how she is the focus of the fight to stay, which in very crucial respects she is leading. Her name is Halimat Babamba and she is from Nigeria.

HALIMAT BABAMBA Hello. My name is Halimat Babamba. Babamba is my surname. It belongs to my husband — I'll soon get off it! [Applause] I'm a Nigerian. I came here in 1980 to join my husband. He was a student at Leeds Polytechnic. We got married in October 1977. Obviously I don't like the man, I don't want to marry him, it was because I don't want to disobey my mum because she loves me, and I love her. And the rule in Nigeria is that you must do what your parents say, until when you are mature enough to stand for yourself as I am today. But when you are under age you must do as your parents say, you have no choice for yourself. That's what I did.

After about three months the violence started, no talk of getting married, he beat me up before we even got married, you see. But we did get married. Two weeks after the wedding I lost me mum. Anyway my dad, he died long ago when I was young, so that was it.

I'd been having problems with my husband right from Nigeria. When I was expecting the first baby, he beat me up, I lost the child. The second baby is here now, his name is Hakim, he will be four years old in December. He is supposed to be the second baby and now today he is the first child. The second child is Mustapha, I left him in Leeds, a friend is taking care of him.

My husband came here in January 1979. The reason why I

joined him is because a friend thought if I joined him in this country, you know, a big change from this violence all the time, you see, but no change anyway. When we came to Leeds the problem continued, beating me up, he don't care about the children, or disturbing neighbours, or policemen called in all the time. I'm fed up, I'm fed up, I don't know what to do because I have no relatives in this country. I have no friends, I don't know where to go and he wants me to move out without the children. He wants to get hold of the children and I am not ready to face that. He says, 'Why don't you move out? Move out, I don't want you any more.' I said, 'No, I want to stay with my children, I can't move out without them.' And he locked me in for three days, he wouldn't let me get out at all, not even boiling the water to make the baby's bottle, no chance for that.

After all my face was bruises and no help from the policemen, because they are the next people I could turn to, no help from them. What they say is 'Don't disturb the neighbour any more. If you disturb the neighbour, I will lock both of you up and take your children off you.' And my husband says, 'Yes, you see, they are going to lock us up and take the children.' He's ready for that. And I say, 'No, I am not ready to face that. These children, they are my children, they are my blood. If you don't care, I will care for them.' But I can't move out because obviously I don't know where to go, I'm still there. He says, 'If you don't move out, I'll kill you. Unless you do that, the problem continues.'

You know, I work part-time. It's a long story. I just want to tell it briefly, because I know it is important for you to know what women face from men. He says, 'You can't go to work and there will be no more nursery for the children. You are not going to take the children to the childminder for you to get to work.' He went to the day nursery where my children go to and he asked that headmistress in that nursery to stop my children coming to the nursery. The lady told him, 'I can't do that unless your wife tells me or you two agree to that.' So he went to the Social Service and asked them to stop my child

benefit. He says, 'She is my wife, who's here on my behalf. I don't want her to receive any child benefit from you.' And they said every child in this country is entitled to child benefit.

And then he turned to the Home Office and asked them to have me sent back to Nigeria.

And then he turned to the Home Office and he asked them to have me sent back to Nigeria. Because I came here on his behalf. The Home Office says there is nothing they can do until when the visa runs out and that is when they will come in. Then he turned to the Nigerian Embassy to have me sent back. Why is he doing all this? Because he has tried in this country to take the children, there is no way that he can do it, but he can do it in Nigeria. That's why he wants me back in Nigeria, to take the children. I believe that there is no life for me without my children. Why am I suffering? It's because of the children.

So then there is nothing for me to do but to call the Social Service and let them know about my problem and they suggested why didn't I go to this Women's Aid in Leeds. I had no idea if there's any Women's Aid, because I stayed with my husband as a prisoner.

Right, so they ring up the Women's Aid and they come down for me, and that is when I am able to move out with my children safely from my husband.

Now he's back to Nigeria. Why he went back, he is thinking, there is no chance for her to stay in Britain, they are going to send her back, they are going to have her deported back to Nigeria. He is just waiting for me to get back, and when I do, he can take the children from me by Nigerian law.

Now I am here to fight. I know with your help I'll win my case to stay here safely with my children. I've applied to the Home Office to have my visa extended but it has been refused. I'm appealing against the decision. The campaign is

> **I will fight with your help. With women's help, I'll win the case.**

going on now in Leeds. I am centrally involved in my campaign. [Applause] Also there are friends, white friends as well as Black, the people working at Women's Aid in Leeds, they organised the campaign for me. But any meeting, any conference, any organisation, I am ready to go there to fight. [Applause] I will fight with your help, with women's help — I'll win the case. I hope I will, with your help. Please, write a letter to the Home Office, my MP Stan Cohen, Denis Healey and all your MPs, whatever the party. Please sign my petition, send us a donation. Take some of my leaflets and give to your friends. Let them write to the Home Office. Please, there are many ways that you can help me, and I know that you will. Let's get together and fight. We have received enough from men — harassment, violence, everything. Enough is enough. [Applause]

SELMA JAMES First of all, that is the collection box for the case. The second thing is, the Women's Centre from which this conference came is just down the road. We are quite happy to be the centre for the distribution in London of this petition, and of any other information that you as the central person in your campaign wish us to circulate on your behalf.

SOLVEIG FRANCIS I'd just like to add that the petition that Halimat is talking about is on the table over there, big piles of them, so people can take them away today. Can everybody sign them before they leave the conference.*

SELMA JAMES O.K. We must move along while the money is

* In 1983, Halimat Babamba, whose stay in Britain was dependent on her remaining with her violent husband and who was threatened with deportation when she left him, won her right to stay in Britain.

jingling. There are two more speakers, both quite dynamite. The first, Ruth Bundey from Leeds, is the only white English woman who has been asked to speak on a panel today, and it's not because we didn't want to hear what white English women had to say, but this was a speakout first of all for Black and immigrant women. And I must say, in my experience, Black and white women get together best when Black women are in the majority, as they are today. [Applause] Ruth Bundey is the kind of woman who recognises that, and for that reason she is a weapon for all of us in our struggle. She is one of those rare birds, a lawyer you can trust. Ruth Bundey.

RUTH BUNDEY I've been asked to say something this afternoon about the Bradford 12 trial and campaign, which took place this year. It's a difficult subject. It's almost like buying a record: you buy it for the A side, you sit down at home, you listen to the side that you bought it for and then you turn the record over and it says 'Version'. There are a number of versions of this trial, there are a number of truths about the trial and the campaign, all of which can co-exist. All I'll try and do in this very short time is to draw out a few things which can be said about it and which I think we can learn from.

The State was quick to exploit differences in experience, age, politics – to turn defendant against defendant.

I think most people here know what caused the arrests of the people who became known as the 'Bradford 12'. But very briefly, a week after the skinhead invasion of Southall [West London] and after a week in which there had been uprisings up and down inner city areas in July 1981, a group of young Asians in Bradford heard that there were skinheads coming up the motorway in coaches to attack the Asian community in Bradford, and they therefore took measures, by way of making petrol bombs and storing these for attack upon the

skinheads if they came. They didn't come, and those devices were later found by the police and twelve people were subsequently arrested.

The first fact that had to be contended with was the diversity of those defendants. Most had been associated in some way with a breakaway organisation called the United Black Youth League which was very young, it was in its infancy, but it was a very important small struggle because it was the first attempt in Bradford to break away from more traditional Asian organisation. It was an organisation which said it was not going to take State funds, a subject which has been touched upon this afternoon, and it was in the process of attracting a membership. And therefore when the police got their hands on these twelve defendants, they seemed to think: We have not just got twelve Black individuals, we have actually got here a Black political organisation that needs to be smashed, however young it is. And because that organisation was at such an early stage and because the people in it were at different stages — some were seasoned political campaigners who had worked on the Anwar Ditta campaign, Nasira Begum campaign, Jasvinder Kaur campaign,* all sorts of other campaigns in the North and the North East; others, younger people perhaps, had only been to a couple of meetings, a couple of marches — when they got arrested the police and the State were very quick to exploit these differences in experience, and tried to turn defendant against defendant, in terms of age, in terms of politics and so on. And so did the legal machine.

* Anwar Ditta, born in Britain, went to Pakistan where she married and had three children. She later returned to Britain with her husband and had a fourth child, but her three earlier children were not allowed to join her. For over five years she fought against Home Office refusal to recognise that the other children were hers. She finally won and the children were allowed in to Britain in 1981.

Ms. Ditta was the first Black Third World person involved in an immigration case (as contrasted with Rudi Dutschke, for example, the German student leader who as a very sick man was deported in the 1970s) who succeeded in building a wide campaign involving among others the Labour Party and trade unions. It is significant in this connection that she was

And we had a situation at the beginning of the case where I was in court week after week attempting to get bail, acting for the four who perhaps at that stage, I don't say now but at that stage, seemed to be the most political ones. The other ones had been given lawyers by the police or the police had suggested to their families which lawyers they should have.

> **There was an enormous court presence for every hearing, which in the end gave the defendants themselves solidarity.**

And we had a complete divergence and conflict in court every single week, whereby whatever I tried to do in terms of reflecting, however feebly, what the defendants I represented wished to be put before the court, in terms of what they had done and their attitudes and why they had done it, some other lawyer would jump up two minutes later and say, 'I wish to dissociate my client from this political diatribe. This is not a political case, this is a criminal offence. My client is ashamed of what he has done, blah, blah, blah.' To wide eyes from the dock, from this particular defendant who had never told his lawyer to say anything of the sort, but whose lawyer was taking over in the usual legal style. So this was a nightmare and this was the beginning of things.

But luckily in stepped support, in stepped a local campaign and, thank goodness, a national campaign. There were

born here and was fighting for her rights as a British citizen rather than as an immigrant.

Having set a precedent, Ms. Ditta has put her considerable experience and speaking and organising talents at the disposal of many campaigns since.

Nasira Begum faced deportation on the grounds that her marriage was not legal. Her campaign, begun in 1977, won her the right to stay in 1981, despite a vindictive Home Office campaign against her: both the adjudicator and later the Immigration Appeals Tribunal sided with her.

Jasvinder Kaur faced deportation and separation from her Bristol-born child, first because of her husband's illegal immigration status, then when she left him because of his violence against her and their child, on the grounds that she overstayed. She won the right to stay in June 1981.

problems in Bradford because, as I've said, of the split in terms
of age groups within the Asian community itself; that was
later to resolve itself to a certain extent. But thank goodness
there were people who came from the King's Cross Women's
Centre, from the movement here. There were people who
came all the time from Southall and other parts of London.
And there was an enormous court presence every time there
was a hearing, which in the end gave the defendants
themselves a sense of the solidarity which was coming from
outside. And the defendants themselves began to take
political decisions and actions in that courtroom: when they
saw what a farce this bail application thing was, that they
weren't going to get it, they refused to come up into the dock.
That may be something standard in London. I can tell you that
in Yorkshire the magistrates had never seen an empty dock
and people who refused to come up.

**The issue of the trial was that Self-Defence Is No
Offence.**

When they did come up there would be interventions,
there would be shouting from public to defendant, and so on.
I remember one particular week when there was a whole load
of what I thought was political invective in Punjabi coming
from the dock and people were going down with their hands
in the air and so on. I said to one of them afterwards, 'Fantastic.
What did it mean?' And one of the guys said, 'I was telling my
family when they come on Saturday to bring a chicken.' Well
it didn't matter as far as the magistrates were concerned, they
heard something they didn't understand and they were
frightened, and as things progressed they began to be very
careful what they did with the case.

In terms of the campaign, there was one decision that was
made I suppose at a fairly early stage which has come in for
criticism and I think rightly, and it should be aired now; it's no
good simply not saying anything about it. And that was the

fact that the issue that was to be *the* issue at trial, that Self-Defence Is No Offence, did not come out sufficiently clearly in the material from the campaign so that as it were everybody in the country would know that that was the case the defendants were making. One of the reasons for that was the divergence

> **The prosecution never believed that the people were going to say, 'Yes, I made these petrol bombs to defend our community, and I would do so again.'**

that I've already mentioned between defendants themselves, that unfortunately at the outset that was not the view of some of the defendants, because they had been told by their lawyers that self-defence in terms of petrol bombs was not a defence, that they were guilty; and therefore until that was sorted out amongst the group of defendants, who because of age were separated in two different prison institutions so communication was hard between them — until that was sorted out, the campaign which wanted to represent a unified group of defendants could hardly move forward on that issue.

The next thing that happened was that there was a view held that a certain surprise element had to be maintained for the trial itself. Now I'll move quickly on to the trial itself and explain what that surprise element was. The police, the prosecution, never believed for one minute that people were going to say at trial, 'Yes, I made these devices. I made them to defend our community. I would do so again.' They didn't believe, although they may have heard rumours to that effect,

> **The prosecution were surprised by the devastating evidence in court about racial attacks on the Black community.**

that that would actually be said, because they thought that would be suicide. And they imagined the defendants would

lie and say that what usually happens had also happened to them: that people would say, 'I was beaten up in the police station. Yes, I said I made these things but I didn't really. I was forced to sign the statement. I didn't do anything.' And that's what the prosecution thought they were going to face.

As a result, the prosecution were taken by surprise when it came to the devastating evidence that came out in court about racial attacks on the Black community. They were not prepared to deal with it, and police officer after police officer went into the witness box and said, 'There is no problem of racial violence in Bradford, we do not have racial attacks. When a white person attacks a Black person, that's not necessarily a racial attack, it's because he resembles somebody else who once went out with the person's girlfriend.' They had all kinds of ridiculous excuses on this score and it made them look stupid and it made the jury lose patience with them.

The other thing was that, because they didn't give credence to the idea of racial assaults, the police never checked out details of the voluntary statements that the defendants had given them, such as: 'We did this to protect our own community,' 'We did it because we heard skinheads were coming,' and so on. They never checked on the rumours of skinheads, they never checked on that story, they never attempted to cut the ground from beneath our feet on that, so that was an advantage.

> **No lawyer should be in any kind of controlling role in a political campaign.**

Having said that, those are the legal considerations. *No lawyer should be in any kind of controlling role in a political campaign.* Sometimes, or many times, you get to a situation with a campaign where, all right, you weigh what might happen legally or what might not, and then you put it on one side and you say, the political considerations here are more

important. Never mind letting the prosecution know a little bit about what we are doing before trial; we must make the decision to take that risk. And it has been said that there would have been greater mobilisation possible amongst the community had everybody really been aware of this self-defence argument much more in advance. And this is something I accept, and I think we must draw lessons from this case, like any other case.

> **The trial was won not by lawyers, but by the campaign and also by the jury.**

Just jumping back again to what happened about the lawyer conflict. Luckily, through the campaign gathering strength and through our friends in London and so on, gradually the lawyer thing sorted itself out when another woman solicitor was brought into the case. That was Gareth Pearce from London. She came up to Leeds and finally we arrived at a situation, shortly after the committal hearing, where each of us had six defendants. After that time we were able to work collectively, we were able to work on the basis of joint meetings, joint decisions, and really move forward. And that was the biggest advance that the campaign helped with. We then came to the trial.

In terms of the trial, that trial was won not by lawyers, but first and foremost by the campaign, and also by the jury. [Applause] As far as the jury was concerned, it was absolutely no accident that it took one week to get the jury we wanted, by endless conflict with the judge about having a jury of one's peers, having a jury representative of the defendants, who could understand the sort of issues that were going to be brought before them. And finally we got a jury of five Black people and seven women. And the composition of that jury was absolutely vital, as we now know. And it was clear by their verdict that the jury believed that the police had gone completely over the top in this trial. First of all with the level of

> **They wanted a show trial of Black political activists which
> would have been a devastating deterrent to young Black
> people.**

charging — conspiracy to this, that and the other, carrying life
imprisonment; and secondly in wanting some kind of show
trial of Black political activists, which in police terms would
then put paid to the uprisings: it would prove to be such a
devastating deterrent to have all the young Blacks getting
sentences of seven, eight, nine years or whatever, that it
would stop anyone else daring in the future to take the law
into their own hands. This was clearly why the police went
over the top in the way that they did.

The judge, realising halfway through the trial that the
police had overplayed their hand, tried to steer the jury back,
tried to say, 'Oh, yes, X charge is a bit heavy, you can acquit on
that, but on this one, no. You cannot have people making
petrol bomb devices in our society.' Or his words, 'You have
chaos and confusion, and what sort of a society do you want,
members of the jury?' This is what he said. Well, the jury
answered that, and they gave their verdict to acquit.

All I'd like to say in conclusion is that the result of the trial
for all of us is a fantastic breakthrough, because it established a
legal basis for self-defence in a far wider way than had been
possible before. And it also established the *necessity* for using
self-defence where the State does not protect Black people, or
any people, in society. It's a far cry from the trial some years
ago of a woman called Sara Dixon in Bradford, who was
charged with carrying an offensive weapon, which was a
knife, at the time when the Yorkshire Ripper still hadn't been
caught, when she lived very near to one of the victims,
Barbara Leach, at Bradford University; and she had taken to
carrying a knife because she didn't know — none of us knew
— what was going to happen night after night on those streets.
She went before the Bradford court and at that time, in that
kind of climate, she was found guilty by a jury, which was

predominantly women, I have to say; and she was convicted and given a suspended sentence. I don't know what would happen to her now. I very much hope that that wouldn't happen.

One other thing has happened since the trial ended, and that is this. It's a very racist thing which has happened but I think, again, we can turn it round and we can use it to our advantage. The same judge who sat in the Bradford 12 trial, Judge Beaumont, subsequently had to deal with a case of a white man called Bone who was a shopkeeper in Chapeltown in Leeds who, during the riots last summer, himself got his own little stock of petrol bombs and put them on his premises. He got a spray gun and he filled it with acid, and he had these preparations in case in the uprisings he was attacked by a hostile crowd. He was going to do something about it to protect his person and to protect his property. He went to court in front of the same judge. The same judge interrupted the proceedings, would not allow the jury even to consider the verdict in this particular case, as of course they had to in our case; he directed the jury to find this man not guilty on the basis of self-defence of his own person and property, a completely racist line to take, having allowed our trial to go six weeks and not given us any such indication. But all right, we nevertheless now have one other case on the statute books, for what that's worth, which has meant that a trial can even be interrupted if you raise self-defence and it seems viable, and you can get acquitted. So there are important lessons and an important breakthrough in terms of what those defendants did, what the campaign did with them, and how the jury eventually gave that verdict. [Applause]

We have to know when in order to defend ourselves we have to defend men. Yes, and *we* will decide when that is.

SELMA JAMES Before I call on the last speaker, I just want to say

that there has been a lot of talk today, and very fine talk it has been, about our getting out from under where the men are concerned. I've heard a lot of truth about that, but we also have to know when in order to defend ourselves we have to defend the men. Yes, and *we* will decide when that is. [Applause] And we are not going to allow the State to get us by attacking the men. No. We also know that every violence men do us is because they know the State is right behind them saying, 'Go ahead, boys, go on.' [Applause] So we're calling it on everybody.

Our last speaker is Andaiye from Guyana. She works with a political organisation there that she will tell you about. She was in London, and we are very glad that she could come to speak because Guyana is about 50-50 African and East Indian — Andaiye informs me the figure is 54-38. If you know that statistic and appreciate how particular she is to get it right, you will know something of the problem. It's a problem of getting ourselves together, and we are anxious that her experience be at our disposal in this country, not because the statistics are 54-38. Unfortunately we who live in Britain have a little something else to deal with here: Black population of 4%, and a white population of 96%. We do have the problem of getting ourselves together here, and from my experience, it seems to me that to the degree that people of African and people of Asian origin get together, to that degree the entire immigrant population, and in fact the entire working class in this country, are in a much, much stronger position. So we have to learn from sisters everywhere, and Andaiye from Guyana is going to address herself to that question, of organising against racial boundaries.

ANDAIYE All right, sisters. The organisation from which I come in Guyana is called the Working People's Alliance. Even though I want to speak today as a woman to women, since we have to acknowledge all those who we need to acknowledge, I want to begin by acknowledging one person in our party whom some of you are aware of, and who was

killed by the Guyanese State in June 1980. I wish for us to acknowledge Walter Rodney. [Applause]

The racial divisions in Guyana between Africans and Asians are exploited by those who have power over us.

We came into being in Guyana as a political group in 1974. We didn't become a political party until 1979. But I begin in 1974 because the main reason that we came into existence, the thing that united those of us who came together to form the loose alliance that we then had, which was called the Working People's Alliance, the main reason that we came together is because we were concerned at the continuing racial divisions in Guyana between the Africans and Asians. Those divisions were continuing to be exploited by those who have power over us, and it was precisely those divisions that were permitting those in power to remain in power. And so our first job, as far as we were concerned, was the work of trying to bring about connections between the Africans and Asians in Guyana.

Africans and Indians in Guyana had been placed in economic competition with each other, and that is where the hostility began.

Let me begin by talking about what is the basis of separation between Africans and Asians in Guyana. I corrected Selma by saying that Asians in Guyana, by which I mean Indo-Guyanese, are 54% of the population and Afro-Guyanese are 38% of the population. The rest of the population are Chinese, Amerindian, Portuguese and what we call Europeans. You notice we make a separation between Portuguese and Europeans and I want to tell you why. And that is because Portuguese came to Guyana as indentured servants. Europeans, as we call them, came to Guyana as those in power, as

masters. So we have always distinguished in Guyana between Portuguese and Europeans.

Obviously, the basis of separation between Africans and Asians in the first place was an economic one. And just to touch on that very briefly, let me say that by the later part of the 19th century, the Africans and Indians in Guyana in particular had been placed in economic competition with each other, and that is where the hostility began. That economic competition led in the second place to a geographical separation, out of which Africans live in certain villages, Indians in other villages and the Amerindians live separated from all the rest of us in the interior. That economic competition of course was competition among African men and Indian men. The overwhelming majority of women in Guyana at that time would have been working in the house, their own house or somebody else's house. The job competition was a competition between men, but of course, as we know, whatever is happening at the level of men traps somewhere within it what is going to happen with women.

> **The power that divides us in the first place very often is the instrument of bringing us back together.**

One of the reasons that I want to stress that the economic competition was in the first place among men is because there was another side of that coin. That competition existed because men went out of the house to work and worked in competition with each other. At the same time, the fact that men worked outside of the house gave them the opportunity as Africans and Asians to come into contact with each other, and therefore gave them some possibility of coming together across racial lines. And therefore there have been periods in Guyanese history in which African men and Asian men have been able to come together in unity. But it has always been a very tenuous unity, always a very precarious unity, one very easily broken.

And so let me come to the present situation because I think for the first time on that front we begin to see evidence in Guyana of some small victories, and victories in Guyana have to do with the coming together of Asians and Africans, and the victories of course are the victories of women.

When I was telling Wilmette Brown, the co-ordinator of this conference, what was happening in Guyana now, she asked me at the end whether I was saying that women have begun to come together in Guyana because the government have brought us together. Wilmette asked me that question yesterday and I couldn't answer. (I very often can't answer Wilmette's questions.) But I thought about it all night, and I feel now to say, 'No, Wilmette, that is not what I am saying.' But I am saying that, as we say at home, 'What goes around must come around.' And one of the things that is true is that the power that divides us in the first place very often is the instrument of bringing us back together. [Applause]

It's a very simple way that women in Guyana have begun to come together across racial lines. The situation in Guyana — there is no time to go into it, we all know that throughout the Third World the situation is bad, but believe me when I tell you that the situation in Guyana is worse than anything we have ever experienced in the English-speaking Caribbean, and I mean simply at the level of people's daily lives and therefore at the level of women's daily lives in particular.

> **We are talking of women being in the front line of the struggle for survival in Guyana.**

Just to give you a few figures so that you get the background. The economy of Guyana collapsed in February [1982]. I do not mean it has a crisis. I do not mean it is in recession. I mean it has collapsed. So that there is no foreign exchange. So that we have no money to import food. So that we do not have a proper electricity supply. So that women in Guyana are back to walking to fetch water in the morning. So

that we have an unemployment rate of 50%. So that the
minimum wage for the few who have jobs is 12 dollars a day
but a loaf of bread costs 8 dollars. So that the minimum wage is
12 dollars for the 50% who have jobs, but five pounds of milk*
costs 60 dollars. That is how we are living.

Since the daily issues are the issues of food and water and
electricity, obviously we are talking of women being in the
front line of the struggle for survival in Guyana. And women
on the front line of that struggle have found out who else is on
the front line: in other words, the food line, which is the
longest line you can find anywhere in Guyana now — we have
to go and line up from three and four o'clock in the morning to
attempt to get food — the food line in a certain sense has
become the front line in Guyana. And by the very nature of
women's work, the food line is where you find women. A man
here, a man there, sometimes some children, but women from
back to front. So far, a lot of the activity that has taken place on
that food line that I call the front line has been spontaneous
activity. But I am not amongst those Marxists who don't like
spontaneous activity. [Applause] And I would suggest that
one of the reasons why the kind of unity that was sometimes
built up before between male or male-dominated organisa-
tions collapsed, is because it is not a unity that was built from
the ground and on the ground; it was an imposed unity. And
the actions that they took together were not actions that they
worked out for themselves on the ground, the so-called
spontaneous action. They were planned actions, planned by
leaders sitting somewhere in a room, planning other people's
lives and fates. What is happening on the food line, which I
insist on calling the front line in Guyana, is that African and
Asian women standing on that line have begun not in abstract
terms but in real concrete terms to understand, one, their
particular oppression as women; two, that they share that in

* In most of the Caribbean there are no dairy herds, and almost all
dairy products are imported. Condensed and evaporated milk in tins
and powdered milk sold by the pound are part of the staple diet.

have to understand that one of the reasons why it's not going to work particularly for the older women in our communities is because we are still so involved in the protection of this little unit that is supposed to be our business and our care. And because, worse than that, we are trying to protect that unit within a racist society.

And I raise that only to say that the question for me is not what is legitimately a women's issue, I hate the term — but excuse me, I am talking shorthand — not what is legitimately the business of women to struggle over and what is not, but what is it we can find that in some way impels us forward to make the connections that we have to make.

> **If African and Asian women cannot find connecting links in what is taking place in immigration, then you will never find links at all.**

And I want to begin by saying that it seems to me in relation to African and Asian women that if you cannot find connecting links in the whole question of what is taking place in immigration, then you will never find connecting links at all. [Applause] If you take what I said earlier about the food line in Guyana — I was using the food line as a place in which the oppression that we know we suffer becomes naked, becomes open and becomes so dread that you have to fight it in order to survive – the equivalent in this country of our food line is the immigration line.

> **I hope you won't come back home without putting together some skills and some money.**

And even though I respect the position of sisters who tell me that they want to go back home, I have a couple of things to say about that. The first is that I hope you are not going to come back home without putting together some skills and

some money. [Applause] The saying is you came here for the money, so if you're going to come back, come with the money! [Laughter and applause]

The second thing is that I know that the scene is dread here. I know the scene here is dread particularly for women and particularly for Black women, but believe me when I tell you that after you have lived here for ten years or fifteen years and so on, you are going to have a difficulty that you are not anticipating, back dealing with the fetching of water from three o'clock in the morning and so on. [Applause] Women are not short of places in which to fight, we can fight wherever we are. [Applause] And I would suggest to you, although it is always your right to go home if you wish to, I would suggest to you that the best thing for the overwhelming majority of you to do is to say that you are here, that you have a right to be here, and take your stand right here and fight. [Applause]

SELMA JAMES The floor is now open for discussion and comment. The collection for the Halimat Babamba campaign is approximately £35.

NEW SPEAKER I'd just like to make an announcement about another deportation case that we haven't heard about. And that's partly why I wasn't here this morning, because this afternoon we had a demonstration to defend Afia Begum. Afia Begum is a nineteen-year-old Bengali woman who came to this country to join her husband in June this year. She has a year-old child. She was allowed into this country to join her husband. After she got her permit to actually enter the country her husband died in a fire in Brick Lane [East London]. Now his death is a direct result of the racist housing policy of the council and of this country, because we all know that Black people have to wait a long time to get decent housing.

Now that her husband has died, the Home Office want to deport her because they say the terms of her entry have changed because he has died. That's what the demonstration

was for this afternoon. Afia Begum is fighting her own case. At present she is in hiding because the Home Office say she should live in the same shell that's burnt down in Brick Lane because obviously nobody's at present willing to re-house her or anything like that. She appeared right at the end of the demonstration, but we need a lot of support for her. We need money to hide her, we need signatures, we need signatures on petitions (which I have) and a collection.

I think that Andaiye is absolutely right when she says that women, now that we're here, we have to fight. What the campaign is trying to do is to fight all immigration controls. Here it is, the heartland of British imperialism, trying to shunt us about, and in her case particularly so because what they are saying is, now that you don't have a man, the whole terms of

> **What they are saying to Afia Begum is, now you don't have a man, the terms of your permit have changed completely.**

your permit have changed completely. So I hope this conference will support her, and I have collection tins and forms and everything else and I hope that you'll sign them. Thanks. [Applause]

NEW SPEAKER Hello. I'd just like to ask: are there any more Hungarians in the house? I know that there must be one. My name is Judit Kertesz from Women Against Rape, but I'm not going to speak for Women Against Rape because so many people have said so many of the things, and particularly on violence and rape, that I wanted to hear said. But I'd just like to identify myself as a Hungarian refugee. I came here in 1956 with my mother when I was four years old and people have spoken a lot about the kinds of attacks that come down on us. I'd just like to say very quickly that what I've also realised in organising is the *power* of being immigrant as well, because the first thing that you know is that you have been one place

and you are now another place. So when they tell you things have to be the way they are, that they cannot change, they cannot be different, you know that they can, and that's a big power.

> **When they tell you things have to be the way they are, you know they can be different, and that's the power of being immigrant.**

And also in getting here, that's a massive amount of organising, that's a massive struggle and that is what people, immigrant people, bring to any country that they come to, the experience of someplace else, and that massive experience in organising.

And also having come from the Hungarian Revolution, that is an enormous power and leadership to everybody every-where. And so you know when there is a riot in Brixton, when the Polish people are on strike, when there is a revolution, when there is any kind of struggle, that is a power to us all. [Applause]

NEW SPEAKER We are all here today because of one simple thing: we are all victims of Western imperialism. I'd like to bring to your attention that there are other women in different parts of the world struggling against the system which oppresses us. The women of SWAPO* of Namibia, the Black women of South Africa, the women of Palestine, the women of El Salvador and all oppressed women all over the world. [Applause]

SELMA JAMES I have an idea that we have almost talked ourselves out for the moment — only for the moment. These will be our last two speakers for the day. And then you must not rush away, I have promised to make announcements, and you must be as great as you have been so far.

* South West African People's Organisation.

NEW SPEAKER Thank you, chairpersons and all the sisters. I was very impressed about the conference today on Black people and I am organising another conference on health and race.

British ethnic minority groups, particularly Black communities, have been shown to have a different health status than their socio-economic counterparts. Morbidity and mortality rates indicate that they are at an enormous disadvantage in specific areas. Notably perinatal and infant mortality rates, death from hyper-tension, heart diseases and general physical and mental health. Why is that?

Many place the causal factors on the distinctive culture. Others place it entirely on the lack of possibility for advancement which drives Black people to the lowest socio-economic position of Britain. Others attribute it to racist aspects of British society. Therefore some of those solutions proposed to workers in the National Health Service are in many cases contradictory and often lead to confusion as to which the real alternatives are. During this three-day symposium, a continuation of last year's 'Ethnicity and Health: The Way Forward', the symposium will try to identify the main areas that produce ill-health and death within our ethnic communities. Thank you. [Applause]

NEW SPEAKER Hello, everybody. My name is Rose for those who don't know me. Earlier on somebody was talking about jobs with the GLC and project-hatching was the word, etc. Well, let's look at it this way. Most of us who are working for a living, we don't get very much for our trouble. Right? Now I'm a nurse, I've been a nurse for seven years. How much do I take home a week? Never mind. The point is, out of seven years of working, materially I've got a black and white television to my name. Plenty of experience up here, you see, and it's about time I used that experience with a job that gave me my worth, you see. £8,000 a year would be very welcome as far as I am concerned. [Applause]

MARGARET PRESCOD Just an announcement. For those Black women who are interested in getting together, we'll be meeting next Saturday at 2 o'clock at the King's Cross Women's Centre. You'll be able to hear more from Clotil Walcott from Trinidad and myself — we've been doing a lot of work, Clotil in Trinidad and I in Los Angeles and other parts of California and the US, that we have not had the opportunity to speak about today because there wasn't time. But we'd really like to let you know how we're organising there.

To give one quick example: the case of the Bradford 12. When we heard of that case in Los Angeles, Black Women for Wages for Housework organised a picket outside the British Consul, which blew their minds because they were not expecting a Black women's picket about the Bradford 12 in Los Angeles. [Applause] Worse yet, we had a lot of media coverage about police brutality in Los Angeles and in Britain, and they were quite upset. We forced them to telex London for news of the trial. The Bradford 12 said themselves that that kind of international organising was very important to them in their case. So you see, power has to travel that way. We want to get together to talk about what we're doing here, what we're doing there, and how we're going to put it all together so we can take what's ours. That's next Saturday, 2 o'clock, at the Women's Centre.

> **After the fires of Brixton and Bristol and all over the place, there are job opportunities and wages.**

NEW SPEAKER I just wanted to thank everybody who attended the conference, but mainly to thank all the sisters that organised the conference. And what I really picked up my hand to say is to appeal to the Blacks in this country, that right after the fires of Brixton and Bristol and all over the place, there are job opportunities and wages. It is appeasement wages, we are all aware of that, and I'm saying this because I am personally involved in these jobs that are appeasements to

keep the peace, if you like, with the system.

Whilst we don't have the power to change the government, to make it into a socialist government tomorrow, now or the day after, we have to survive, and we are not a people who are independent in businesses and things of that nature. We have to get jobs and we have to pay our bills. My appeal to you, sisters, is when some of us have got these jobs, these government jobs, please stop attacking us as sellouts because we are not. It is very heartrending when you are inside an Establishment that is pushing an Establishment line and you are trying to fight for your people to get as much out of that little bit that is there; and instead of supporting you, they are attacking you, therefore making it easier for those inside to kick you because you have no support from outside.

> **Prostitutes have seen the money they say doesn't exist. If we begin with that, £8,000 a year ain't nothin'.**

NEW SPEAKER We are talking about organising ourselves. Now we need to organise from a local level. I live in the London Borough of Southwark, we have got an association together. It's called the Southwark Black People's Association. If anybody here who lives in Southwark wants to get involved, come and see me afterwards.

NEW SPEAKER I'd just like to ask the sister from the campaign for Afia Begum to make sure that the petitions are out in the registration hall before everybody goes out.*

SELMA JAMES I want just very briefly to sum up. The conference has been a great experience for me and something which I in a way have looked forward to for many years.

Some of you may know that I speak for the English Collective of Prostitutes and I have to tell you a brief story

* Afia Begum was deported to Bangladesh in 1984.

about the first public statement the ECP ever made. It was read at a conference of the Wages for Housework Campaign, by someone else because none of the prostitute women could be public — like Afia Begum. We are all in hiding in one way or another. The statement ended by saying to the women present, a hundred women or so, when they tell you that they don't have the money for what you are demanding, tell them that we prostitutes 'have *seen* the money they say doesn't exist'. [Applause] And if we begin with that, then £8,000 a year ain't nothin'. They owe us a lot.

The name of the book which inspired the Conference is *Black Women: Bringing It All Back Home*. It was based on a speech which Margaret Prescod made to a meeting called 'Black Women: We're in Britain for the Money'. Not for the weather, but for the money. And we have to bring it all back home. Now 'back home' means many things to women, a lot more than it means to men, and the money will also be much better in our hands.

> **We want money of our own so we can live any way we choose.**

I want to say in relation to that, it is not only the immigration queue where we are united. At the present moment in time we are also united in the unemployment queue and the welfare queue. I was very glad a single mother spoke today in her own name, that's the wave of the future: we want money of our own so that we can live by ourselves, if we so choose, [Applause] or any way we choose. And welfare is the key to that.

I hope you will avail yourselves of the services of the women who are here from abroad who are ready to do public speaking while they remain here, to go to your organisations and to build your power by putting theirs with yours. Please also avail yourselves of the resources that we have tried to put together and introduced to you by way of this conference.

I want finally to say that we got some money to run this conference, and not all people who get money spend it on brandy. You can have a conference of women where you can make that money work so that we can get double in return, in terms of strengthening our connections. That's what we hoped for this conference today, and that I think is what has happened.

Now we promised that we would announce all the meetings that people wanted us to, and I'll go through them quickly and then I have some work for you to do. Don't go home yet.

'No Pass Laws to Health' — speakers include Amrit Wilson, Cyril Taylor and others. County Hall, Waterloo, SE1, 12 December, 10.00 a.m. to 5.00 p.m.

An appeal for women present to show solidarity for the SWAPO women's struggle in Namibia and Angola by signing the petitions on the front desk for Ida Jimmy, who was sentenced to seven years' imprisonment for addressing a SWAPO meeting. She was seven months pregnant at the time and both she and her child are still incarcerated by white South African and British hands.

The Workers Institute of Marxism-Leninism-Mao-Tse Tung Thought, 3 and 4 December at the University of London, 'Women Need Socialism'.

Camden Women Opposed to the Nuclear Threat welcomes new members. They meet on Monday nights, beginning with this Monday at 7.30 p.m. at the Women's Workshop, 169 Malden Road, Kentish Town. If you miss these addresses the address sheets are available.

A final announcement: Clotil Walcott, when she came from Trinidad, brought greetings from a man whom some of you may know — Macdonald Stanley, an old Butlerite. A man from the West Indian risings in the 30s, who is still rising, I'm glad to say, despite the fact that he has lost his sight, and who sent greetings to this conference, which I am pleased to convey and record. [Applause]

And finally, the housework that always falls to women. Gigi

wants your help. A number of the displays are expensive, all of them are very precious. Will you please help us to pack them up and clear the hall properly. Gigi will give you some clue about the kind of help she wants, so that we can tell Camden Council that we want the hall again next year. Thank you for coming. [Prolonged applause]

PART THREE
Completing the picture —
the method

EVALUATION
Making trouble, making history

As the reader will see from the Introduction to this book, the conference came out of a relatively long history of organising at the King's Cross Women's Centre. But whatever it owes to the Centre's perspective and practice, the conference stands on its own, a specific effort to achieve particular objectives.

As the work of the conference began long before the actual event, so the work did not end when the conference was over. The concluding stage was our customary evaluation meeting. Recording the aims and purposes of this evaluation process here will help explain the methods as well as the purpose of our organising, and will complete the conference picture.

*　　*　　*

Evaluation is not less necessary if an event is successful. Our evaluation meeting always seeks to integrate the big moments with the ongoing day-to-day work of the Women's Centre. It is a thorough post mortem, an organising tool we've used since the Wages for Housework Campaign first had public events in the mid-seventies. A public event is a test of your analysis, your tactics and strategy, and the quality — the abilities, skills, clarity and focus — of your people. Success or failure, meeting or demonstration, organised by us or jointly with others, after the rush is over we sit down among ourselves and with other interested participants and break it down. Being women, who are doing two-thirds of the world's

183

work and who have fewer resources than men with which to organise, we must get as much as possible out of every investment of our most scarce and precious commodity, our labour time. Something as major as a conference must be scraped clean of its meanings and uses, like a bowl of food when you're broke.

The evaluation meetings seek again and again to answer the same questions, and to do this, they have the same simple format: report and discussions. (Wilmette Brown, the conference co-ordinator, gave the opening report of the conference evaluation which I have referred to in the Introduction above.) The questions aim to uncover the basic facts of political life around us and among us, to pool information and to reach conclusions about the terrain of our struggle, conclusions which we try to make as precise and practical as possible.

The raw material for the picture we build up is basically what each of us has observed and lived through. Because you're usually working during your own event, it is only later, by exchanging experiences, impressions and anecdotes with others, that you get to hear about what you missed, and only then can you arrive at an overall view. The discussions branch out to any concerns and information which any woman can show to be remotely connected: there are an infinite number of bits and pieces which make up the answers we are putting together collectively and in each individual mind. Since we don't presume ever to have all the answers, and for the purposes of evaluation presume to have even fewer, every evaluation meeting begins with the great expectation that we will be at least a little wiser at the end. If we are evaluating a success, it begins also with great excitement.

The meeting looks first of all to register our victories: how much we achieved of what we set out to do; what we learnt preparing it and throughout; what talents were revealed among us and in others; how much sectors of women (and occasionally men) saw common interests, and even worked together, who ordinarily would not have; how, and how

much, we weakened the case of those who wield power against us; what long-term effects we can expect or should keep our eyes open for.

Spelling out what a political occasion has won is part of our survival strategy:[1] for a group whose existence is always under attack because it stands out against the Establishment, working out ways to maintain yourself is decisive. The ways you choose also reflect what your organisation stands for.

For example, many pressure groups which claim to be anti-Establishment hold out the promise of money and power as prizes for the most ambitious and cleverest members. That has become their reason for existence, shaping their policies and their practices: they are cautious with their members' future. Such pressure groups are a traditional step in the career ladder of British society: people who aspire to be MPs, for example, make their name by rising to the top in organisations which fight for the needy, with moderation.

On the other hand, almost every shade of the Left promises its members State power as the ultimate reward when 'the workers' realise whom they must follow.

The race relations industry and the newer but no less deadly gender relations industry are not essentially different from these two.

The evaluation meeting where we first of all count our victories is vital to maintaining us as who we are: campaigners who reject this careerism, measuring our success by the effectiveness of what we do, rather than by whether one or two of our personal bank accounts grow — a dominating motive, ironically, among many feminists who deny that money is important!

The Wages for Housework Campaign is extremely interested in money, but knowing it is social power, we also know that when only a few get it at the expense of the rest of us, we are further divided.

Counting our victories, we make our work count and we quantify its effectiveness. As with women's more private — but no less political — housework, most of our organising

work is invisible. Along with acknowledged politics, such as writing leaflets or setting up meetings, is the political housework of drawing people out, discovering and encouraging their skills and talents, breaking down barriers to people identifying with each other and finding a basis on which to propose they move together — all of which require time, concentration and energy, skill and compassion. Women do this work especially well — not because it is natural to us but because we are trained almost from birth to do it within the family. Yet this political housework, the cement of any movement (and there is never enough of it), is rarely seen and even more rarely considered work. The evaluation process lifts this work from obscurity, appreciating its productivity, quantifying its results.

Counting our victories we appropriate our own history.

With the growth of women's power, the history of all kinds of contributions by women, as individuals and as a sex — in literature, language, art, music, politics, religion, agriculture, science, etc. — has at last begun to surface. For the record, women are not the only sufferers at the hands of historians. The Great Man theory of history hides not only Great Women but defines almost everyone out of greatness.

Specifically, the invisibility of women's work as organisers — which includes every woman rather than just 'Great Women' (writers, scientists, painters and so on) — itself reflects a class bias, a career bias, in the women's movement, itself perpetuates a historical censorship in another form.

The evaluation process is part of righting the historical wrong which condemns most of us, women and men, to an unimaginative and unproductive past and, by implication, to a destiny of more of the same, *by preventing the same thing from happening to the history we are making now, at this very moment.*

We are in a stronger position to do that at present than ever before. Among other things, we know (or should know) more about *how* our history is swallowed up by others with more power: how politicians live off 'their' reforms which we

lobbied, cajoled and pressured them into; how the media lies, distorts, trivialises and hides altogether; how the same view out of the mouth of a white/man carries more weight than out of the mouth of the Black/woman who first worked it out. In metropolitan countries we often have literacy and weapons of our own based on that literacy which record our ideas, our struggle, our successes: leaflets, newsletters and — much more rarely — even books.

But grassroots women (and men) don't know ourselves the history we are making, and this is the greatest deterrent to our recording it. Such lack of self-consciousness is one of the most debilitating effects of the power of education and the media against us. We must regretfully add that the Left on the whole reinforces it. Having had it drummed into us from birth that we can't influence events and must submit to authority, and having almost always been forced to submit, we are trained not to appreciate our own effect or the effect of other people like ourselves. When we do succeed in breaking out, appreciating our experiences, articulating our thoughts, we can rarely get them into recognised and widespread channels; and even then, they are almost unrecognisable: hacked to pieces, stripped of essentials, and dismissed with a sophisti-cated phrase implying that they are irrational ravings. Later we see them regurgitated from the mouths of journalists or others on the make as if fresh from their minds; and we sit quietly grieving, tragically defeated: the product of our struggle, our gut and our mind, robbed from us and spouted by those who had scoffed and jeered, confirming our incapacity and backwardness.

This is a common experience. It is a matter of life and death for any working class organisation but especially a women's organisation not to allow itself to be subverted by such intellectual imperialism and plunder.

Our actions are under similar attack. What we do, we are told, has no impact since we are just a few, or a few dozen, or a few hundred, or even — as with recent peace demonstrations —just a few hundred thousand. There are, we are told, always

more on the other side, and sensible, straight, white, respectable, police-loving, work-loving people they are — *real* housewives and mothers worthy of the name, local residents, not 'outside agitators' (which we are everywhere!) like us. And yet governments adjust their arguments because of these 'few', but in such a way as to conceal our impact, to keep us from knowing our own power: how we made them shift, how the majority are *moved* by us, are *like* us, *are* us; how in some measure we are changing the balance of power, changing the world; how in making trouble we are making history.[2]

Our evaluation meetings aim precisely to record how much history we have made, how much power we have wielded and how much potential power we might have as a result of what we and others have done.

We and others. For in developing the habit of awareness of your own historical acquisitions and potential, you learn also to respect and understand other women's and men's struggles. You are aware, from appreciation and consciousness of your own experience, of the problems they had to overcome and what, despite these problems, their efforts have won, for themselves and also for you. In this way, you prevent yourself from being used to cover up others' contributions to the history of the movement — the women's movement, the immigrants' movement, the gay movement, the labour movement, etc. — the working class movement. We have, after all, one history that we are reappropriating, protecting, recording; one tradition of struggle that we are advancing; from which common pool each of us draws our power and to which we all contribute.

But we can only protect the achievements of every sector of the movement by evaluating and quantifying from the bottom up. Although we are one, we are also many, which is less than one, less than unified. We can never afford to lose sight of the power divisions among us.

To give an example from our current experience, we are raising money for the mining communities during their present strike because we know that if they lose, we all lose,

and if they win, we win with them. But all the money we raise goes to the women, who then have the bargaining power of the purse strings. Miners are confronting government and police for all of us, but that does not mean that we can afford to forget the power men wield over and against women. The strike does not absolve them of wife-beating, queer-bashing, racism, etc. We insist that they acknowledge how dependent they are, and have always been, on the women of the mining communities.

Since the miners are asking for — and getting — our support for their struggle now, we will be in a better position in future to demand their support, but only if we establish with them now that our autonomy is the basis of our support of their strike. Such an *exchange of power*, where we are strengthened because of what others do on their own behalf, is always taking place between groups who are confronting the powers that be, and whose actions identify them as part of the movement. What ensures that there is an exchange of power *both ways*, between the more vulnerable and those who are socially more powerful, is the autonomous organisation of the less powerful. The women in the mining communities are deriving great strength from autonomous organisations of women such as ours (and are saying so publicly), to build their own autonomy from the union and from men: for the men as strikers on the one hand, and against the men as wife-beaters — as scabs on women — on the other. Our autonomous organisations are always involved in threading their way through this contradiction, between the slavery we share with the more powerful and the slavery we don't: their managerial relationship to us. *The work of balancing these opposites is the price of winning*.

So that the habit of identifying and claiming our own victories, and identifying and acknowledging other people's victories, which the evaluation meetings are about, is one with the process of finding the basis for working together with others whose level of power is different from our own and whom we need in order to win. Which was the purpose of the

conference in the first place: discovering common ground not between women and men, but among women, Black and white, immigrants and natives. The sectors may change. The process and the goal are always the same.

Last but by no means least, our evaluation meetings invite anyone attending to complain about and criticise any part of what anyone did, didn't do or left half-done for the event. In this way, one woman can be critical of another in a direct and positive framework, which prevents necessarily negative comment from festering internally into personal resentments and rivalry. (For the record, there were a number of criticisms of people's work at the conference, ranging from how the books were displayed, to when people turned up in the morning and whether they carried out jobs they had volunteered for carefully, well and on time.)

Taking what each of us does seriously enough to spend our precious time constructively criticising it, is another expression of our respect for each other's time and work, of our self-respect as women, and of our collectivity. In the process we set the terms of relationships among us, adjust our tactics and re-examine our division of labour. Each individual trains her judgment and becomes more autonomous, more conscious of herself as protagonist with skills and capacities — more able to stand up for herself anywhere. If political life is not also personally rewarding in this way, is not individually educative, exciting, power- and confidence-building, it is just another piece of alienating work, just another capitalist tragedy, that can lead to burnout, dropout or careerism. So far the Wages for Housework Campaign has suffered very little from these.

* * *

The decision to publish the conference proceedings was taken at the evaluation meeting, as well as the decision for a follow-up conference.

When we began in earnest to plan Conference II, we got out all the documents from our first born to find out how useful they might now be in the light of the history we and the rest of the movement had made in the intervening year. It is our hope in presenting them below that others besides ourselves will still find them useful in their organising, if only to clarify what they want instead.

Notes

1. There are of course other parts of our survival strategy. The Campaign's international network has always been decisive in warding off provincialism, nationalism and racism. It has also given us access to many more victories and thus more power than if we accepted the boundaries that governments set.

Goodwill and even good works are not enough to build and maintain such an international network. It requires constant hard work and above all constant attention to all the barriers and pitfalls of organising beyond national ghettoes. But that is another, and even longer, story.

2. Perhaps the most convincing proof of how effective the peace movement and other movements have been is the degree of illegality the government is prepared to engage in, in order to spy on us, tap our phones, keep files on us, etc.

DOCUMENTS
For the record and the future — the grant application and other useful tools

Housewives in Dialogue's intention with the conference was that though it would be an occasion for all women, the voices of Black and immigrant women — the voices most rarely heard — would be heard above all others. To accomplish this, HinD asked Wilmette Brown, who wrote the Afterword to *Black Women: Bringing It All Back Home*, to co-ordinate the conference. She was to gather an independent committee of mainly immigrant women, Black and white, to plan and organise such an occasion. Only they, drawing also on the experience, skills and womanpower of as many other women as possible, could ensure that their own voices would predominate.

I was part of that conference committee, which Wilmette refers to in her Welcoming remarks above as having had 'to grapple with all the issues that emerge when immigrant women try to do anything collectively.' I witnessed the organisational imagination, patience and energy of the chair in shaping, steering and fuelling that group. If only the people turn up, I thought, this is going to be a great conference!

Our first and in some ways our most agonising task was to try for funding.

The following application for a grant was prepared and sent round in the spring of 1981, eighteen months before the event. It remains the basic statement of conference aims and intentions. Reading it again after four years, I think it stands up well. My hope is that it will help other determined

grassroots organisers with the wearying task of begging for
bread in writing.

CONFERENCE
Bringing it all back home:
Black and immigrant women speak out and claim our rights

Paid jobs are limited to domestic work –
going to clean other people's houses, washing their
clothes, cooking for them, waiting on them – and all
you get in return is a pittance. All that housework and
then home again, to start all over again. And the
mothers ask 'Is there no end to this struggle . . . ? Life
must be easier abroad'.

* * *

The public fight over immigration focuses on how
much we are given – housing, jobs, the boat fare. We
have never heard how much we had to pay to
immigrate and to stay in a second, third or maybe
fourth country . . . As housewives it has meant more
housework – reorganising and reuniting the family,
easing the emotional trauma . . . Once this work and
pain are highlighted we also see that we are owed far
more than we owe.

The above are from *Black Women: Bringing It All
Back Home* which we published in March 1980. It is the
first book of its kind to appear in Britain: two West
Indian women speak of their personal experience of
becoming immigrants, why they emigrated, and what it
cost them and their families financially and emotionally to
change country. We felt it was important for the
discussion of the new information and ideas they
expressed to be widened and deepened. A conference

seemed to us to be the most appropriate format to do
that.

OBJECTIVES

1. Immigrant and Woman

To show how the concerns of Black and immigrant
women are integral to the movement for greater
equality for women generally. Immigrant women
grapple daily with issues of childcare, low status jobs,
housework, rape and violence, financial dependence,
but within the framework of their status and situation
as immigrants. Yet these women's issues have
remained largely invisible in discussions about the
'problems of immigrants', discussions which hardly ever
refer to women specifically.

Conversely, we want to place the issue of racial
discrimination on the agenda of all women seeking
their rights. This will begin to rectify the position of
immigrant women who are left out of the mainstream
of efforts to counter not only sex discrimination, but
also racial discrimination. While both issues attract
attention, immigrant women very rarely benefit from
public interest and concern in their own name.

2. Women's Work and What It Contributes

To examine the workload falling on the shoulders of
immigrant wives and mothers as wage earners and as
those with the primary responsibility for resettling the
family. We want to explore the quantity and quality of
that workload and what these efforts by immigrant
women contribute to British society generally.

3. The State and Immigrant Women

To give first-hand information on how welfare, work
permits, and the written and unwritten rules of society
are perceived by and actually work for immigrants, and

how they can be made to work better. An important
function of the conference will be to facilitate
immigrant women claiming their rights with help from
non-immigrant people.

PROPOSED AGENDA

We are proposing a one-day conference with three
sessions.

In considering the agenda, we tried to avoid certain
pitfalls. We don't want the conference to be a platform
for a demoralising catalogue of the evils of
discrimination. There is also the danger that the way
issues are dealt with can distract the conference from the
problems specific to Black and immigrant *women*.

Therefore we feel that the basis for discussing
difficulties must be the uncovering of positive efforts and
accomplishments, little known to non-immigrants.

1. Organising to come here – why and how we did it.
2. The problems of adjusting: resettling the family and
 making a living.
3. Claiming our rights: what we're entitled to, how it
 works in practice and who can help.

We feel the first two sessions should be open to women
only because this is the only way to guarantee

a) that some women whose culture forbids sexual mixing
 will be able to attend;
b) that no husband or male colleague will be able to
 intimidate;
c) that women from different backgrounds can
 communicate without interference;
d) that it will be publicly acknowledged that immigrant
 women too have a right to meet independently of men.

The last session will give men a chance to benefit
from the previous deliberations and to participate with
their own expertise or with questions related to their own
needs, thus allowing all to feel reunited.

AUDIENCE

Although the conference is first of all for immigrant women it will be open to all. The publicity will be directed mainly to immigrant and women's organisations, but we plan to invite representatives of migrant services and the Church, community and welfare rights workers and others active in combating sex and race discrimination.

SPEAKERS

We intend for the majority of the speakers to be immigrant and to reflect a diversity of situations – mothers, single women, community workers, etc. Naturally, the authors of the book should also speak. We would like the panel for each session to be international, i.e. to have immigrant speakers from other countries – Holland, France, Italy and/or Germany to compare the situation here with that of immigrant women in Britain.

MONEY

What we can do depends largely on funding. We want the conference to be well-publicised. The entrance fee needs to be subsidised so that poorer women can attend. We also want to pay fares so that we can draw on the experiences of people living in the provinces as well as in London, and from abroad.

The reader will have noted one major change from the proposed agenda above: it was a women-only conference, at that time a relatively new departure for immigrant women. The conference committee was in two minds about whether men should be present, so it asked women at the Centre, in the majority immigrants themselves, if *they* wanted men excluded. They did – mainly, they said, because since this was the first time such a diverse group of women was coming together to discuss race and immigration, men might prevent a free dialogue; and might also prevent women, beginning with

themselves, from speaking freely about male domination in their communities and in mixed organisations. In my view, the conference proceedings justified that decision.

The grant application drew help from the Race and Community Relations Unit of the British Council of Churches; the Commission for Racial Equality; and the Gulbenkian Foundation (which had originally given the seed money for publishing *Black Women: Bringing It All Back Home*). The last grant wasn't agreed until almost the eve of the conference, but as soon as the first £1 was secure, the hall was booked, the three international speakers were invited and the conference committee set about the rest of the business of creating a conference.

The following are from the letters of invitation. The first, from Housewives in Dialogue, was sent mainly to local social and community workers, politicians and other professionals on whom Black and immigrant women are dependent day to day, and who are in turn dependent on the kind of information HinD was offering through the medium of the conference.

14 October 1982

It is our pleasure to invite you to be our guest at the above conference.

This is the first conference of its kind to be held in Britain. Black and immigrant women will be coming together to dispel the illusion that 'immigrant' and 'Black' means only men, or that 'women' means only white and English. Participants will be attending from all over the country and from abroad – Europe, the West Indies, USA – so that women can compare experiences of immigration internationally.

The conference is carrying forward the work started by the book, *Black Women: Bringing It All Back Home* (Falling Wall Press, 1980) which threw new light on the debate about immigration. In their own words, immigrant

women spelled out the price they paid financially and
emotionally to come to work in Britain; they speak as
mothers, as wives, as daughters and as wage earners,
and in doing so, enable all women – immigrant or not,
Black or not – to identify their common experiences and
aspirations.

Details of the conference are enclosed. If you can help
publicise the event, we will be pleased to get additional
flyers and/or posters to you, or to others you suggest.

Please take this letter as entrance to the conference.
We very much look foward to meeting you there.

Yours sincerely,

Solveig Francis,
Co-ordinator, Housewives in Dialogue
Wilmette Brown
Conference Co-ordinator

Nina Lopez-Jones wrote this to the constituency of the
English Collective of Prostitutes:

You are invited to the above Conference on November
13th, which the English Collective of Prostitutes are
helping to organise. It aims to bring together the
experience of immigration for *all* women – including
prostitute women.

The conference is a follow-up to the book *Black
Women: Bringing It All Back Home* published in 1980.
In it Margaret Prescod-Roberts says that:
. . . something else not talked about much is the high
level of prostitution that went on in the villages and in
the towns of our home countries. In other words,
whole families were supported off the money that
women made from prostitution, children were raised
on it . . .
As part of our campaigning, we are working to finish
up with the myth that when you are talking about

prostitution, you are *not* talking about women's rights, race, immigration or class. But when the police harass the Black community, part of that harassment is the arrest of prostitutes who are often Black and immigrant, and almost always women.

This conference is our chance to speak out about our lives in Britain and in other countries, and to claim, finally, our membership of the Black and Women's Movements.

And Anne Neale told the constituency of Wages Due Lesbians that the conference was also for them:

Too often Black lesbians, and immigrant lesbians, Black and white, have been invisible, both within the lesbian community and within the Black and immigrant communities. We hope that this conference will provide a forum for Black and immigrant lesbians to speak out about what it means to be a lesbian in Britain and in other countries. We want to discuss how the racism of the immigration laws, racist attacks and discrimination in jobs, housing and child custody affect our daily lives. As lesbian women we have something to say about every aspect of immigration and racism, and we don't intend to keep quiet about it.

Finally, Ruth Hall and Judit Kertész of Women Against Rape invited their supporters to the conference on this basis:

In WAR we have seen too often how the law works against women's safety. The legality of rape in marriage makes it quite clear that, as far as the law is concerned, women matter less than men. The law sets the pattern and the standards for our treatment by individuals and society in general.

The same is true of racist laws: immigration controls further increase women's vulnerability to rape and violence. The racism that Black and immigrant women face stems directly from one government after another saying: 'You are not welcome, don't expect any rights!' And when we are attacked by government, then police, employers, local officials, immigration officers and individual men get the message. THE GOVERNMENT HAS GIVEN THEM A PASSPORT TO RAPE.

Only to the degree that *all* women – Black and white, immigrant and native – are protected against rape and violence can any of us feel secure.

In this conference Black and white women, immigrant and native, will be coming together to speak out against rape as it affects all our lives and to discuss how we are organising together to fight against it.

We are looking forward to your participation.

In the pre-conference publicity, the committee had advertised its willingness to reproduce up to four pages that any woman wanted other participants to have. We also agreed that there was some basic information which we should provide to everyone present.

HinD, not widely known, had to say who and what it was, and make clear that it was a women's charity not only because it was formed and run *by* women, but because it was formed and continued to work *for* women. Here is how it introduced itself to the conference. This is followed by the fact sheet and the other papers which were given to every participant at the door.

What is Housewives in Dialogue?

Housewives in Dialogue is an educational, charitable Trust. Our primary objectives are research and the gathering and dissemination of information about women, with a particular focus on race. For us,

'information on race' begins with what women of colour
know from experience.

The history of Housewives in Dialogue

We began in 1976 as a project of the Wages for
Housework Campaign, which was based at the Women's
Centre in the Bengali community near Euston Station.
Local housewives, women from the Continent working as
au pairs, single mothers, lesbian women, company wives,
began coming to the Centre about problems related to
housing, money, children, isolation, immigration, benefits.
Some of the women working at the Centre, who
themselves had experienced the hardships and loneliness
of being immigrants and settling in Britain, or
reorganising their lives in other ways, felt the need to
inform other women of what they knew, and to provide
an information service. In particular they wanted to focus
on the experience of Black and immigrant women, and to
make that experience generally available. The under-
standing and information exchange that had grown out
of the interaction between women of different
nationalities, backgrounds and situations using the
Centre, were the foundation for Housewives in Dialogue.
Since then, we have applied for and received charity
status, and have taken over the running of the Centre.

Women's work

Running a women's centre, we have witnessed the
reservoir of skills, invisible community networks and
enormous resilience in all kinds of women in the face of
material and social hardships – in short, an underground
pool of work performed by women which keeps the
family, the community and each other together. This
work has never been given official recognition; and all
applications of women for social services and benefits,
even when they are for the family, children and the
community, are treated as applications by women for

charity – as though women had done nothing to deserve them. That Black and immigrant women face an even heavier workload than their neighbours, but the work itself was more or less the same as other women's, was the key to mutual appreciation of each other's situation. It was therefore important that we helped to make this mountain of work visible, and demonstrate what a social contribution it actually is. Our information demonstrates in a day-to-day way the truth of the United Nations figures that women do twice as much work as men.

Our slogan is: 'To bring housewives together is the first step in putting into dialogue those members of society whom housewives care for, service and support.' We also believe 'that women have more in common than the problems of race and ethnicity which separate us, and that women of ethnic minorities must be a prime consideration of the ethnic community and the women's movement' (from *The Invisibility of Black Housewives*).

Housewives in Dialogue has therefore concentrated on acquiring resources to provide a forum for women to speak of themselves and promote the dialogue between them. This conference – BRINGING IT ALL BACK HOME: BLACK AND IMMIGRANT WOMEN SPEAK OUT AND CLAIM OUR RIGHTS – has exactly that intention.

Summary of our activities

Our first publications demonstrate our approach and its effectiveness. *Black Women: Bringing It All Back Home* (Falling Wall Press, 1980) uncovered women's experiences of immigration in their own words and brought a new perspective to the subject. The conference will be developing some of its themes. *The Invisibility of Black Housewives*, which the Centre published, stated the obvious which is never stated. Both are available at the conference.

These writings, as do other of our activities, spread the information and take the dialogue beyond the

physical boundaries of the Centre. Discovering women's history, sifting through statistics, bringing to light women's writings and other skills, publishing the results of research on women, tracing what women are doing and saying in other parts of the world as well as in this country, are all part of our work of bringing to women the information we have been deprived of.

To this end we have also held exhibitions (e.g. 'Black Roots in Britain'), organised film shows, courses, discussion groups and public meetings. We have produced a videotape of immigrant women (available from us for rental), maintain a clippings library and run a Speakers' Bureau. Our international contacts are crucial resources. The Centre receives women visiting from both metropolitan and Third World countries who bring us and take back news and information. We attended the United Nations World Conference on the Decade for Women in Copenhagen in 1980, which greatly enriched our experience. More recently, our sister organisation, Women in Dialogue, has started in Philadelphia along the lines begun in London.

Womanpower

Housewives in Dialogue is not a membership organisation. It is run completely by voluntary labour. From December 1, we will have two paid employees, but the bulk of the work will continue to be done by volunteers drawn from the individuals and organisations who use the Women's Centre. We welcome your help.

Helping womens organisations

While we are not ourselves a campaigning organisation, we ensure that the information we gather is available to all women and their organisations.
Wilmette Brown and Solveig Francis
Joint Co-ordinators
11 November 1982

FACT SHEET FACT SHEET FACT SHEET FACT

I. WOMEN DO TWICE THE WORK OF MEN

A woman's work is never done

- Women : do two-thirds of the world's working hours
 : earn 5% of the world's income
 : own 1% of the world's assets
- Bangladesh : 90% of the agricultural work done by women
 Africa : 60–80% of the agricultural work done by women
- Between 25–33% of all households in the world are *de facto* headed by women
- Almost two out of three people who are illiterate in the world are women

What we left back home

- Women in Third World countries spend 1–4 hours per day in water collection
- Less than 10% of rural Third world women have access to a safe water supply
- Only 25% of Third World urban dwellers have courtyard or in-house clean water
- The chance of children dying in the first year of life is 10 times higher in Third World countries
- Most Third World countries have no welfare, social security or national health programme

* * *

In preparing section II and section III of this fact sheet, we aimed to present to the conference some basic economic facts of life for Black and immigrant women in Britain, together with some international comparisons. But our data is incomplete. Government departments are unwilling to show the economics of racism and sexism in hard figures. It was therefore impossible to pin down the wage differentials between Black and white, immigrant

and non-immigrant, women and men – even though everyone knows they exist.[*] One obvious fact, for example, is that women's unpaid work – no matter what our race, age or country of origin – does not appear in government statistics at all.

On the other hand, Black and immigrant women are not eager to give any information to governments: we know that any information we give them can be used against us, to deport us, or accuse us of doing something illegal. But we also need 'the facts' about ourselves. Working out how to determine our own data is a big organisational challenge to the Black, immigrant and women's movements.

II. BUILDING A LIFE IN BRITAIN

— 4.1% of the population in Britain is Black
— 7% of children under 16 are Black
— There are 15 million immigrants now living in W. Europe and probably between 6–10 million in the USA
— In the borough of Camden, 30.8% of families with children are headed by lone parents
— In 1980 the total weekly income of one-parent families was less than half (46%) that of two-parent families
— In 1981, women earned an average two-thirds (65.6%) of what men earned
— Over 400,000 health workers earn less than the official poverty wage of £82 a week, and many of these are immigrant women
— Women account for 43% of the total waged work force in London but are heavily segregated in service,

[*] The first figures on the sex and race wage hierarchy became available with the publication of *Black and White Britain — The Third PSI Survey* by Colin Brown, Policy Studies Institute, Heinemann, London 1984.

clerical, cleaning and catering occupations.

* * *

III. CLAIMING OUR RIGHTS

— In April 1982, company profits rose a quarter from the previous six months while take-home pay fell by 2%
— 1981 prices rose by 16%: rents up 40%, gas up 25%, electricity up 22%, phone up 25%, rail fares up 17%
— Britain has been losing more residents than it has taken in for some years now
— During the 1974–76 recession, most immigrant workers in Europe stayed on to draw unemployment pay and look for other jobs
— A conservative estimate of illegal immigrants in the European Economic Community is 600,000
— There are one-third million British illegal immigrants in the United States
— In 1968, 82% of all new immigrant workers in France were technically illegal
— Defence Budgets: Britain £12,000m
　　　　　　　　　　　USA a trillion and a half dollars
　　　　　　　　　　　NATO £104,816m
　　　　　　　　　　　Warsaw Pact £64,621m

Prepared by Wilmette Brown, Sara Callaway and Margaret Prescod. Thanks also to Joan Grant, and the indispensable Solveig Francis.

Information sources: Business Observer, Census 1971, Census 1981, Economic Status of Women in London, National Council for One Parent Families, Journal of International Affairs, Vol. 3 No. 2, National Union of Public Employees, *New Statesman*, One Parent Families 1982, The Commonwealth Institute, *The Times*, Unemployment and Racial Minorities, Wages for Housework International Campaign Journal, Spring '82.

Woman-Headed Households: The Ignored Factor in
Development Planning, Report submitted to AID/WID.

WOMEN AGAINST RAPE
BRITAIN

1. Statement to the Conference
RACISM IS RAPISM

In organising against rape, we have seen too often
how the law works against women's safety. The
immigration laws are a prime example.

— Women have frequently been forced to move to
 escape rape and violence, sometimes from city to city
 but often from country to country. Immigration has
 been a crucial escape route for many of us.

— On arriving in another country, we have found
 ourselves threatened again by the racism which stems
 directly from one government after another saying,
 'You are not welcome, don't expect any rights!' Such
 policies set us up as easy targets and legitimise every
 kind of racist attack against us, whether from
 immigration officers, the police, the courts, employers
 or individual men.

— Often the right to stay in the country is conditional on
 staying with a husband. We have seen how we are
 threatened with deportation when we have tried to
 escape violent relationships.

— We have been afraid to go to the police for help,
 particularly when attacks have come from within our
 own family or community, since we have seen how a
 woman's cry for help has been used as an excuse to

rampage in our community, particularly if we are
Black.

— We have seen the racial and sexual violence of the
police themselves. WAR organised together with other
women to defend and support Mrs. Esmé Baker, a
West Indian mother who was sexually assaulted by
members of the Immediate Response Unit – and won!

— We have seen the prejudice and racism of the police
not only against Black women but against prostitute
women. While the Yorkshire Ripper was killing
prostitutes, they saw no cause for concern. Their
attitude and lack of action allowed him to murder 13
women before he was stopped.

— We have seen how sexism combines with and re-
inforces racism. When Ms. Marcella Claxton, a Black
woman, reported that she had been attacked by the
Ripper, the police told her she was a prostitute and
her attacker must have been Black. Marcella's
description of the Ripper was later proved to be near
perfect – but it had been ignored.

— As women we have all experienced, if not rape itself,
then the threat or fear of rape. We know how rape has
been used to limit our movements and our lives. We
refuse to be locked into our homes or into our
countries. A WOMAN'S PLACE IS EVERYWHERE.

We are determined to end the racist and sexist laws
which set the pattern and the standard for the way we
are treated not only in one country but in the world as a
whole. We know that only to the degree that *all* women
– Black and white, immigrant and native – are protected
against rape and violence can any of us feel secure.

10 November 1982

2. Press Release, 25 October, 1982:
VICTORY FOR ESME BAKER

Today at Walthamstow Magistrates Court Mrs Esmé
Baker, a West Indian woman, and her two sons were
found not guilty of assault, threatening behaviour and
obstructing the Police, which was a victory in the
campaign against rape and violence.

Since the case began on Monday 16 August, two
entirely contradictory versions of what took place were
given to the court. The Police maintained that Emile
Folkes (16 years old) had tried to resist arrest for
causing a disturbance and that Mrs Baker and her
younger son (14 years old) had tried to obstruct.

Mrs Baker maintained that the Police had beaten her
older son. She herself was arrested when she went to
investigate the cries she heard. Her dress was torn open
and her breasts handled and poked with a truncheon by
members of the Immediate Response Unit, while other
Police officers jeered and laughed. Meanwhile, her
younger son was held face down on the floor of the
Police van.

Both defence solicitors, Mr Paul Boateng and Mr
Peart, pointed out that though the magistrates were often
under pressure to side with the Police, their job was to
decide on the evidence. Since a lot was at stake if the
Police were proved to be falsifying evidence, the
tempatation was for them to lie.

Mrs Baker's courage in testifying against the Police
was rewarded by support from Women Against Rape,
other community groups, neighbours and friends and by
the decision of the magistrates.

3. Leaflet, 25 November 1979:
CUTBACK ON RIGHTS — PASSPORT TO RAPE

The new immigration proposals attack every woman.
The racism that Black and immigrant women (Black and
white) already face stems directly from one government
after another saying 'You are not welcome, don't expect
any rights'. AND THEY MEAN IT.

Mrs. X, a 55 year old West Indian woman, who has
been a home help for seven years, was picked up by
police when her son was arrested. Ten plain clothes
flying squad police officers went to her home. They
harassed her 14 year old daughter and abused her 16
year old physically and mentally handicapped son, who
was obviously distressed to see his mother taken away
by a number of strange men.

She was taken to a London police station where she
was stripped and searched between her legs while
continually being verbally mocked and insulted. She
asked the police woman who was examining her 'Haven't
you got a mother?'

W.A.R. are fighting the case.

Miss X, a 14 year old British woman with West Indian
parents, was raped while in the 'care' of a local London
Council. As a result she now has a six year old child. The
council first tried to ignore the situation, then they tried
to cover up, and are now trying to get out of their
obligation to give compensation to this young mother.

W.A.R. are fighting the case.

THE GOVERNMENT cuts WOMEN'S rights when it
cuts our paid jobs, nursery provisions, SS benefits,
pensions, hospitals and schools.

WOMEN ARE THE ONES who are forced back into
the home to do for free the nursing, teaching, social
work and childcare we used to get paid for.

THIS NEW CONTROL FURTHER ATTACKING

WOMEN is one more cutback, this time on our right to
marry whom we want and live where we want.

EVERY IMMIGRATION CONTROL ATTACKS THOSE
ALREADY HERE. It makes us an easy target. When we
are attacked by government, then police, employers, local
officials, immigration officers and individual men get the
message.

THE GOVERNMENT HAS GIVEN THEM A PASSPORT
TO RAPE.

WOMEN AGAINST RAPE
WAGES FOR HOUSEWORK CAMPAIGN

Black Women for Wages for Housework
English Collective of Prostitutes
Wages Due Lesbians

2 April 1982

Dear Sisters & Friends,

We would like to draw your attention to the enclosed
leaflet about the Campaign to Defend the 'Bradford 12'
and its forthcoming activities. We think the issues raised
by this case are of particular importance for women in
the lesbian and women's movements and for men in the
gay movement.

The case of the 'Bradford 12' concerns 12 Asian
youths who were arrested in July 1981, then held
without bail for three months, and who go on trial on
April 26th accused of 'conspiring to destroy or damage
property by fire or explosion and to cause grievous bodily
harm'. These charges carry a maximum sentence of life
imprisonment and are a blatant attempt by the
Establishment to undermine the power of the Black

community, not only in Bradford but throughout the
country.

'Conspiracy' trials are not new. They have always been
a favourite weapon for the State to use, not only against
particular communities but as an attack on organising.
For example in the 'Islington 18' case, 18 Black youths
were arrested eight weeks after a 'riot'at the 1976
Notting Hill Carnival. They were later tried on twenty
'conspiracy to rob' charges – mostly from persons
unknown on days unknown. In another case, that of the
'Shrewsbury 12', trade unionists who organised flying
pickets during the building workers dispute in 1973
were accused of 'conspiracy to intimidate'. More recently,
five members of the Paedophile Information Exchange
were charged with 'conspiracy to corrupt public morals',
based on a penfriend service PIE provided for adult
paedophiles. It is not accidental that all those arrested in
the Bradford case have been involved in community
organising. Nor is it an accident that the Establishment
has chosen to make this test case – as part of the
backlash following last summer's rebellions – in
Bradford, where the Black community is well established
and has a long history of fighting back. The gay
community in Bradford also has a history of fighting
back. In fact it's where the Black and gay communities
organised together against the National Front and won a
major victory. Looking at this history we can see how it
is relevant to the situation today, in particular how it
relates to women and gays and the 'Bradford 12'.

In 1977 the National Front intended to make its
headquarters in Bradford and planned to hold a march,
followed by a public meeting in the centre of
Manningham, an inner city district of Bradford. A large
proportion of the community living in Manningham was,
and still is, Black and immigrant. It is also a 'red light'
area where prostitutes live and work and where many

gays live. That community then, as now, bore the brunt of the economic crisis, of poverty and unemployment and of police repression. Manningham is in many ways typical of the inner city areas where last summer's rebellions took place.

Local people were furious and disgusted not only that the National Front planned to march through *their* streets, but that the police and the authorities first gave permission for the march and the meeting to be held, but then allowed it to continue by protecting it from a counter demonstration led by gays and Blacks. (The same happened in Southall last year when the police protected skinheads who were attacking the Asian community.) That night in Manningham there was a 'riot' described as the worst street violence seen in Bradford this century. It was a rebellion directed against the police. Women and children were both very much part of the fight in which the people of Manningham took back their streets.

The 1977 offensive against the NF marked a turning point in relations between the gay and the Black community, between white and Black and between West Indians and Asians. Different sectors of the working class which are set apart from each other (although in many cases they are the same people) came together to fight a common enemy. The barriers dividing them were temporarily broken. Subsequently the Manningham Defence Committee was set up to co-ordinate further resistance to the NF and a 'sitdown' protest against a NF motorcade through Manningham was organised by gays. Due to the pressure of this local opposition, the NF were unable to make their headquarters in Bradford – the people of Manningham had won a major victory.

Later in the same year the police focused their attention on the gay community. Many of you may remember the formation of the 'Bradford Campaign to

Stop the Witchhunting of Lesbians and Gay Men'. The campaign was started to fight back against systematic surveillance and harassment of the gay community by the West Yorkshire police. On the pretext of hunting the murderer of a young man, gay people were taken from their workplaces for questioning without warning, gay organisations were raided and gay people's homes were watched. Altogether 3,000 lesbians and gay men came under direct pressure from the police.

At the same time a police surgeon tried to whip up public outrage against gays by a series of wild allegations made in the local press about 'vice rings' involving young boys in Bradford. Women were very much in the lead of the campaign which saw the harassment of the gay community as part of a much wider attack by the police and the Establishment against the whole community in Manningham. As a result of their organising, which included a very successful march through the centre of Bradford and gathering support from women's groups, immigrant and community groups and local trade unions, the gays won a significant victory. The police were forced to drop their 'vice-ring' allegations and wound down the harassment. The gay community made clear that it refused to be cut off and separated from the rest of the community and refused to tolerate harassment for fear of being exposed.

Since last summer's rebellions, the whole question of police attitudes and methods, of bias and discrimination, has come under close scrutiny, not only in response to issues raised by the Black community, but in response to widespread criticism from many different sections of the community. Women have a long and bitter experience of police bias and discrimination by the courts – whether we're lesbian mothers deprived of custody of our children, whether we've gone to the police to report a rape or domestic violence, whether we work as

prostitutes and are regularly victimised by the police, or whether we're Black women defending our children whose only 'crime' was to be on the streets. Whatever our situation, women's experience at the hands of the police is now beginning to emerge publicly. In addition, gay men, especially those under 21, and those on the game, are regularly victimised and harassed by the police. Others have lost their jobs as a result of court appearances on trumped-up charges, or for breaking laws designed to control their sexual lives.

A value judgement is being made constantly by the police about who deserves protection and who doesn't, about who is considered to be a danger to society and who isn't. It's noteworthy that the police force who so diligently tracked down the 'Bradford 12', the West Yorkshire police, is a force which has a particularly offensive record of harassment, bias and of complete failure to protect women from violence. Their priorities were clearly revealed during the Yorkshire Ripper case – it took five years and £4m to catch Sutcliffe because the police didn't make catching him their priority while the victims were prostitutes. The Home Secretary even admitted that the police had made 'errors of judgement', and still West Yorkshire's Chief of Police, Ronald Gregory, said that he had 'no regrets about his force's performance'. The English Collective of Prostitutes commented:

> As representatives of the community of most of those women who were attacked or murdered by Sutcliffe, those who paid dearly for these 'errors of judgement', sometimes with their lives, we know almost by habit where to look for the fundamental cause of these errors. Gregory's lack of regret is the key: from the beginning of the inquiry in 1975, a judgement was made about the value of women's lives – specifically the value of prostitute women's lives. The fact is that the murder or brutal attack on

prostitute women was not regarded by the police as a serious enough offence to warrant large-scale police mobilisation. In each murder case the police deliberately made the distinction between prostitute victims and so-called 'respectable' and 'innocent' victims, downgrading the murder of prostitutes, who are by implication 'guilty', as irrelevant, unimportant, almost desirable . . . it must be established that every woman, regardless of age, occupation, race, nationality or lifestyle, is entitled to police protection. Police who are seen not to provide this are part of the problem, not the solution, and must be given their cards.*

Women, especially those of us who are Black, lesbians and/or prostitutes, know only too well the effect of police harassment, of racism in the police force and the courts, of court procedures biased against us and of attacks by the State against our organisations. We have constantly to defend our communities from violence, both from the State and from individuals. We have fought against immigration laws which penalise us doubly as Black women. As the economic crisis deepens we are fighting against unemployment and poverty for our survival; and we're fighting not only to survive but to be able to live where we choose, how we choose and with whom we choose.

In fighting for these rights we are dependent on our organisations and on people who are prepared to stand up with us, and who thereby put themselves at risk. The 'Bradford 12' were, and are, part of that fight. Taking a stand with the 'Bradford 12' is to make clear that the women's movement and the lesbian and gay movements belong to and speak for working class, Black and white, anti-racist and anti-fascist, women and men.

Lie Back and Think of English Justice by Selma James and Anne Neale, February 1982

Black and immigrant women have always defended
men and young people from racism, injustice,
harassment and brutality by the police and the courts.
What distinguishes the men in the 'Bradford 12' is that
they put themselves on the line to defend Black and
immigrant women – some were key people in the
successful campaign to get Anwar Ditta's children back
into this country. Not to defend the 'Bradford 12' is to
take a stand against Black and immigrant women. It is
also to strengthen the government's hand in attacking all
of us, because it allows them to pick us off one by one,
isolated and divided from each other. We can be certain
that if the 'Bradford 12' are found guilty, we will all be
guilty by implication and weaker as a result.

The Bradford 12 Mobilising Committee is calling for
all the charges against the defendants to be dropped. In
addition to pressing publicly for that, you may also like to
consider what else your organisation can do: affiliate to
the campaign, come on pickets and demonstrations,
circulate petitions, hold benefits or socials to raise
money, write to local and national newspapers.

We will be glad to discuss concrete suggestions with
you, or you can contact the National Mobilising
Committee directly.
Power to the sisters and therefore to the class.

Wilmette Brown
for Black Women for Wages for Housework, and Wages
Due Lesbians

Anne Neale
for English Collective of Prostitutes, and Wages Due
Lesbians.

* * *

From the *New York Times* 3 May 1982:

Reunion Recalls Movie on Hispanic Strikers Made at Time of Film Blacklist

Special to the New York Times

SILVER CITY, N.M. [New Mexico], May 2 [1982] — Almost three decades after the completion of *Salt of the Earth*, the 1954 movie about a militant union's successful strike against a zinc mining company, participants in the movie and the strike itself gathered here this weekend to remember the filming and its impact.

Salt of the Earth, shot here amid local hostility in 1953, used many of the mostly Mexican-American miners and their families to play roles based on their own experiences. It was made by filmmakers blacklisted in the 1940's and 50's for refusing to cooperate with Congressional inquiries into what was identified as 'leftist subversion' in the movie industry.

Anniversary of McCarthy's Death

Paul Jarrico, producer of *Salt of the Earth*, was among the filmmakers attending the reunion Saturday. He was blacklisted in the early 1950's for refusing to tell the House Un-American Activities Committee whether he had been a Communist. He told the gathering: 'This country has matured a great deal in the 29 years since we made *Salt*. I don't think McCarthyism could start up again in the manner it once did.'

Today is the 25th anniversary of the death of Senator Joseph R. McCarthy, Republican of Wisconsin, who used his Senate investigations committee as a pulpit for accusations of Communism.

Paul Perlin, the movie's technical coordinator, said he remembered 'armed vigilantes and goon squads' threatening

the case and crew after their efforts were denounced in Congress by Representative Donald L. Jackson, Republican of California, as Communist-inspired and 'designed to inflame racial hatred.'

The 15-month strike at the Empire Zinc Company over pay and working and living conditions was hailed at the reunion as a major breakthrough in the role of Mexican-American women and the dignity of Mexican-American workers. Midway through it, a provision of the Taft-Hartley Act was invoked, barring the miners from picketing at their Hanover, N.M., work place. Miner's wives enthusiastically took over the picket line, and despite mass arrests and physical abuse from the authorities, they continued picketing until the strike was resolved in January 1952.

Rosaura Revueltas, the Mexican actress who portrayed a miner's wife experiencing personal and political growth in the strike, told the gathering that as a result of the role, she was blacklisted by the Mexican film industry. Near the end of the filming, Miss Revueltas was arrested by the Immigration and Naturalization Service and held until shooting was over.

Miss Revueltas joined the others Saturday night at the premiere of *A Crime to Fit the Punishment*, a documentary about the blacklist, the making of *Salt* and the strike.

Juan Chacon, who played the union leader, served at the time of the filming as president of Local 890 of the International Union of Mine, Mill and smelter Workers, which helped finance the movie. He retired this spring as president of the same local, now affiliated with the United Steel Workers. Later this year he is scheduled to tour factories in China, taking along a print of *Salt* with Chinese subtitles.

Salt of the Earth was directed by Herbert Biberman, one of the 'Hollywood 10' who were jailed for contempt of Congress for refusal to testify on their political sympathies in 1947. It was written by Michael Wilson. Both have since died.

Theatrical distribution of *Salt of the Earth* was effectively blocked by the motion picture industry, but the movie has since become a noncommercial favorite, with numerous screenings by groups promoting women's rights, Mexican-American dignity and unions.

In the communities near Silver City, where many miners have been laid off and where union activities are now quiet, the strike is nevertheless seen as a catalyst for social change. Angela Sanchez, who participated in the original picket line and the movie, said:

'Mexican culture has traditionally been that women belong in the home. After the strike, men didn't see us as weaklings anymore. Also, the two races started getting together and mixing in nightclubs.'

Raul Delgado, who moved to the area in 1953, said local discrimination still lingered. 'You've got the same feeling now you had back then, but it's subdued,' he said. But Mrs. Sanchez said that an integrated picnic like the one held Saturday to honor the filmmakers could not have occurred in Grant County 30 years ago.

And finally, a letter from an Argentinian immigrant woman, *The Guardian*, 21 May, 1982.

Sir,

As an Argentinian woman settled in Britain, I have never noticed the British Government expressing any concern about Argentina's military regimes. It seems rather late in the day to discover the realities and horrors of such regimes which have – with a few brief exceptions – ruled Argentina for several decades.

Considering our history, it is insulting and painful to see the Argentine people portrayed by the British media as supporters of Galtieri's policies. Since when has a military dictatorship been equated with the people it was set up to oppress? Why is the media silent about the

opposition to the dictatorship?

Argentine women in particular have a long history of struggle. They have organised demonstrations, marches, pickets, and strikes against their government. For several years now women have held weekly rallies in front of the Casa Rosada to protest against the 'disappearance' of their loved ones and to force the Government to stop this genocide. None of this was ever reported in Britain at any length.

That Margaret Thatcher should be concerned to expose Galtieri's dictatorship today is not a matter of principle, but a matter of convenience: until two months ago she had no principle against selling arms to Argentina. These same arms were used against women and men who actively opposed the military regimes, and against their children and relatives. They are now being used against British soldiers.

That she should be concerned with the Falklanders 'right to choose' is also a matter of convenience. There was no mention of 'right to choose' when the Nationality Bill was passed, creating an increasing number of second-class citizens in Britain and in territories under British 'protection,' including the Falklands.

In fact both Galtieri and Margaret Thatcher are using the 'Falklands crisis' as a ploy to distract attention from opposition to their respective governments. Unemployment, strikes, and riots have all been swept under the carpet of the 'Falklands crisis.'

What about the price of war that Argentine and British citizens alike will have to pay? Galtieri has already imposed emergency taxes to finance the war; Margaret Thatcher has made it clear that ' . . . it is the future of freedom at stake and the reputation of Britain. We just cannot look at it on the basis of precisely how much it will cost.'

Why doesn't this apply when money is needed to

finance peace instead of war?

This war is not our war. Women in Britain and in Argentina are allies in a common fight against the war, and against the poverty and unemployment imposed by our governments.

We all want the 'right to choose' not only between two governments, but also to decide how the money that comes from our work and taxes is to be spent by those governments. Women Against Rape slogan, 'Give women the defence budget and we'll defend ourselves,' has taken on a new significance and urgency.

In the same vein the nurses of Whittington Hospital carried placards saying 'Give Falklands money to our nurses.' These among others are women's priorities for Argentine and British money – not financing a war that nobody, other than our governments, wants.

Yours,

Anita Garcia
Women's Centre
London WC1

POSTSCRIPT

Publication of this book was originally planned for Autumn 1984. The rapidity of events since then makes it necessary, I feel, to provide an update of the contents before it goes to press. Many of the themes first raised by the strangers and sisters who came together at the conference in 1982 have been further developed by the growth of the movement, and the growth too of the forces against it.

* * *

The Women Count conference, 16–17 June 1984, the preparations for which are described in the Introduction (see pp. 39–43), exploded in an entirely unexpected direction.

Invited to count women's work, women began not by quantifying but by cataloguing and naming what that work is. In the two days, 600 women compiled a list of over 200 jobs which they do, are not acknowledged to be doing, and often perform so automatically and so invisibly that they may not even be aware themselves of doing them. By Sunday afternoon, a woman who said at the open mike, 'Now I know why I'm so tired!' got something of an ovation.

Women attended over two hot and sunny days, rare for London, a mark, we felt, of considerable engagement and interest. Many who came on Saturday insisted that their friends come with them on Sunday so as not to miss this remarkable occasion.

A large banner hung from the balcony commemorating the eighth anniversary of an important moment in world history. It said simply, 'SOWETO 16 JUNE 1976'. A year later it was clearer what Soweto had begun and how rapidly the revolution in South Africa is moving. The lives and struggles of people everywhere are bound to be transformed in ways we can hardly imagine by what is happening there.

Conference II was structured into three sessions according to the main themes of the United Nations Decade for Women: *Equality* —compared to what?, *Development* — for us or against us? and *Peace* — how, when we are still hungry? It set out to use women's work as a yardstick for evaluating what the Decade had accomplished. It was the first grassroots event in Britain to inform women about the Decade so they could consider whether and how to prepare for the UN End of Decade Conference to be held a year later in Nairobi, Kenya.

The Women Count — Count Women's Work petition launched at Conference II (see pp. 40–1) had been circulating widely in a number of countries in preparation for Nairobi in 1985. There were two events in Nairobi. The first (10–19 July) was the non-governmental Forum which attracted 14,000 women from all over the world, and the second (15–26 July) was the government conference. The International WFH Campaign Journal, prepared for the Forum, declared:

If governments count what we do, we — and they — will know what we are owed. Demanding what we are owed is a demand to change the world from the bottom up.

Women at the Forum generally understood this, but for the Third World women who crowded round our table and signed the petition in one of ten languages — including Swahili, the language of Kenya — it was sometimes a matter of life and death. For example, the invisibility of women's work on the land is a prime cause of the present famine in Africa. (This is now hinted at even by the 'experts', but it is very rarely stated. We will go into detail about it in *The Global Kitchen: the*

Case for Counting Women's Work, which is in preparation.) It was particularly ironic, therefore, that measures to deal with the famine, which had struck within a few hundred miles of where we were meeting, were never debated at the government conference on women.

Housewives in Dialogue got consultative status with the UN in the Spring of 1985, which gave it access to the government conference. HinD presented a number of amendments to the Forward Looking Strategies document which was under consideration by the governments. To our joy, HinD's amendment to paragraph 120 was passed and the document now reads:

> The remunerated and, in particular, the unremunerated contribution of women to all aspects and sectors of development should be recognised and appropriate efforts should be made to measure and reflect these contributions in national accounts and economic statistics, and in the Gross National Product. Concrete steps should be taken to quantify the unremunerated contribution of women to food and agricultural production, reproduction and household activities.

All kinds of women rejoiced with us and are now in the process of organising across national boundaries to get governments to implement it. The petition will continue to be a tool for the ongoing struggle to get implementation.

* * *

In 1985, the campaign and trial of Jackie Berkeley, a young Black woman in Manchester, who complained that while she was in custody two white policemen raped her while two white policewomen held her down, brought to far greater public attention the rape and sexual assault of Black women by the police, which Esmé Baker had raised. Police response was to charge Jackie with wasting police time by making a false complaint.

Women Against Rape was an expert witness in her defence.
There was a picket outside the court every day during the trial
in Manchester. WAR and Black Women for Wages for
Housework helped to publicise Jackie Berkeley's case
nationally by a parallel picket outside the High Court in
London, and by picketing the Magistrates' Association the day
of the verdict. BWWFH in the US also organised a picket
outside the British Consulate in New York (as it had for the
Bradford 12 in Los Angeles) and international messages of
support from many women's organisations, Black and white.
BWWFH in Trinidad also sent a message of support.

Tragically, Jackie Berkeley was found guilty. It was a harder
case to win than Esmé Baker's, and it was not handled as well:
women's autonomy and Black women's leadership were
bypassed, which meant that the strategy for fighting the case
left something to be desired and the mobilisation of opinion
and action was less than it had to be to win. But we owe as
much of a debt to Jackie Berkeley and her parents for standing
up against State violence as we do to Esmé.

* * *

In the 'Claiming Our Rights' session of Conference I, you
will remember a discussion on whether to accept grants from
local governments. Parminder Vir and Margaret Prescod
from the platform and an underpaid nurse from the floor all
agreed we had a right to the money that leftwing local govern-
ments were beginning to offer community groups. The problem
seemed to be: would this funding corrupt these groups?

Within a month of the conference, a public meeting of
women in London voted Wilmette Brown to be a co-opted
member of the Greater London Council's new Women's
Committee. Therefore for two years we at the King's Cross
Women's Centre had a painfully close look at what much of
such funding is about, by watching what the Women's
Committee, the main channel for GLC funding to women's
groups and projects, funded and didn't fund. This is a long
and important discussion which needs plenty of space

elsewhere, but something must be said here to add to the brief conference discussion.

Some groups did suffer by being funded, for a variety of reasons, including lack of advice; some flourished with funding; and some did very little with the money. The major problem, however, was that many groups which deserved funding didn't get the money they needed and, worse, many groups — racist, sexist, separatist and anti-working class — got substantial funding; some even now own their own buildings. These groups now constitute an Establishment within the movement: they are funded, have political backing and are not accountable to the grassroots. The problem this poses will be with us for some time to come.

I will give only the latest and in some ways the most shocking example of this that I know.

Early in 1985 the Black Female Prisoners Scheme held a conference funded by the GLC Women's Committee. At the event, the two leading women, Afro-Caribbeans, made clear that for them only 'African' women were Black; Asian women were not. In any case, they said, few Asian women were in prison and they were 'only in for immigration cases'. Challenged by an Asian sister, they reaffirmed their position and one then added, 'anyone who doesn't like it can leave'. Some of us left.

Many of us always carry in our minds the useless and tragic bloodshed in Guyana and elsewhere as a consequence of an Afro-Asian split; this was the terrain of Andaiye's advice to us in the last session, to find out what we have in common — quickly. Some of us have taken as an absolute priority for our organising the necessity of building the unity of Black communities in Britain — for self-defence and even survival. We were horrified by this promotion of division among women and among Black people. We learned later that an Asian woman, a GLC employee, had been asked to stop

* Mildred Gordon, a working class Labour Party member, also opposed it, but as an advisory member of the Committee she didn't have a vote.

working with this project to maintain its racial purity. But
more was to come.

Some weeks later, this group, already previously funded by
the Women's Committee, was awarded an additional hundred-
thousand pounds. Wilmette alone* opposed the funding in the
Women's Committee. The other women — Afro-Caribbean,
Asian, Irish, English — who were employees or co-opted
members defended it, and it was passed. Ken Livingstone,
leftwing leader of the GLC, voted for the funding. Livingstone
is the prospective Parliamentary candidate in Brent East, a
London constituency with a population of both African and
Asian descent. What does this mean for them?

This funding was neither an accident nor a temporary
aberration. Separatism of every kind ultimately becomes
divide and rule, and for that reason is popular with
governments and with funding agencies generally. In Margaret
Thatcher's Britain the sellouts, the scabs and the political
pimps have come out of hiding to collect their thirty pieces of
silver. To call them racist is to hide a big truth with a smaller
one. They are motivated not by prejudice but by willingness
to act on behalf of whoever has the power of dispensation of
funds, jobs and influence. This willingness to sell oneself to
the highest bidder is the indispensable ingredient of nazism.
In Margaret Thatcher's Britain, there's a lot of it about.

* * *

In spite of this, and to confront it, new sectors of the
movement are coalescing and making their presence felt. As I
write, the anti-deportation movement, made up of a network
of dozens of individual campaigns, has begun to surface. They
have a decade of experience fighting deportation cases, and
almost two decades of the autonomy of a women's movement,
a Black movement, an immigrant movement, lesbian and gay
movement and so on. This network reflects the power and
combination of these. In preparation at the moment is an anti-
deportation resource pack of information and ideas which
aims to be useful to those who want to know what's going on,

what to do about it and how to do it.

* * *

At the same time as we build the anti-deportation and anti-racist movement in Britain and the rest of Europe, we will have to make strong connections with what is happening to other immigrants on other continents, and grasp the significance of the anti-deportation struggle to international politics.

For example, as I mentioned in the Introduction (pp. 26–7), an important part of opposing US policy in Central America is helping those threatened with torture and death in El Salvador to enter the US and protect them from deportatin by the State Department, the American equivalent of the British Home Office. Reappropriating the right of entry and the right to stay in the US has been a practical way of expressing international working class solidarity. Rhetoric against imperialism rarely expresses itself in the practical internationalism of supporting immigrants. We have to change that, along with much else.

15 August 1985 S.J.